NORDIC LIGHT

SIMON BAJADA

NORDIC LIGHT

Lighter, everyday eating from a Scandinavian kitchen

hardie grant books

CONTENTS

INTRODUCTION

What is Nordic light? With my photographer's hat on, I think of it first in literal terms; it's that beautiful light you find during the afternoon hours when the sun drops and casts unfamiliar long shadows, or that intense magenta glow of warmth on a clear morning.

As a food writer, however, and for the purposes of this book, Nordic light is a name I have given to a particular style of eating – one that combines elements of new Nordic cuisine, classic Scandinavian, raw food and vegetable-focused eating to create a better balanced diet that satisfies our desire to eat more healthily, more interestingly and more deliciously. It sure is a mouthful... but that is what I want it to be!

Having come to be working in the Nordic countries from Australia I've been able to see Nordic cuisine from a different perspective – as an outsider looking in – and it has proved to be incredibly stimulating. A dinner at the award-winning Copenhagen restaurant Noma in 2006 sparked my love of Nordic cooking and formed the foundations for me to author *The New Nordic* nine years later. My interest in the cuisine has by no means waned, it continues to inspire me and prompts a desire for me to share ideas.

In my time here, Nordic cuisine – with its use of seafood, grains, berries, seasonal vegetables and lean wild meats – has revealed itself to be a very healthy diet. While engrossed in the food culture of the region, I have also developed an interest in other modern diets that focus on healthier eating.

The recipes ahead draw on this interest. They are easy to make and quick to prepare (always a plus). At times they might prove a little unfamiliar, for example when setting a parfait with silken tofu or making a chia pudding with carrot cake flavours, but I hope you, like me, find this exciting. Personally, I love the creative element of cooking – discovering methods of preparation and combinations of ingredients. It's where I find most satisfaction and fun in the kitchen.

I don't profess to being a nutritionist, a longevity coach, or an advocate for animal welfare – in other words, this book is not attempting to be raw, whole, vegetarian, Paleo or coeliac friendly – rather it aims to provide you with a better balanced foundation for whatever lies ahead. It is a unique position in a crossroad of influencing factors and a snapshot of how my family and I are eating today.

So how is that, exactly? Well, for example, since moving to Sweden, my family has felt the positive effects of a more diverse, less meat-heavy diet. Don't get me wrong, I still love to bite into a steak, it's the 'how often' that has changed, something encouraged by Sweden's preference for seafood as protein of choice. This newly found diversity at our table can be seen at breakfast, where our boys are as happy tucking into smoked fish roe and cucumber on rye as they are Vegemite and avocado toast.

My interest in new Nordic cuisine – the celebration of traditional Nordic methods of sourcing local ingredients and preparing them in different ways – has also given our diet a better balance through the importance it places on bringing vegetables to the fore. Vegetable-based cuisine demands the best-quality vegetables, so wherever possible I now try to use seasonal, organic or locally grown produce (and I suggest you do the same). In much the same way as a weekly seasonal veggie delivery service, this has meant that we have been eating vegetables in their prime, and has encouraged us to try and prepare fruit and veggies that we might not otherwise buy.

I have also been able to observe the ways in which new Nordic cuisine and the raw and whole food movements share common ideology, and the ways in which they have to operate with limits placed upon them in terms of the range of ingredients and techniques they are able to work with. These limitations however can prove inspirational – new Nordic cuisine's ideology of focusing on using produce grown in the harsh North climate, for example, has stimulated the creation of exciting new cooking techniques and methods of preparation to present these ingredients in previously unimaginable ways. Likewise, where raw food chefs cannot use the most common techniques in cookery they are motivated to think beyond what they know works and develop new techniques for creating dishes. For me it's a win-win to not be bound by these 'rules' of raw and whole food cooking, but to be able to consider them so as to create new ideas while at the same time eating more healthily.

Working as a food and travel photographer I encounter new techniques regularly, and take the ideas home with me to test and domesticate them for the home kitchen, where they continue to inspire me. Ahead you will see some examples of these. Coupled with a motivation to enjoy a better balanced diet, I hope they inspire you to think differently in your approach to your everyday cooking and eating.

NORDIC LIGHT EQUIPMENT

The food in this book calls for much of the typical kit found in the ordinary home kitchen. There are, however, a few tools that will help produce the best results and bring authenticity to your dishes, and these are detailed below.

CAST-IRON PANS AND CASSEROLES

At one time, Sweden produced the best quality coal and as a result of this industry they also perfected the art of cast-iron. Old cookbooks passed down through the generations all call for the use of this sturdy cookware, and for many good reasons. Cast-iron gives a well-rounded temperature, ensuring foods cook all the way through with less direct heat. As an added benefit, the cookware acts as a natural iron enrichment, a mineral that many of us lack in our modern-day diets.

Cast-iron is a long-lasting material that can be used over and over again. Eventually though, your pan will dry out, and when this happens it's easy to re-season. Pour a thin layer of rapeseed oil into the dry pan then heat it to a high temperature. After 10–15 minutes, when the oil has stopped smoking, the pan will be black and properly seasoned again, ready for use.

FOOD PROCESSOR

A good food processor is essential for preparing raw food, breaking down ingredients into forms that would otherwise be unattainable. When choosing one, try to avoid those with too many fancy features and attachments and look instead for a simply designed machine with a high wattage and a powerful motor. Some of the multi-use processors, however, do have the advantage of providing a smaller processor attachment, which can be great for making small batches of sauces or dressings such as the yoghurt ones on pages 110–111. When using a food processor it's important to remember to scrape down the sides while working with particular ingredients to ensure an even consistency.

MANDOLINE

The mandoline is a great tool, allowing you to play around with raw and pickled ingredients to all manner of effects. Because it slices vegetables so thinly, veggies that we normally don't associate with being eaten raw can be consumed this way. Preparing vegetables like this can add important texture, as well as acidity if they have been pickled.

CHEESE SLICER

In 1925, Norwegian inventor Thor Bjørklund introduced us to the Nordic cheese slicer. His design drew influence from the carpenter's plane, enabling you to shave off very thin slices. It is essential in the everyday eating of open sandwiches. Its uses extend beyond cheese though, making it a great addition to any kitchen. It can also be used like a mandoline to slice vegetables very finely – just be very careful! If you do acquire one, sooner or later you will know what I mean when I say your cheese wedge looks like a ski jump.

PICKLING JARS

These were mandatory in Nordic countries when preserving food was essential to keep going through the seasons, and they are still used today. Jars benefit from a sealed lid for pickles, brines, compotes and jams. They are also perfect for storing grains and seedy garnishes such as those detailed on page 199. You can never have enough jars!

NOTCHED ROLLING PIN

These famous bread pins, called *kruskavel*, are from Sweden and they put the dimples in flatbreads that help them cook more evenly. They come in two different depths of textures, depending on what type of bread you are making. Crispbreads use a more pointed dimple version, so the hot air can reach a greater surface area, and the other less defined type is used for softer flatbreads. If you cannot find a *kruskavel* you can always use the back of a fork to make your dimples.

EGG SLICER

While most of the world enjoys a yolk oozing out onto some sourdough, Nordic countries love a hard-boiled egg. This slicer uses a wire frame to cut perfectly even slices and it is essential to the ritual of open sandwiches. The large Swedish furniture retailer sells them cheaply.

SWEDISH BUTTER KNIFE, SMÖRKNIVAR

These special butter knives are made from open-grained, flexible wood. The finish of the wood is very smooth and you can get them in many different shapes, but the most important design feature is that the blade is wider than the handle. Swedes hold these knives dear to their hearts.

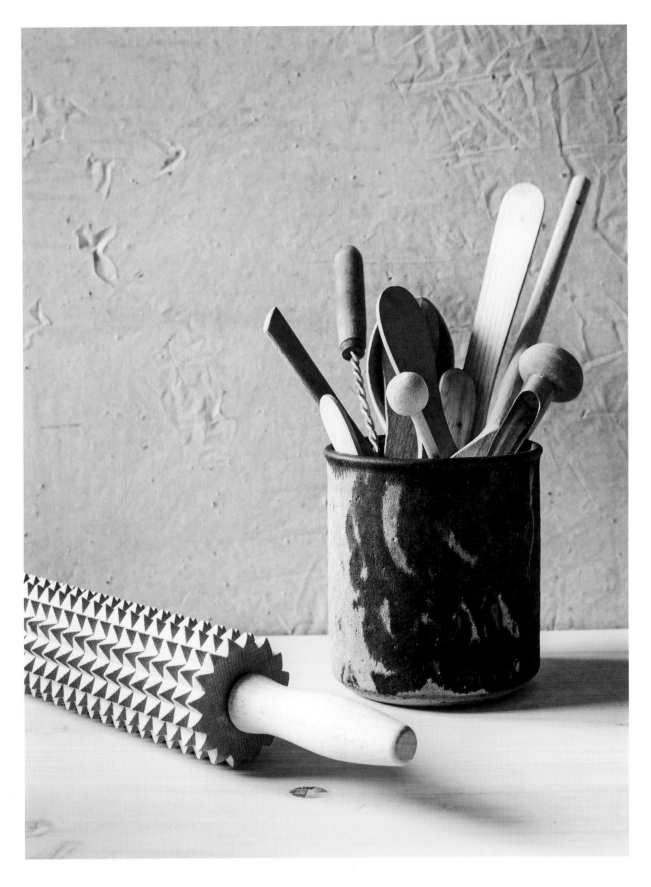

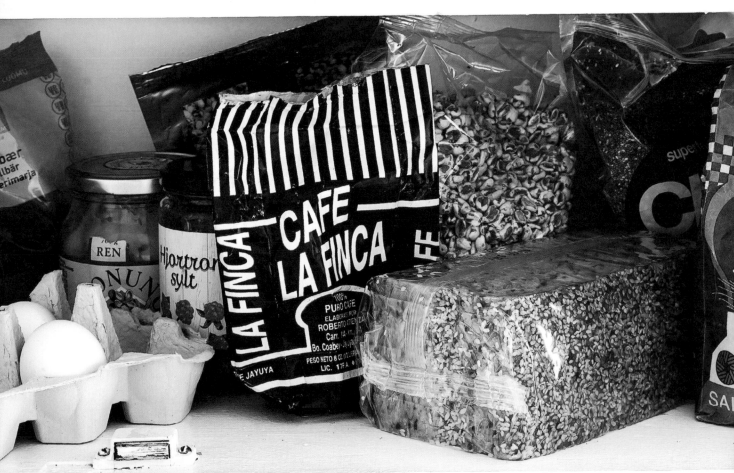

CHAPTER ONE

NORDIC BRUNCH

Surprisingly, brunch culture is in its infancy in Nordic countries. There are very few cafés serving up eggs *en cocotte* with chorizo and caponata, or poached eggs with dukkah and goat's cheese matched to complicated latte combinations that require graphs to comprehend. This is partly due to the open sandwich and filtered coffee culture being so strong. That said, brunch is growing in both presence and popularity.

The Nordic affinity for sandwich and toppings doesn't mean Nordic folk aren't getting creative on the weekends, however, and more and more cafés are diversifying their pre-lunch menus. In the recipes that follow I have brought some lesser-used grain and flour varieties into play and where possible substituted dairy milk for other options such as nut, oat and rice milks. The recipes bring a scandi touch to some familiar brunch ideas.

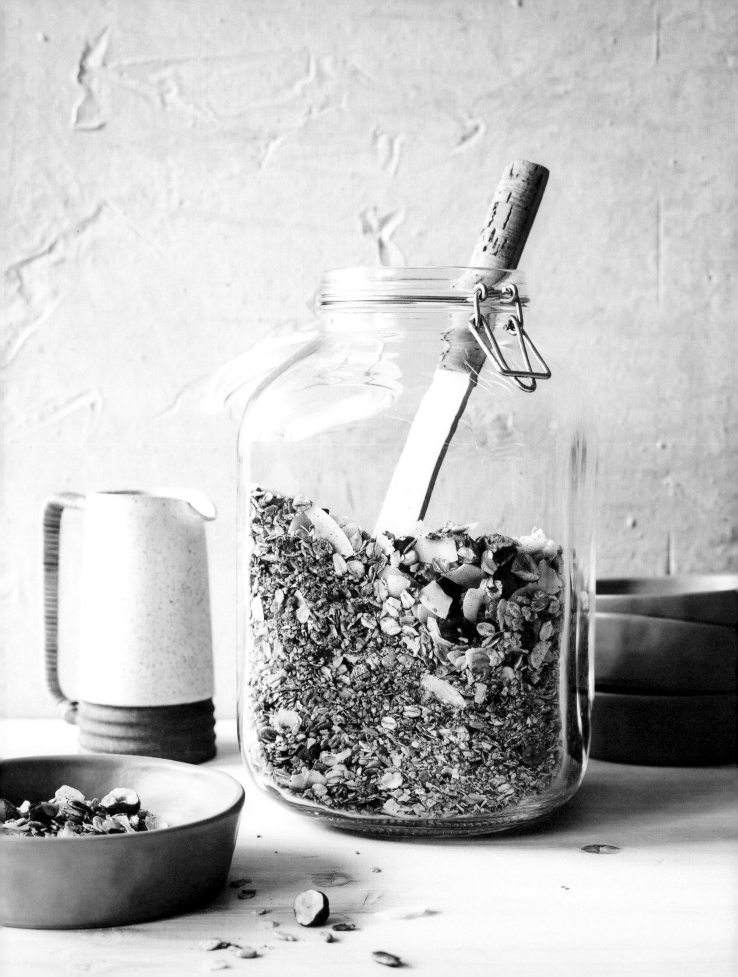

NORDIC GRANOLA

There is so much satisfaction to be had in making home-made granola. First of all the kitchen smells incredible for a couple of hours, secondly you save some coin because boutique granolas fetch ludicrous prices, and most importantly you get to be creative with what goes in the mix.

Quite often in our kitchen the pantry will dictate what's going in, but this is my ideal combination.

MAKES ABOUT 14 SERVINGS

PREPARATION TIME: 5 MINUTES
COOKING TIME: 45 MINUTES

Preheat the oven to 140°C (275°F/Gas 1). Line two baking trays with baking paper.

Place all the ingredients, except for the coconut flakes, oats and dried berries, in a very large bowl and mix everything together well.

Stir the oats through the granola mixture, then spread it out over the prepared baking trays in an even layer. Bake in the preheated oven for 45 minutes, adding the coconut flakes for the last 10 minutes of cooking, until golden. (To ensure even cooking you may have to rotate the trays during this time.)

Turn off the oven and leave the granola to cool in it with the door left slightly ajar. Once cool, remove the granola trays from the oven and sprinkle over the dried berries, then transfer to suitable airtight containers or jars. Serve the granola with yoghurt, milk or oat milk and fresh fruit, or with fruit nectar and yoghurt.

— 100 g (3½ oz/1 cup) spelt flakes

— 125 g (4½ oz/1 cup) buckwheat flakes

— 100 g (3½ oz/1 cup) rye flakes

— 90 g (3¼ oz/½ cup) pepitas (pumpkin seeds)

— 60 g (2¼ oz/½ cup) sunflower kernels

— 140 g (5 oz/1 cup) hazelnuts, chopped

— 100 ml (3½ fl oz) lingonberry cordial (syrup)

— 4 tablespoons rapeseed oil

— 2 teaspoons cardamom seeds, crushed (open the pods to remove the seeds inside)

— 1 teaspoon ground cinnamon

— 2 tablespoons sesame seeds

— pinch of salt

— 55 g (2 oz/1 cup) coconut flakes

— 240 g (9 oz/3 cups) rolled (porridge) oats

— 100 g (3½ oz) dried berries (I like blueberries and lingonberries, but you could use cranberries, raisins, etc.)

CARDAMOM RYE CRÊPES, BANANA & SALTED CARAMEL

While you can't go wrong with caramel and banana, the batter for this recipe is also great with savoury pairings like smoked salmon. It produces crêpes with a similar consistency to French *galettes* and keeps really well, so you can use the batter for up to a week after making.

SERVES 4

PREPARATION TIME: 10 MINUTES PLUS RESTING
COOKING TIME: 20 MINUTES

Add the eggs to a bowl together with 500 ml (18 fl oz/2 cups) of water and whisk together. Continuing to stir, gradually sift over the flours and salt and mix together to form a smooth batter. Cover with plastic wrap, transfer to the refrigerator and leave to rest for 30 minutes.

While the batter is resting, put the banana chips in a food processor and blitz for 10–20 seconds to a crumb-like texture. Set aside.

For the salted caramel, place all the ingredients, except the salt, in the food processor and blend together to form a smooth, lump-free sauce. Pour into a bowl and stir through the salt flakes.

To cook the crêpes, heat just enough butter to coat the base of a small frying pan or crêpe pan over a medium–high heat until the butter has melted and is bubbling. Pour in enough batter to create a thin coating on the base of the pan. Lift, tilt and rotate the pan so the batter forms an even, thin layer over the entire base. Cook for about a minute on each side, until bubbles start to appear on the surface and the edges are solid and easy to lift up with a spatula. Stack the cooked crêpes on a plate and cover with a clean tea towel to keep warm while you cook the rest, adding a little butter to the pan as needed in between crêpes (I find I use less and less as the pan seasons).

To serve, divide the crêpes between plates and top with the banana halves. Spoon over the salted caramel and a little extra honey and scatter over the dried banana crumbs to finish.

— 3 large eggs

— 100 g (3½ oz/1 cup) rye flour

— 150 g (5½ oz/1 cup) plain (all-purpose) flour

— ¼ teaspoon salt

— 90 g (3¼ oz/⅓ cup) dried banana chips

— 15–30 g (½–1 oz) unsalted butter

— 4 bananas, peeled and halved lengthways

SALTED CARAMEL

— 100 ml (3½ fl oz/⅓ cup) maple syrup

— 115 g (4 oz/⅓ cup) honey, plus extra to serve

— 125 ml (4 fl oz/½ cup) coconut oil, melted

— 70 g (2½ oz) almond butter

— 1 teaspoon sea salt flakes

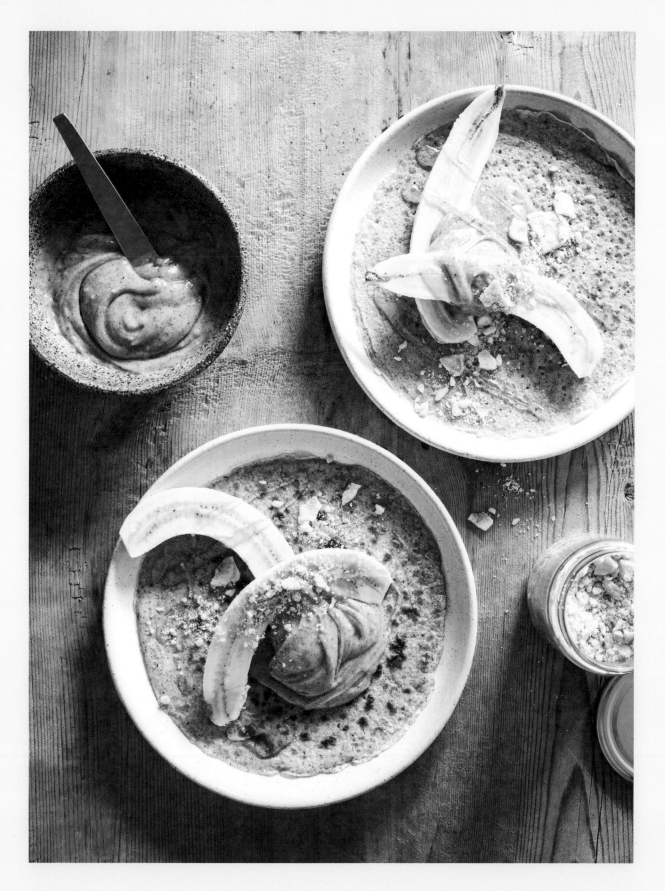

LINSEED WAFFLES, CLOUDBERRY JAM & MALTED MAPLE YOGHURT

These waffles have a delicious nutty flavour and use no flour, yet they are still light and fluffy from the egg. Preserved fruits are a fundamental part of Nordic cooking given the short summers. Lucky for us, as it means that wherever you are in the world you should be able to find some Nordic fruit jam. Lingonberry and cloudberry are the typical ones found outside Scandinavia as these berries do not commonly grow elsewhere, and are perfect for these waffles. Otherwise use any berry jams.

SERVES 4

PREPARATION TIME: 5 MINUTES
COOKING TIME: 10–15 MINUTES

For the malted maple yoghurt, put all the ingredients together in a food processor and whiz together until smooth. Taste and adjust the sweetness by adding a little more honey if needed. Set aside in the refrigerator.

To make the waffles, put the linseeds in a spice grinder or small food processor and blitz into roughly cracked pieces. Place in a large bowl together with the baking powder and sea salt and stir to combine.

In a separate bowl, whisk the eggwhites together until medium peaks form. Add the egg yolks, rapeseed oil and 125 ml (4 fl oz/½ cup) of water to the linseed mixture and stir to combine, then carefully fold through the whites to form a fluffy batter. Allow to sit for 3 minutes.

Preheat the waffle maker to medium, or your desired setting for crisp waffles. If desired, preheat the oven to 120°C (250°F/Gas ½) to keep the waffles warm while cooking in batches.

Depending on the size of your waffle maker, spoon in an appropriate amount of mixture and cook for about 1–2 minutes on each side, until golden brown at the edges (note: the actual time needed will depend on the type of waffle maker you have – a Belgian-style waffle maker will require much longer than this).

Serve the waffles topped with the malted maple yoghurt and jam.

— 300 g (10½ oz/2 cups) golden or brown linseeds (flax seed)

— 1 tablespoon baking powder

— 1 teaspoon sea salt

— 5 large eggs, separated

— 80 ml (2½ fl oz/⅓ cup) rapeseed oil

— 100 g (3½ oz/⅓ cup) cloudberry jam

MALTED MAPLE YOGHURT

— 200 g (7 oz) thick Greek-style yoghurt

— 2 tablespoons honey, plus extra if needed

— 2 teaspoons dark malt powder

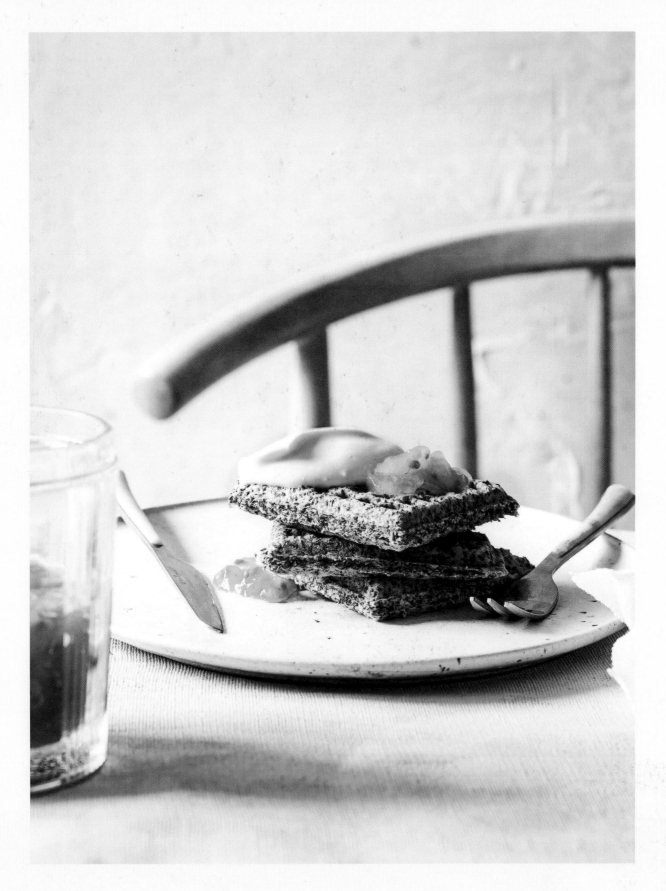

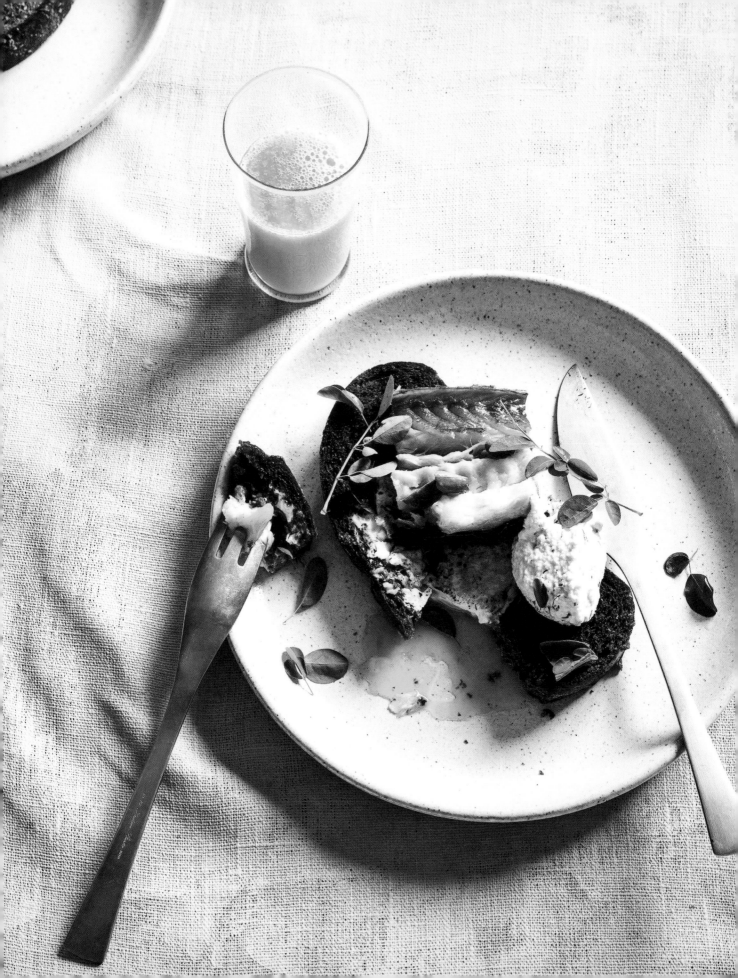

RYE EGG-IN-A-HOLE, SMOKED EEL & HORSERADISH CREAM

Smoked eel has a lovely natural sweetness that pairs perfectly with horseradish. While you may not consider eel for breakfast commonplace, in Nordic countries seafood is eaten 24/7. Take this leap and soon enough you'll be eating pickled herring for breakfast.

SERVES 4

PREPARATION TIME: 10 MINUTES PLUS SOAKING
COOKING TIME: 20 MINUTES

To make the horseradish cream, place the drained cashew nuts in a food processor together with the remaining ingredients and 125 ml (4 fl oz/½ cup) of water. Blend everything together until well combined, about 2 minutes. If it's too thick you can add a little more water. Season to taste and add more lemon juice or horseradish if desired. Set aside.

Use a sharp-rimmed glass to cut a circle out of the centre of each of the rye slices.

Heat the butter in a frying pan over a medium heat until foaming, then add a bread slice to the middle of the pan and crack an egg into the circular hole in its centre. Cook for 30–45 seconds until the egg has set on the bottom, then flip the bread slice over with a spatula. Continue to cook the egg-in-a-hole to your liking – if you prefer a runny yolk, cook it just a little more, if you'd rather it was set, cook for a while longer. Tip the egg-in-a-hole onto a plate and repeat with the remaining eggs and bread slices.

To serve, flake chunks of the eel fillet over the top of each egg-in-a-hole. Top with salad leaves or herb leaves and dollops of the horseradish cream.

- 4 soft dark rye loaf slices (an authentic Danish rye will be too dense and waxy for this)

- 15 g (½ oz) salted butter

- 4 eggs

- 1 x 200 g (7 oz) smoked eel fillet, cut into 3 cm x 6 cm (1¼ in x 2½ in) pieces

- watercress, rocket or soft herb leaves to serve

HORSERADISH CREAM

- 190 g (7 oz/1¼ cups) cashew nuts, soaked in water for 4 hours and drained

- juice of 1 lemon, plus extra if needed

- 1 tablespoon apple-cider vinegar

- 1 tablespoon nutritional yeast flakes

- 1½ teaspoons freshly grated horseradish (or from a jar), plus extra if needed

- small pinch of white pepper

- ¼ teaspoon sea salt

MILLET PORRIDGE, CARDAMOM, CACAO & COCONUT

A great way to introduce more grains into your diet is through porridges. Porridges are to Scandinavians what fry-ups are to Englishmen. There are an endless amount of toppings and flavour combinations that can be used to vary your porridge. This Bounty-inspired combination works well with any grain, though I particularly like it with millet.

SERVES 4

PREPARATION TIME: 5 MINUTES
COOKING TIME: 5 MINUTES

Put the millet flakes, cardamom, coconut oil, vanilla extract, sugar and cacao powder in a saucepan together with 1 litre (36 fl oz/4 cups) of water. Bring to a simmer and cook for 5 minutes, stirring occasionally, or until all the liquid is absorbed.

Divide the porridge between bowls, pour over the milk and top with the coconut flakes, hazelnuts and cacao nibs.

— 250 g (9 oz/2 cups) millet flakes, rinsed

— ¼ teaspoon ground cardamom

— 2 tablespoons coconut oil

— 1 teaspoon natural vanilla extract

— 2–4 tablespoons brown sugar or honey

— 2 teaspoons cacao powder

— 500 ml (18 fl oz/2 cups) coconut milk or oat milk

— 60 g (2¼ oz/1 cup) toasted coconut flakes

— 80 g (3 oz/⅔ cup) chopped toasted hazelnuts

— 2 tablespoons cacao nibs

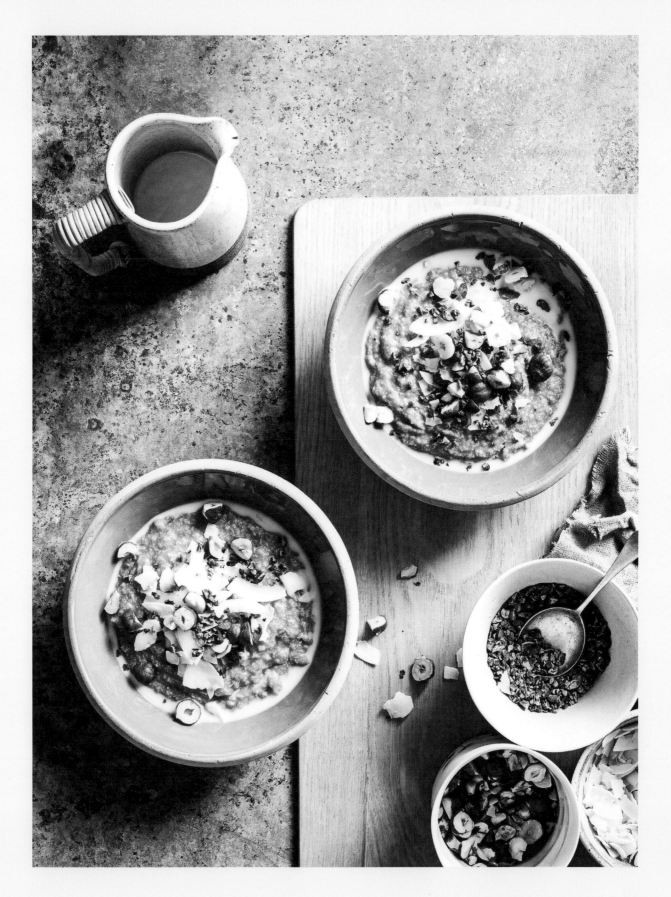

KALE & BUCKWHEAT WAFFLES WITH EGGS

Buckwheat is a great wheat replacement for those with gluten intolerances. It possesses a unique flavour and can be enjoyed cooked in its many forms – whether as flour, flakes or groats. I like to serve these with *bockling* – a form of hot-smoked herring very similar to smoked mackerel – though if fish is not your thing for breakfast they can also be served with bacon.

SERVES 4

PREPARATION TIME: 15 MINUTES
COOKING TIME: 10 MINUTES

Preheat the waffle maker. If desired, preheat the oven to 120°C (250°F/Gas ½) to keep the waffles warm until you're ready to serve.

Whisk together the buckwheat flour, baking powder, bicarbonate of soda and salt in a bowl. In a separate bowl, whisk together the buttermilk, coconut oil or melted butter and egg. Pour the wet mixture into the dry mixture and mix together well to form a wet dough similar to a thick pancake batter. Cover with plastic wrap and leave the batter to rest for at least 5 minutes, or up to 20 minutes (the longer you leave it the better).

Wash the kale and pat dry, then tear the leaves from the stems. Add the kale leaves to the heated waffle maker in batches for 30 seconds or so to par-cook slightly, then remove from the waffle maker and set aside.

Depending on the size of your waffle maker, spoon in an appropriate amount of mixture and top with a few kale leaves. Secure the lid and cook for about 5–6 minutes, or until the waffle is no longer letting off steam and is golden brown and crispy. Transfer the cooked waffle to the oven to keep warm while you continue to cook the remaining waffle mixture (be careful not to stack the waffles as you go as they will lose their crispness).

While the waffles are cooking, poach or boil the eggs to your liking. Fry or grill the bacon, if using, or pull the flesh from the smoked *bockling* or mackerel.

To serve, divide the waffles between plates and top with the eggs, your side of choice and a few thyme leaves.

— 4 eggs

WAFFLES

— 175 g (6 oz/1¼ cups) buckwheat flour

— 1½ teaspoons baking powder

— 1 teaspoon bicarbonate of soda (baking soda)

— ¼ teaspoon salt

— 300 ml (10 fl oz) buttermilk, whisked

— 4 tablespoons coconut oil or melted butter

— 1 large egg

— 30 g (1 oz) kale leaves

TO SERVE

— smoked *bockling*, smoked mackerel or bacon rashers (slices)

— thyme sprigs, leaves picked

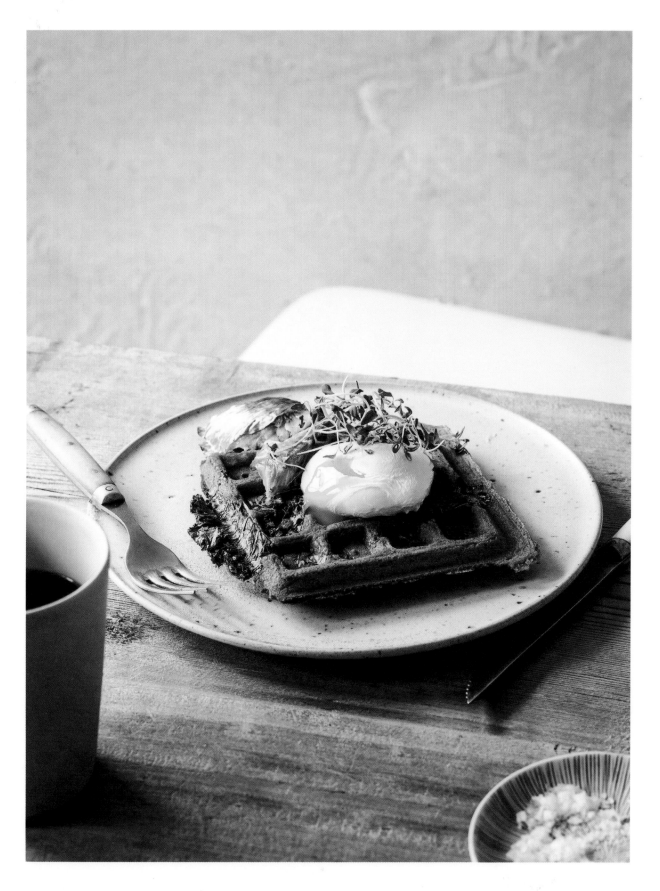

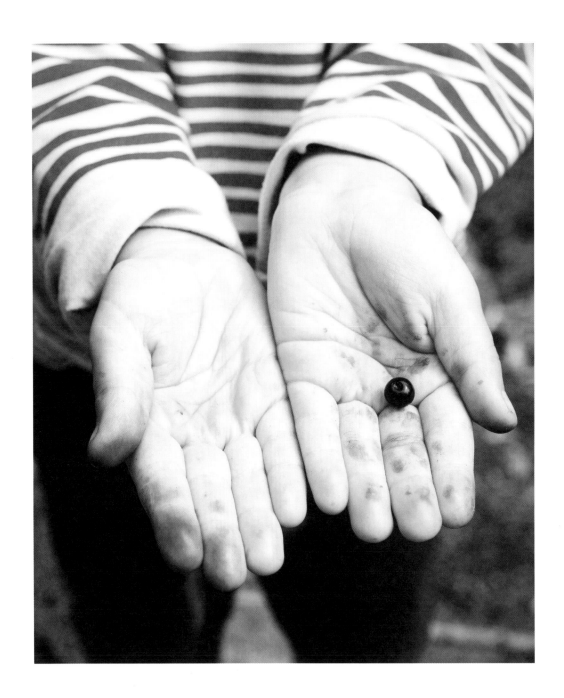

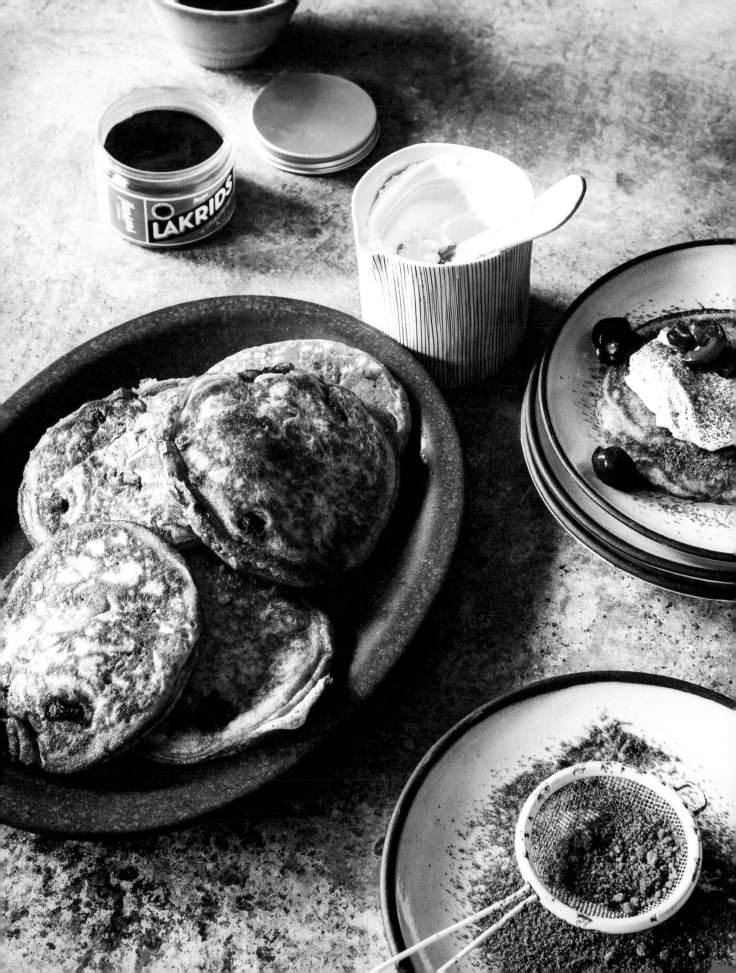

CHERRY SPELT CAKES, MASCARPONE & LIQUORICE SUGAR

Nordic countries have an affinity for liquorice, both the common sweet type and the sweet and salty. Liquorice powder, derived from liquorice root, can be tricky to find but it's an interesting product for adding that distinctive aniseed flavour to sweet or savoury dishes.

SERVES 4

PREPARATION TIME: 5 MINUTES
COOKING TIME: 10 MINUTES

Preheat the oven to 120°C (250° F/Gas ½) to keep the pancakes warm until you're ready to serve.

To make the batter, mix together the beaten egg and milk in a bowl. Gradually add the spelt flour, whisking as you go, then whisk in the baking powder and salt to form a dense, thick batter. Stir through the cherries and set aside.

For the liquorice sugar, mix together the ingredients in a small bowl.

Heat a little oil or butter in a small frying pan or crêpe pan over a medium–high heat. Add 4 tablespoons or so of batter to the pan to form a cake about 2 cm (¾ in) thick and cook for 1–2 minutes, until bubbles start to appear on the surface and the edges are crispy and easy to lift up with a spatula. Flip over and continue cooking for a further 1–2 minutes. Stack the cooked pancakes on a plate and transfer to the oven to keep warm while you cook the rest.

To serve, sprinkle the sugar over the pancakes, dollop over the mascarpone and top with some fresh cherry halves.

— 1 large egg, lightly beaten

— 375 ml (13 fl oz/1½ cups) milk (or oat, rice or nut milk)

— 230 g (8 oz/1¾ cups) spelt flour

— 1 tablespoon baking powder

— ¼ teaspoon salt

— 75 g (2¾ oz) halved and pitted fresh or thawed cherries, plus a handful of extra fresh cherries to serve

— 2 tablespoons rapeseed oil or butter

— 200 g (7 oz) mascarpone

LIQUORICE SUGAR

— 1 teaspoon liquorice powder (adjust this amount to your liking depending on how much you like liquorice!)

— 1 tablespoon light or dark brown sugar

SPELT, GINGER, CARROT & BIRCH PORRIDGE

A bit like a morning 'boost' drink but in porridge form, this is such a great marriage of flavours for a frosty morning. I love it. Birch syrup has a more distinctive, savoury flavour than maple syrup, yet contains around the same sugar content. If you can't find any you can always replace it with maple syrup instead.

SERVES 4

PREPARATION TIME: 5 MINUTES
COOKING TIME: 20 MINUTES

Add the spelt flakes, carrot juice, ginger, cinnamon and 500 ml (18 fl oz/2 cups) of water to a large saucepan. Bring to a simmer and cook for 2–3 minutes, stirring occasionally, until the flakes have absorbed the liquid. Check on the porridge from time to time throughout the cooking – if you feel it's getting a little dry, simply add a little extra water.

To serve, divide the hot porridge between bowls, pour over the milk and birch syrup and scatter over the bee pollen and sunflower kernels. Garnish with a few dehydrated berries and some redwood sorrel or beetroot leaves.

— 200 g (7 oz/2 cups) spelt flakes

— 500 ml (18 fl oz/2 cups) carrot juice

— 2 teaspoons grated fresh ginger

— 1 teaspoon ground cinnamon

— 250 ml (9 fl oz/1 cup) milk (or milk substitute of choice)

— 2 tablespoons birch syrup or maple syrup

— 3 tablespoons bee pollen

— 2 tablespoons toasted sunflower kernels

TO GARNISH

— dehydrated berries or dried cranberries

— redwood sorrel or beetroot (beet) leaves

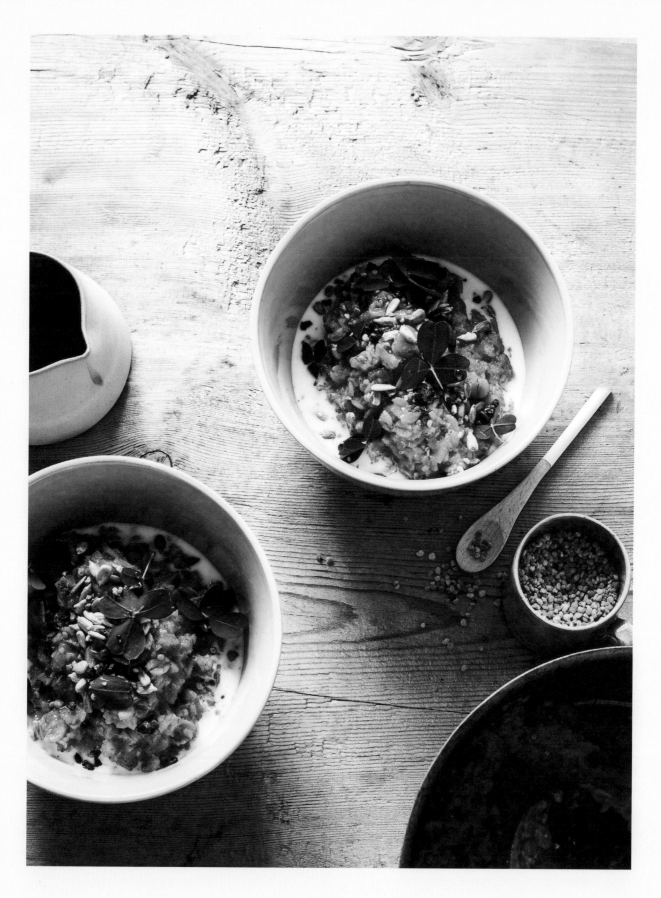

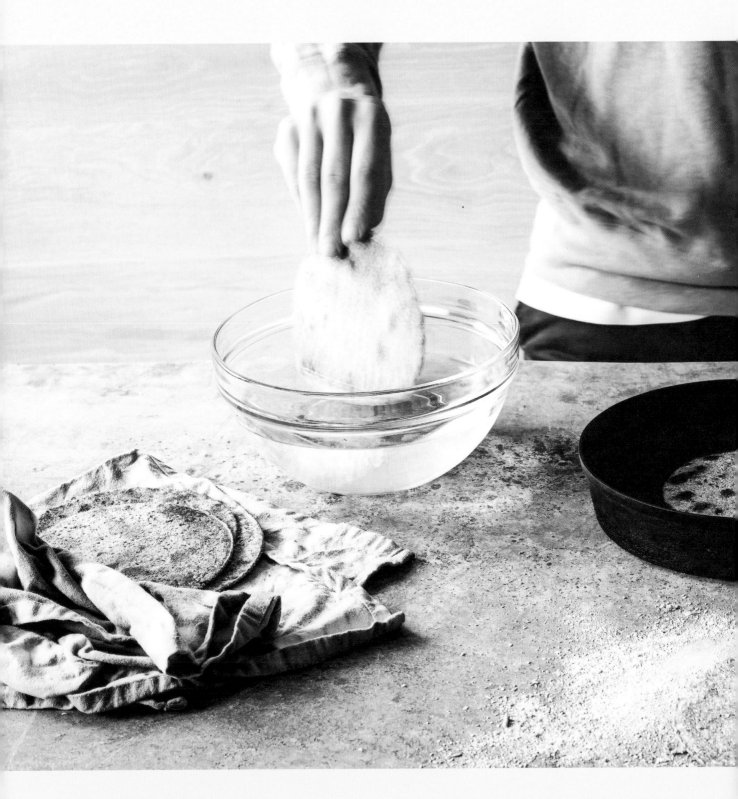

CHAPTER TWO

MID-
MORNING
SNACKS

In Nordic countries a large lunch is served relatively early – at midday or earlier for nine-to-fivers. Personally, however, I need something to get through my mid-morning cravings, and while I'd love to eat a cinnamon bun everyday as a mid-morning snack, it would likely wreak havoc with a healthier agenda. Instead I have come up with some other treats that will sustain without providing the carb and sugar overload.

The recipes here make enough to save some for other days and can also be used for *fika* (see pages 86–105) with guests. Also things like the beetroot crispbread and Icelandic flatbread are great additions to other meals. Don't be put off by cooking times – there is return on the investment as many of the components of these dishes can be used later.

SMOKY QUINOA & CACAO BARS

Smoke finds its way into many Nordic foods. In the past it was out of necessity to preserve foods but today its primary function is flavour. Nordic folk have developed a unique palate for all things smoked and pickled. There is also a unique crossover of sweet and savoury that commonly takes place, particularly on new Nordic restaurant menus. The recipe ahead is a little ode to this.

MAKES ABOUT 16 BARS

PREPARATION TIME: 5 MINUTES
COOKING TIME: 10 MINUTES

Put the prunes in a bowl and mash well with a fork, then add them together with the coconut oil to a large saucepan over a low–medium heat. Stir in the nut butter, oil, honey and cayenne pepper, mashing the prunes further with the back of a wooden spoon to bring everything together. Cook over a low heat, stirring, for 2–3 minutes, until the mixture is soft and gooey, then remove from the heat, stir in the pepitas, cacao nibs, puffed quinoa and chopped brazil nuts and set aside.

Put the chocolate in a heatproof bowl, set it over a saucepan of simmering water and stir gently until the chocolate has melted.

Line a 30 cm x 12 cm (12 in x 4½ in) loaf tin with baking paper. Transfer the mixture to the tin and drizzle over the melted dark chocolate. Sprinkle over the smoked salt, transfer to the refrigerator and leave to chill for at least 1 hour, or until set.

Once set, remove the log from the tin, transfer to a chopping board and cut into bars. They will keep for up to 1 week in a suitable airtight container.

— 220 g (8 oz/1 cup) pitted soft prunes, diced

— 2 tablespoons coconut oil

— 150 g (5½ oz) almond, hazelnut or peanut butter

— 50 ml (2 fl oz) rapeseed oil

— 1 tablespoon honey

— pinch of cayenne pepper

— 180 g (6 oz/1 cup) pepitas (pumpkin seeds), lightly toasted

— 20 g (¾ oz) cacao nibs

— 25 g (1 oz/1 cup) puffed quinoa

— 90 g (3¼ oz/½ cup) toasted brazil nuts, coarsely chopped

— 100 g (3½ oz) dark chocolate (70% cocoa solids), broken into rough pieces

— 1 tablespoon smoked salt flakes

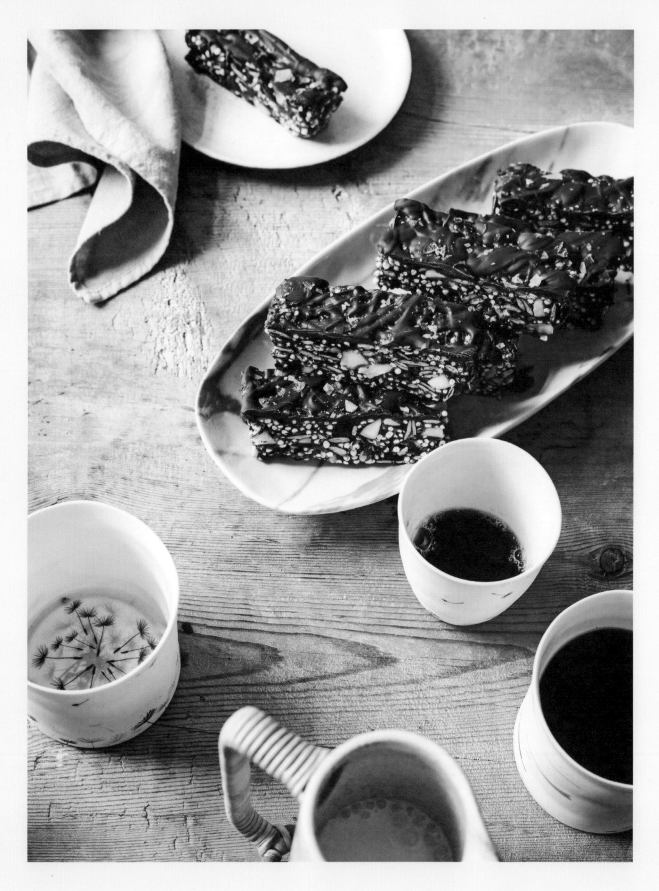

ALMOND, HEMP & NETTLE BALLS

Nettles are very common in Scandinavian countries. The fresh leaves are often used to make a traditional soup served with boiled eggs, while the best pizza I have ever had in Stockholm was a pizza bianca topped with fresh nettles. Rich in vitamins A and C, the dried leaves can be used in many preparations – the recipe below makes a nutrition-filled energy ball perfect for snacking.

MAKES ABOUT 15 BALLS

PREPARATION TIME: 10 MINUTES

Put the dried berries in a food processor or spice grinder and blend briefly to form a fine powder. Set aside.

Add all the ingredients, except for the hemp seeds and the berry powder, to the food processor and pulse together, gradually adding 5–6 tablespoons of water, until the mixture comes together and resembles a sticky dough.

Mix together the berry dust and hemp seeds in a bowl, then scatter the mixture evenly over a plate. Fill a small bowl with water.

Roll the dough into walnut-sized balls, then dip the balls into the water before rolling in the hemp seed and berry dust mixture. They should keep for up to 1 week in a sealed container.

— 15 g (½ oz/½ cup) dehydrated raspberries or strawberries

— 140 g (5 oz/1¾ cups) rolled (porridge) oats

— 200 g (7 oz) soft dried figs

— 75 g (2¾ oz/⅔ cup) ground almonds

— 2 teaspoons honey

— ½ teaspoon dried nettle powder

— ½ teaspoon ground cinnamon

— 115 g (4 oz/¾ cup) hemp seeds

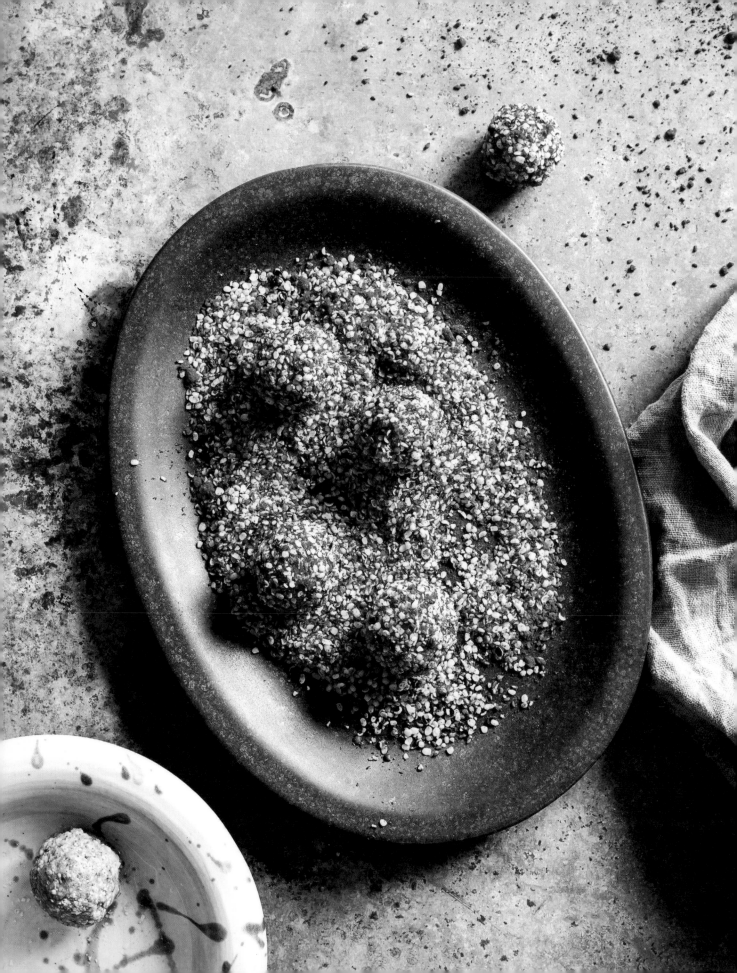

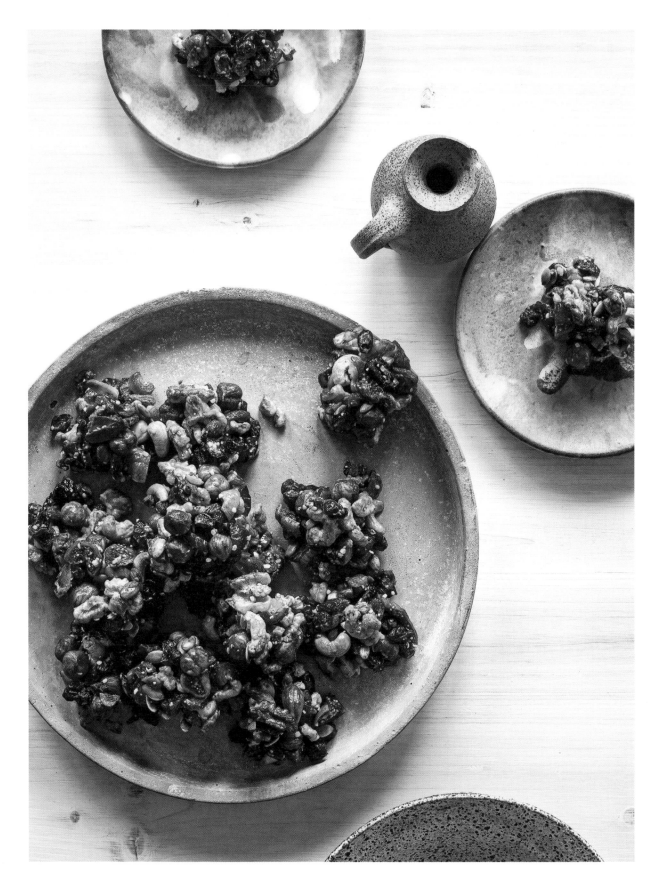

NUT BOMBS

These can be packed for snacks on the go. They will keep for up to 5 days in a sealed container in the pantry or dry store.

MAKES ABOUT 10 BOMBS

PREPARATION TIME: 5 MINUTES
COOKING TIME: 10 MINUTES

Preheat the oven to 180°C (350°F/Gas 4). Line two baking trays with baking paper.

Lightly whisk the eggwhites together in a large bowl with a hand whisk until frothy, then fold through the nuts, fruits, hemp seeds and ground cinnamon or cardamom. The eggwhite will help to hold the nut mixture together when cooking, so make sure it's evenly distributed.

Carefully transfer mounded spoonfuls of the mixture onto the prepared baking trays, then bake for 10 minutes, or until golden amber in colour. Leave to cool, then pack away in paper bags ready for snacking on later.

— 3 large eggwhites

— 300 g (10½ oz) raw unsalted mixed nuts (I recommend peanuts, cashew nuts, brazil nuts, almonds and hazelnuts)

— 300 g (10½ oz) dried mixed fruits (I recommend prunes, apple, figs, raisins, sultanas and cranberries), chopped

— 4 teaspoons hemp seeds

— ½ teaspoon ground cinnamon or cardamom

HOME-MADE 'NUTELLA', SOURDOUGH & FIGS

I'll never forget standing at the most impressive breakfast buffet I have ever seen in Rome and seeing the Italian businessmen pass on the salmon and jamon Iberico and opt for the Nutella on white bread instead. Given Italy's relationship with food it was quite a statement. Like most internationally known processed foods, however, this spread is actually full of naughties, but it's so easy to make your own I suggest you give it a try.

MAKES 1 LARGE JAR

PREPARATION TIME: 5 MINUTES

Put the hazelnut butter in a food processor and blend for 1 minute to incorporate the oil. Add the remaining ingredients and blend for another 1 minute until smooth.

Transfer the 'nutella' to a jar and store in the refrigerator until needed, bringing it to room temperature 5–10 minutes before using. When ready to serve, spread the 'nutella' over a slice of toasted sourdough, top with slices of fresh fig and sprinkle over some chia or hemp seeds and herbs.

— 180 g (6 oz) hazelnut butter

— 90 ml (3 fl oz) coconut oil

— 1 tablespoon cacao powder

— 4 tablespoons runny honey

TO SERVE

— sourdough toast

— figs

— chia or hemp seeds

— mint or lemon balm leaves

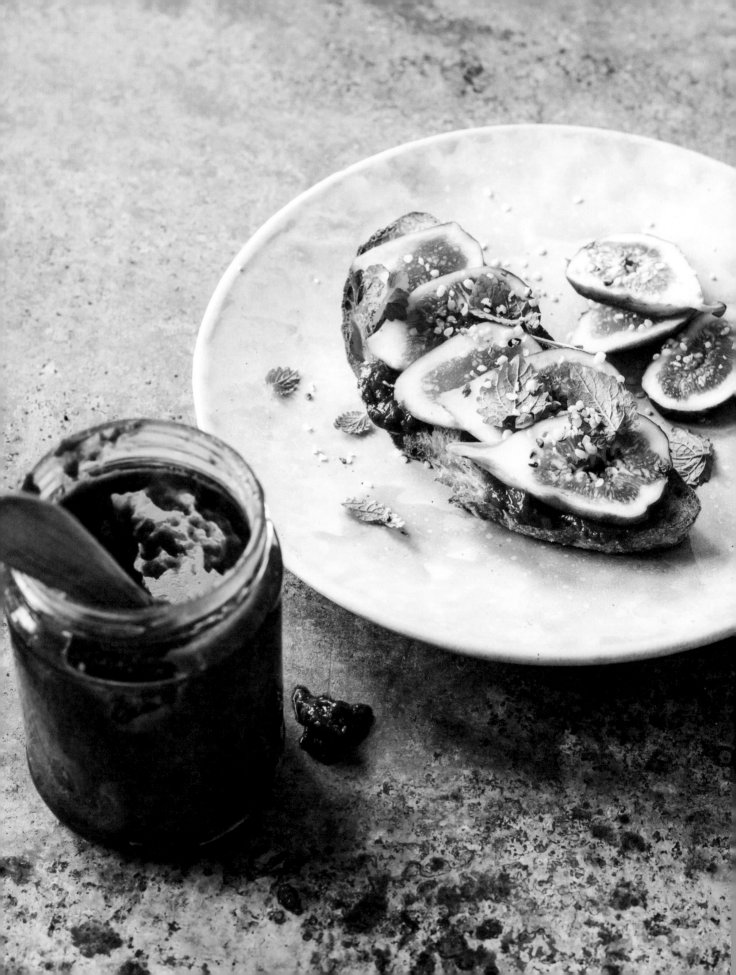

ICEBERG SMØRREBRØD WITH GRAVLAX, HERB SALAD & YMERDRYS

I love the idea of flipping convention upside-down, particularly when taking another look at how we use carb- and protein-heavy foods to help bring balance to our diets. This recipe tips the idea of the typical Nordic open sandwich – or *smørrebrød* – on its head, putting rye on salmon and lettuce rather than the other way around.

SERVES 4

PREPARATION TIME: 5 MINUTES
COOKING TIME: 10–15 MINUTES

Preheat the oven to 180°C (350°F/Gas 4). Line a baking tray with baking paper.

To make the *ymerdrys*, pulse the bread in a food processor, gradually adding the sugar, until the consistency resembles loose soil.

Spread the mixture out over the prepared baking tray and bake in the oven for 10–15 minutes, until it takes on a rich brown colour. Watch closely in the last 5 minutes to make sure it doesn't burn. Remove from the oven and allow to cool on the tray.

For the dressing, mix the mustard, yoghurt and honey, if using, together in a bowl.

In a separate bowl, mix together the herbs, chopped chives and lime juice.

Place the lettuce upright on a chopping board and cut vertically into 2.5 cm (1 in) rounds. Setting aside the outer pieces, transfer four of the central lettuce rounds to a serving plate.

To build your 'smørrebrød', spread the dressing over the lettuce rounds, top with the gravlax or smoked salmon and spoon over the lime juice and herb mixture. Sprinkle over the *ymerdrys* and pea tendrils to serve.

— 1 handful each of dill, chervil and parsley, roughly chopped or torn

— 2 tablespoons chopped chives

— juice of ½ lime

— 1 firm, compact iceberg lettuce, trimmed and outer leaves removed

— 200 g (7 oz) thinly sliced gravlax or smoked salmon

— pea tendrils to serve

YMERDRYS

— 200 g (7 oz) authentic waxy Danish rye bread, broken into large chunks

— 2 tablespoons brown sugar

MUSTARD DRESSING

— 1 teaspoon mild American-style mustard

— 3 tablespoons plain yoghurt

— ½ teaspoon honey (only if you are using smoked salmon, gravlax is sweet enough)

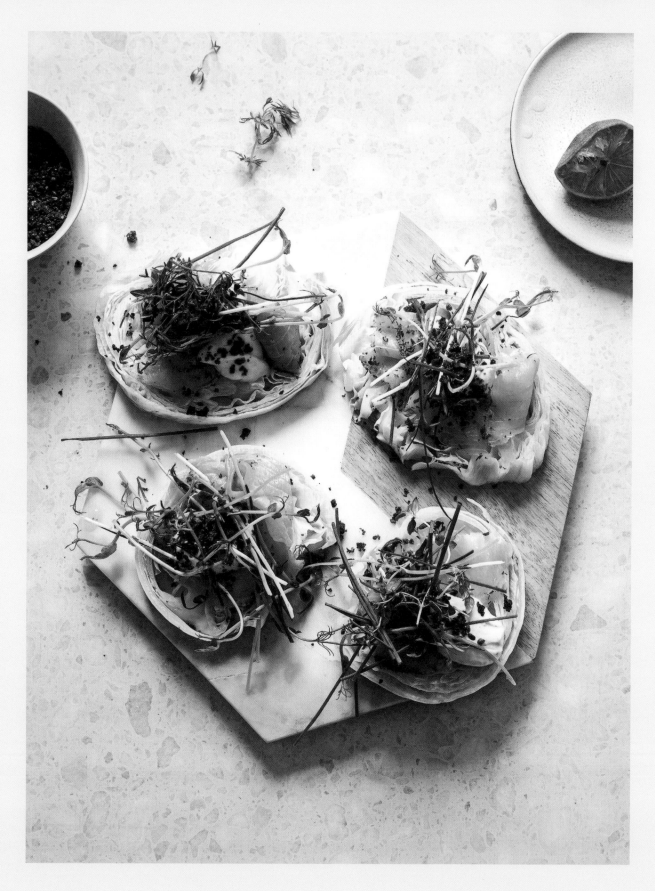

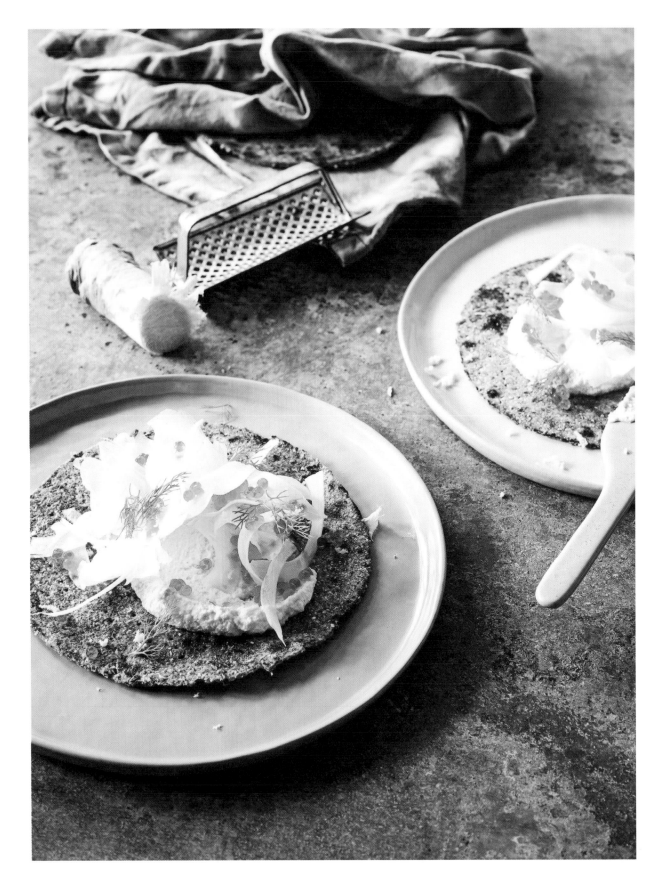

ICELANDIC FLATBREAD, HORSERADISH CREAM & ROE

This unique bread dates back to Icelandic settlement in 874 AD. Back then, before Icelandic households had stovetops, this bread was cooked on the embers of sheep dung! Why? Iceland has always lacked trees, so wood fires were rare – it's this absence of trees that contributes to the beautifully stark, dynamic landscape found there.

These flatbreads (or *flatkökur*) will keep in a sealed plastic container in the pantry or refrigerator for a couple of days and toast really well the day after making.

SERVES 4

PREPARATION TIME: 30 MINUTES
COOKING TIME: 20 MINUTES

Add the rye flour, wholemeal flour, baking powder and salt to a large bowl and mix together well. Gradually stir in the boiling water and bring together to form a dough.

Tip the dough onto a floured work surface and knead for 4 minutes, until smooth and elastic. Divide the dough into eight even-sized pieces and roll each one into a ball. Roll out the balls to a 2 mm (1/16 in) thickness. Use a plate approximately 15 cm (6 in) in diameter to cut the rolled dough into round discs. Prick both sides of each disc all over with a fork.

Heat a large cast-iron frying pan or flat hotplate over a high heat and cook the breads one at a time for about 2–3 minutes on each side, or until covered with black charred spots.

Using your fingers or a pair of tongs, dip the cooked breads quickly into a bowl of lukewarm water. Hold each bread under for a few seconds, then stack the cooked breads underneath a clean, damp tea towel to allow them to steam and prevent them from drying out.

Serve the flatbreads topped with dollops of horseradish cream, drained fennel slices and salmon roe.

— 200 g (7 oz/2 cups) coarse rye flour

— 100 g (3½ oz/⅔ cup) wholemeal (whole-wheat) flour

— ½ teaspoon baking powder

— ½ teaspoon salt

— 250–300 ml (9–10 fl oz/ 1–1¼ cups) boiling water

TO SERVE

— Horseradish Cream (page 25)

— ¼ fennel bulb, thinly sliced into cold water

— 2 tablespoons salmon roe

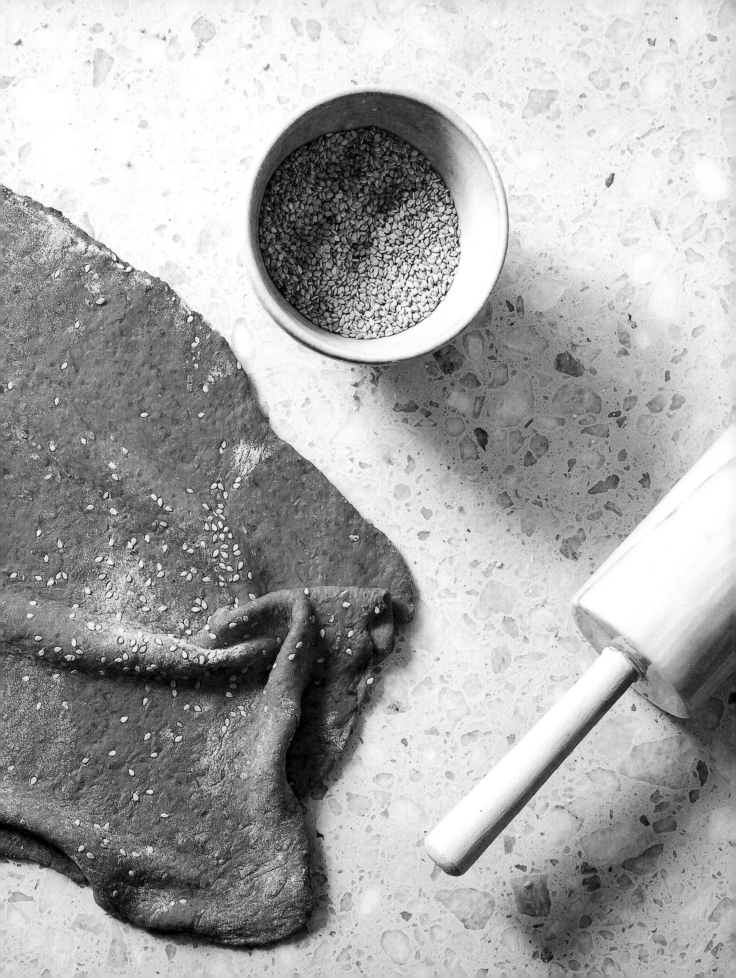

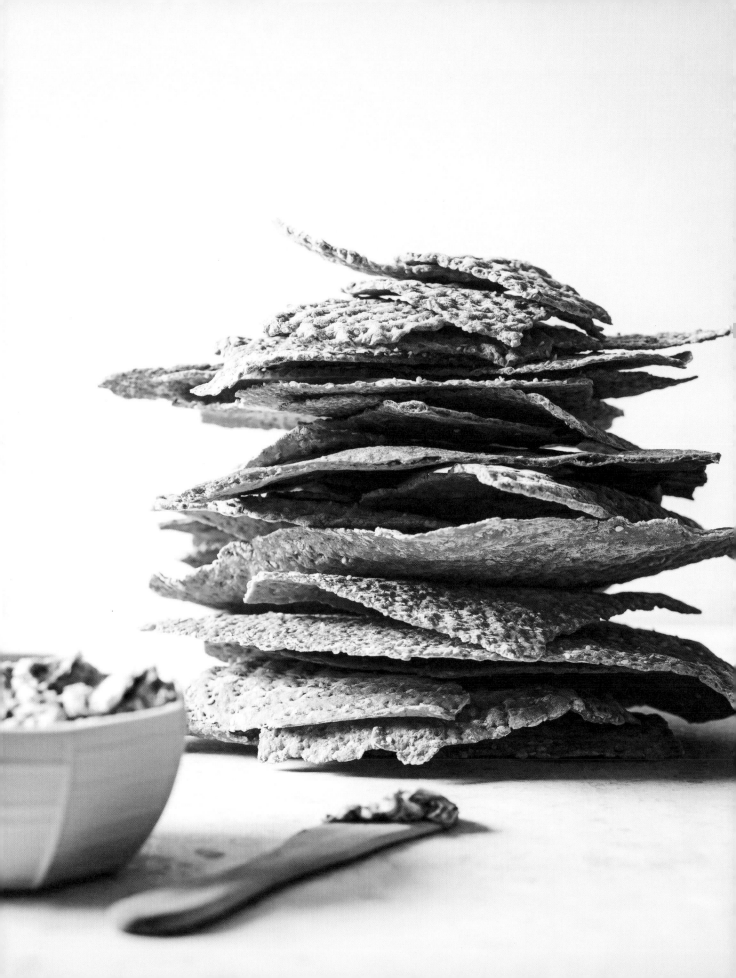

BEETROOT CRISPBREAD & SEAWEED BUTTER

If Italy has the tomato and Russia the potato, then the Nordics have recently claimed beetroot. They pop up everywhere: roasted, pickled, in liquid form, the list goes on. I love both the colour they bring to food and their sweetness. I also love crispbread – it's easy to make, it keeps very well and is the perfect snack food. The following recipe is a take on the classic with the added beetroot.

This seaweed butter is for lovers of umami. The butter takes on the seaweed's flavour and is quite unique. It can also be used to cook seafood, or melted over cooked vegetables. If umami's not your thing, try mixing some dill and lemon zest through the butter instead.

SERVES 8

**PREPARATION TIME: 15 MINUTES PLUS RESTING
COOKING TIME: 30 MINUTES**

For the seaweed butter, toast the seaweed sheets over a naked flame for 20 seconds on each side. Alternatively, preheat the oven to 220°C (425°F/Gas 7), spread the seaweed sheets over wire racks and bake for 10 minutes, until crispy and beginning to colour. Leave the sheets to cool and crisp up before crumbling them into a bowl. Add the salt, butter and lemon juice and mix together, then transfer to the fridge to set.

To make the crispbread, add the yeast, fennel seeds and milk to a large bowl and mix together. Stir in the grated beetroot, then gradually sift over the flours, stirring everything together to form a firm, slightly sticky dough (you may need to add a little extra flour depending on the moisture content of the beetroot). Add a pinch of salt and mix together, then use your hands to shape the dough into a ball. Cover with a clean tea towel and leave to rest for 20 minutes.

Preheat the oven to 160°C (325°F/Gas 3).

Once the dough has rested, divide it into two even-sized pieces. Roll one of the pieces out on a clean, floured work surface into a 45 cm x 35 cm (18 in x 14 in) rectangle, then cut it in half. Lay one of the halves between sheets of baking paper and roll it out to the same size. Repeat with the remaining dough pieces.

Prick the dough sheets with a fork or roll with a *kruskavel* (see page 10) and sprinkle over the sesame seeds and sea salt flakes. Slide the rolled-out dough sheets onto baking trays and bake in the oven for about 25 minutes, or until the edges curl up and the middle of the crispbread sheets rise off the tray – there is a small window between them being dry and cooked and turning brown, so keep an eye on them.

Turn off the oven and leave the crispbreads inside with the door slightly ajar for at least 2 hours. To serve, break the crispbreads into shards and spread with the butter. The crispbread will keep wrapped in baking paper in a cool, dry place for up to 2 months.

- 1½ teaspoons (5 g) dried instant yeast
- ½ teaspoon crushed fennel seeds
- 125 ml (4 fl oz/½ cup) milk
- 100–125 g (3½–4½ oz) fresh beetroot (beets), peeled and finely grated
- 125 g (4½ oz/1¼ cups) rye flour
- 300 g (10½ oz/2 cups) plain (all-purpose) flour
- 4 tablespoons sesame seeds
- 4 teaspoons sea salt flakes

SEAWEED BUTTER
- 4 nori seaweed sheets
- 1 tablespoon sea salt flakes
- 250 g (9 oz) unsalted butter, at room temperature
- juice of ½ lemon

OAT, PEAR & CARDAMOM SMOOTHIE

I have a love–hate relationship with smoothies. The idea of people replacing meals that are full of different textures and flavours with drinks makes me squirm – yet a cold sweet-and-sour fruit smoothie in the morning can be hard to beat.

Frozen fruit gives smoothies a nice coldness without requiring ice and helps make use of over-ripe fruit that's on the way out. Bananas are often used and are great for this, but why not experiment with other fruits to see what you can come up with? Smoothies are also the perfect vehicle for natural nutrient powders, so feel free to add a teaspoon here or there if you are so inclined.

SERVES 2

PREPARATION TIME: 5 MINUTES

Chuck all the ingredients, except the bee pollen, into a blender and blend away. Pour into glasses and sprinkle over the bee pollen to serve.

— 500 ml (18 fl oz/2 cups) oat milk

— 2 pears, cored, peeled and frozen

— 6 cardamom pods, seeds extracted and crushed

— 100 g (3½ oz) plain yoghurt

— 2 teaspoons honey

— 2 teaspoons bee pollen

CHAPTER THREE

LUNCH
PLATES

The recipes ahead are designed to be reach-in-the-refrigerator type dishes, where a little advanced cooking will yield the items you need to help put together a quick, yet interesting and delicious lunch. They are light meals made up of components that I like to mix and match, and can be eaten as they are or beefed up a little with sides. I have concentrated on using texture and healthy ingredients to steer away from the normal carbohydrate- and fat-heavy combinations.

All the recipes featured here will feed at least two, but are likely to give you leftovers for another meal on another occasion. For example, the venison cauliflower and celeriac recipes require initial cooking but, once cooked, leftovers can be kept in the refrigerator to aid preparation, if not for the following day, then certainly for later in the week. Alternatively, these prepared ingredients can be used in salads at dinner.

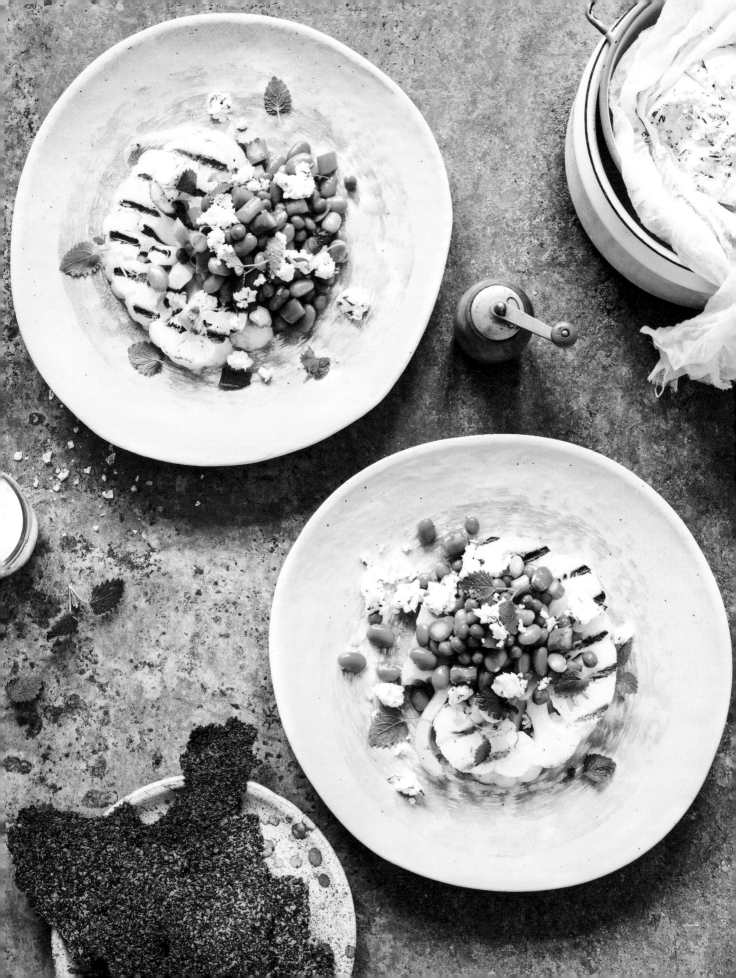

CAULIFLOWER STEAKS, ROUND GREENS & LEMON BALM

Chargrilling cauliflower is a perfect example of how Nordic chefs are thinking differently about using vegetables. It's common to see this technique along with whole-roasting used on celeriac and cabbage among other veg – it features on many Nordic menus – and the charred flavour that it imparts on the cauliflower is delicious. Leftovers of this salad are good cold, although the cauliflower can easily be poached in the reserved stock to reheat it if you prefer. Lemon balm has a pleasant citrus flavour similar to verbena, which I love, and acts as a good substitute if the latter proves difficult to find.

SERVES 2 WITH LEFTOVERS

PREPARATION TIME: 15 MINUTES
COOKING TIME: 15 MINUTES

For the cauliflower steaks, fill a large saucepan with water, add the juniper berries and salt and bring to the boil. Lower the whole cauliflower into the water and boil for 7 minutes, or until a knife easily passes through the florets to the core. Remove from the water and leave to cool (this can take some time).

When cool enough to handle, cut the cauliflower vertically into 2 cm (¾ in) thick steaks. Some of the cauliflower steaks will not hold their shape and will crumble – these can be used in salads.

Preheat a chargrill pan or plate over a high heat, brush the steaks with the olive oil and grill for about 3 minutes on each side until nicely charred. Cover with foil to keep warm and set aside.

Meanwhile, bring the stock to a simmer in a saucepan. Add the peas, asparagus, broad beans and soy beans, cover with a lid and simmer for 4 minutes until the vegetables are warmed through.

Remove the greens from the pan using a slotted spoon, reserving the stock, and transfer to a bowl. Stir through the olive oil and spring onions and season with salt and pepper to taste.

To serve, arrange the cauliflower steaks on a serving plate and top with the greens and cheese. Spoon over a few tablespoons of the warm vegetable stock, then scatter over the lemon balm or mint leaves. Serve with red cabbage chutney or rosehip ketchup, and accompany with crispbreads.

- 300 ml (10 fl oz) Vegetable Stock (page 190)

- 125 g (4½ oz) fresh or frozen peas

- 125 g (4½ oz) asparagus, cut into 1 cm (½ in) pieces

- 85 g (3 oz) broad (fava) beans, podded

- 85 g (3 oz) soy beans

- 1 teaspoon olive oil

- 2 spring onions (scallions), green parts only, cut into 1 cm (½ in) pieces

- 100 g (3½ oz) ricotta or Fresh Cheese (page 203)

- 1 large handful lemon balm or mint leaves

CAULIFLOWER STEAKS

- 2 dried juniper berries

- 2 teaspoons salt

- 800 g – 1 kg (1 lb 12 oz – 2 lb 4 oz) whole cauliflower, leaves removed

- 1 teaspoon olive oil

TO SERVE

- Red Cabbage Chutney (page 191), optional

- Rosehip Ketchup (page 196), optional

- Linseed and Poppy Crisps (page 90)

GRILLED COS, PEAR, COTTAGE CHEESE & SUNFLOWER PESTO

The grilled cos lettuce gives this dish a unique, pleasant flavour and texture, although you don't have to grill it if you don't want to. I like to make a batch of this pesto up and keep it for other dishes – unfortunately the sunflower kernels turn the pesto bitter if they are not soaked, so you'll need to start preparing this a day before eating.

SERVES 2 WITH LEFTOVERS

PREPARATION TIME: 10 MINUTES PLUS OVERNIGHT SOAKING
COOKING TIME: 5 MINUTES

To make the pesto, place the rinsed sunflower kernels in a small bowl or jar and pour over enough cold water to cover. Cover with plastic wrap and leave to soak overnight at room temperature.

Drain and rinse the sunflower kernels, then place them in a food processor or blender together with the garlic, spinach, basil, oil, honey, cheese and lime juice and blitz until all the ingredients have come together to form a rough paste. Season with salt to taste. If the pesto is a little too thick, thin it with a tablespoon or two of water.

Heat a chargrill pan until almost smoking. Brush the lettuce halves with the rapeseed oil, add to the pan, cut side down, and cook for 2 minutes, or until nicely charred.

Divide the lettuce halves between serving plates, top with the pear slices and spoon over the cottage cheese and dollops of the sunflower pesto to serve.

— **4 baby cos (romaine) lettuces,** halved lengthways

— **1 tablespoon rapeseed oil**

— **2 crisp nashi or bosc pears, cored** and thinly sliced into acidulated cold water

— **200 g (7 oz) cottage cheese**

SUNFLOWER PESTO

— **125 g (4½ oz/1 cup) sunflower** kernels, rinsed

— **2 garlic cloves**

— **50 g (1¾ oz) baby spinach leaves**

— **1 bunch basil, leaves only**

— **100 ml (3½ fl oz) rapeseed oil**

— **1 teaspoon honey**

— **100 g (3½ oz) hard, granular** cheese (such as västerbotten or parmesan), grated

— **juice of 1 lime**

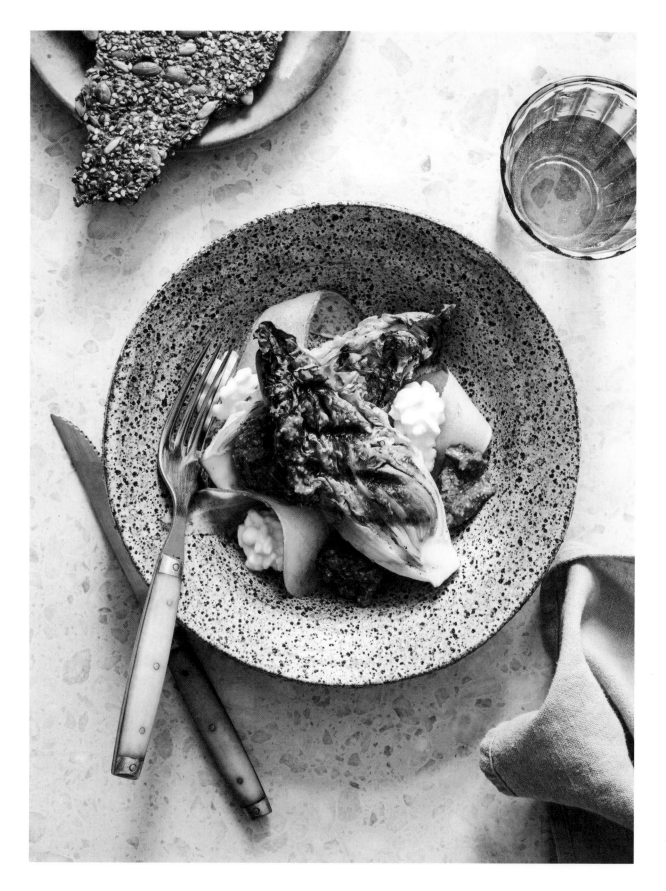

ROASTED CELERIAC, SILL RÖRA & POMEGRANATE

Sill, also known as pickled herring, is a standard ingredient in Swedish homes. An intense whack of salty, sweet, fishy flavour, there's no denying its unique taste. For this reason it pairs well with ingredients that can knock back its intensity – crispbread, potatoes and egg, for example. In this *röra*, a Swedish word for a seafood mixture, the jerusalem artichoke, along with the acidity from the lemon zest and pomegranates, helps to soften the herring's intensity well. Roasting a whole celeriac mellows its flavour and gives it an additional, beautiful sweetness, while the buckwheat groats get a pleasant kick from the sriracha chilli sauce.

SERVES 4

PREPARATION TIME: 10 MINUTES
COOKING TIME: 45 MINUTES

Preheat the oven to 160°C (325°F/Gas 3) and line a baking tray with baking paper. Mix together the buckwheat groats and sriracha in a bowl, then spread the mixture out onto the prepared baking tray and bake for 20 minutes, or until lightly golden and toasted. Remove from the oven and set aside.

Increase the oven temperature to 180°C (350°F/Gas 4).

Add half the butter to a roasting tin and place in the oven for 30 seconds, or until the butter melts.

Place the celeriac halves, cut side down, into the tin and rub them in the melted butter. Spread the remaining butter over the top of the celeriac halves and roast in the oven for 45 minutes, basting them occasionally with the melted butter, or until they are soft all the way through when pierced with a knife.

While the celeriac is cooking, add the *röra* ingredients to a bowl and mix together well. Set aside.

Once cooked, remove the celeriac halves from the oven and cut them into 3 cm (1¼ in) thick steaks. Serve warm, topped with the *röra*, pomegranate seeds, spinach leaves and toasted buckwheat. The celeriac steaks that have been cooked on the bottom of the roasting tin are the best – so be sure to save one of them for the chef!

— 170 g (6 oz/1 cup) buckwheat groats

— 2 teaspoons sriracha chilli sauce

— 40 g (1½ oz) butter

— 1 x 800 g–1 kg (1 lb 12 oz–2 lb 4 oz) whole celeriac, peeled and halved crosswise

— ½ pomegranate, seeds only

— 1 large handful baby spinach leaves

RÖRA

— 200 g (7 oz) pickled herring, drained from brine and finely diced

— 150 g (5½ oz) jerusalem artichokes, cut into 5 mm (¼ in) cubes

— juice and finely chopped zest of 1 lemon

— 2 tablespoons chopped dill

— 3 tablespoons olive oil

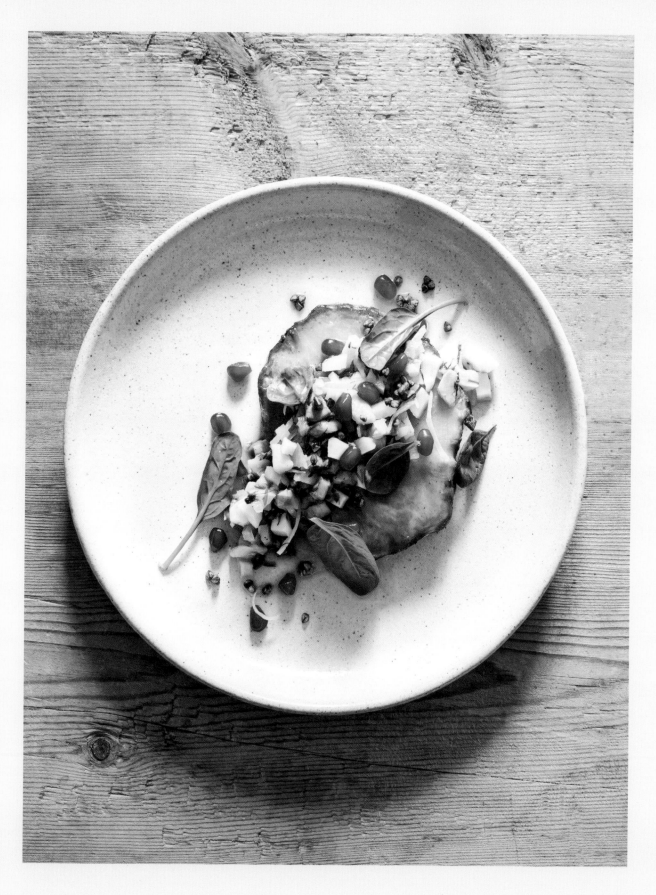

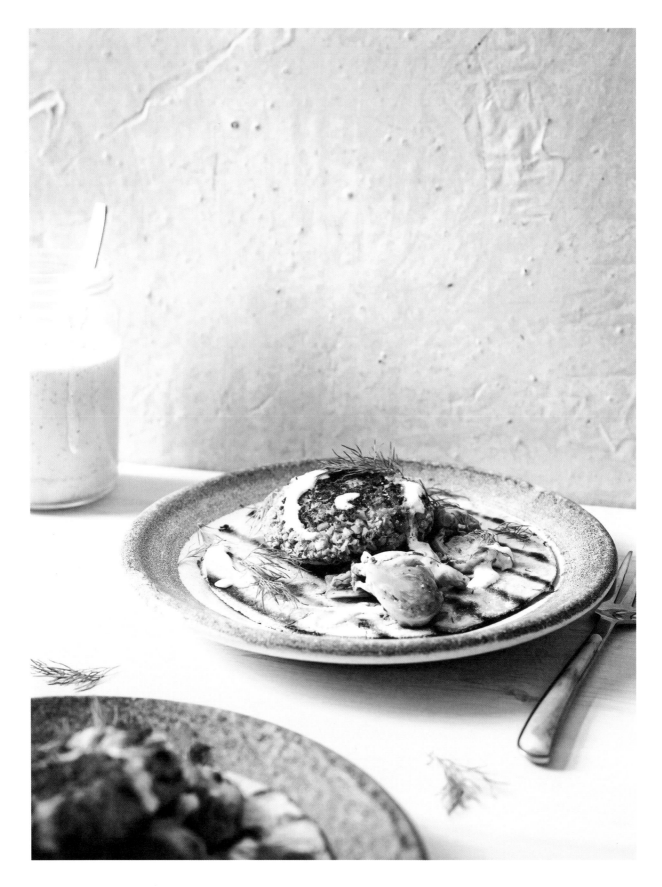

QUINOA FLATBREADS, WITH PEA PATTIES & BRUSSELS SPROUT KIMCHI

Swedish peas are delicious. I'm guessing the climate is ideal for growing them – even bought frozen they are sweet little delights. These patties are great hot or cold and keep well for leftovers. The quinoa flour creates a beautifully short dough for these flatbreads that is so quick and easy to make.

SERVES 6

PREPARATION TIME: 25 MINUTES
COOKING TIME: 15 MINUTES

To make the flatbreads, mix together all the ingredients in a food processor on the slowest speed until a dough forms. Transfer the dough to a lightly floured surface and knead for a minute or so, or until the dough is smooth.

Divide the dough into six even-sized portions and roll out with a lightly dusted rolling pin to form roughly circular flatbreads approximately 18 cm (7 in) in diameter. Set aside.

Preheat the oven to 170°C (340°F/Gas 3½). Line a baking tray with baking paper.

To make the patties, add all the ingredients, except the oil, to the food processor and blend to a wet, chunky paste. Test the mixture by taking a small amount in your hand and forming it into a patty in your palm – if the patty crumbles, add a tablespoon of water to the mixture before testing again. The mixture is ready when the patty just sticks to your palm. Shape the mixture into six even-sized patties about 4 cm (1½ in) thick.

Heat the rapeseed oil in a pan over a medium–high heat. Add the patties and cook for 2 minutes on each side, then transfer the patties to the prepared baking tray and bake for 5–8 minutes until cooked through.

Heat a chargrill pan over a medium–high heat and cook the flatbreads one at a time for 1–2 minutes on each side, or until cooked through and charred in places.

To serve, divide the flatbreads between plates. Spoon over a little kimchi, top each flatbread with a pea patty and drizzle over your chosen yoghurt dressing (I recommend either the tahini, lemon and dill or the juniper and pink pepper).

— 250 g (9 oz/2 cups) quinoa flour, plus extra for dusting

— 1½ teaspoons sea salt flakes

— 2 teaspoons baking powder

— 200 g (7 oz) Greek-style yoghurt

— 1 tablespoon chopped dill, plus extra to serve

PEA PATTIES

— 1 x 400 g (14 oz) tin chickpeas, drained

— 210 g (7½ oz/2 cups) fresh or frozen peas

— 50 g (1¾ oz/⅓ cup) quinoa flour

— 100 g (3½ oz) ricotta or Fresh Cheese (page 203)

— 60 g (2¼ oz/⅓ cup) pepitas (pumpkin seeds), lightly toasted

— 1 garlic clove, finely chopped

— pinch of white pepper

— 1 teaspoon dried mint

— ½ teaspoon ground fennel seeds

— 2 tablespoons lemon juice

— 1 tablespoon rapeseed oil

TO SERVE

— Brussels Sprout Kimchi (page 194)

— Yoghurt Dressing (pages 110–11)

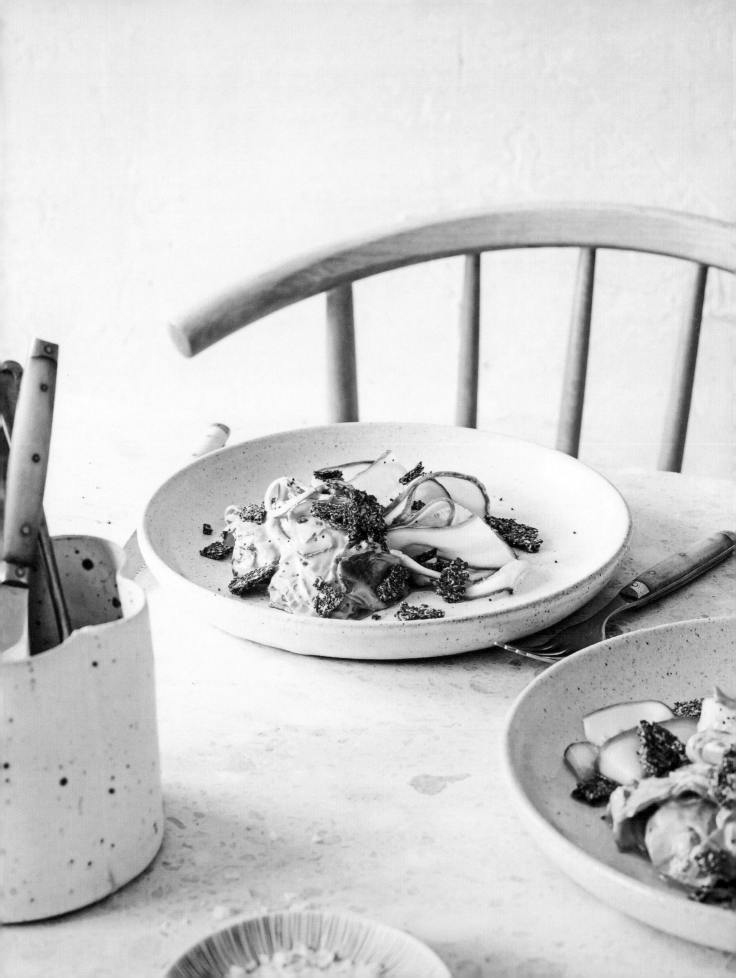

BEETROOT, SMOKY CUCUMBER & LINSEED CRISPS

Smoking foods is a tricky procedure best left to restaurant chefs, or for when you happen to be taking a sojourn at a Scandinavian summer house, where outdoor smokers are commonplace. However, using smoked salt like this can impart a little of that same smoky flavour to the cucumber in this recipe quite easily.

You'll have some left-over beetroot here – these can be used to make beetroot crispbreads (see page 57), blended into a cold beetroot gazpacho or used to make a beautiful salad with goat's cheese, toasted nuts and greens.

SERVES 2 WITH LEFTOVERS

PREPARATION TIME: 10 MINUTES
COOKING TIME: 40 MINUTES

Bring a large saucepan of salted water to the boil. Add the beetroot, cover and cook for 40 minutes, or until a paring knife passes through the centre easily.

Meanwhile, add the smoked salt to a bowl together with 1 litre (36 fl oz/4 cups) of water. Stir to dissolve the salt. Using a mandoline, shave the cucumber in long thin strips into the bowl of salted water. Set aside for 10 minutes.

When the beetroot are cooked, drain and refresh them under cold running water or in a bowl of iced water for 1 minute. Keeping one or two of the beetroot out for the salad, set aside the remainder in the refrigerator for another meal. Peel off the skins of the reserved beetroot and cut them into thin discs with the mandoline. Place the beetroot discs in a bowl, add the yoghurt dressing and sprinkle with sea salt. Toss to combine.

Remove the cucumber pieces from the water and arrange on serving plates together with the beetroot. Scatter over the linseed and poppy crisp shards to serve.

- 700 g (1 lb 9 oz) whole beetroot (beets)

- 1 tablespoon smoked salt

- ½ telegraph (long) cucumber

- 3 tablespoons Horseradish & Apple Yoghurt Dressing (page 111)

- 50 g (1¾ oz) Linseed and Poppy Crisps (page 90), broken into shards

SALMON CARPACCIO & CUCUMBER WALDORF

I like to keep a large salmon fillet in the freezer like this – it makes for easy slicing whenever you want beautifully thin strips for a carpaccio, while the act of freezing also kills off any parasites that can be found in this naturally oily fish. To avoid the salmon's flavour being tainted by other products in the freezer, be sure to keep it stored in a zip-lock bag.

The salmon slices here are very versatile and can be used with a variety of salad and dressing combinations, while the salad itself can be used to accompany many dishes. If you prefer your salmon less raw, give it a more solid hit of citrus and it will develop more of a cooked profile through a little maceration.

SERVES 2 WITH LEFTOVERS

PREPARATION TIME: 15 MINUTES

Remove the salmon from the freezer and leave it to thaw a little on a clean work surface for 15 minutes.

Meanwhile, mix together the dressing ingredients in a bowl until well combined.

For the cucumber waldorf, put all the ingredients in a large bowl. Add the dressing and toss together well.

Now, back to the salmon. Using a very sharp knife, and starting at the narrow end of the fillet, slice it into very thin slices on a 45° angle (this will give each slice the maximum amount of surface area). Plate each slice as you go, fanning the slices out side by side to cover two serving plates. Return the remaining salmon fillet to the zip-lock bag and freezer.

To serve, pile the salad over the centre of each plate, drizzle over the olive oil and squeeze over as much lime juice as you like. Garnish with redwood sorrel leaves.

— 1 x 800 g (1 lb 12 oz) super-fresh skin-on salmon fillet, sealed in a zip-lock bag and frozen (it's best to buy a larger fillet and leave it in the freezer for multiple occasions)

— 1 tablespoon extra-virgin olive oil

— lime wedges to serve

— redwood sorrel leaves to garnish

CUCUMBER WALDORF

— 1 handful green grapes, halved

— ½ cucumber, peeled and thinly sliced on a mandoline

— 40 g (1½ oz) walnuts, roughly chopped

— 1 celery stalk, thinly sliced on an angle

— ½ granny smith apple, cored and thinly sliced on a mandoline

DRESSING

— 1 teaspoon dijon mustard

— 125 g (4½ oz) plain yoghurt

— a squeeze of lemon juice

— 1 teaspoon olive oil

— 1½ teaspoons sea salt flakes

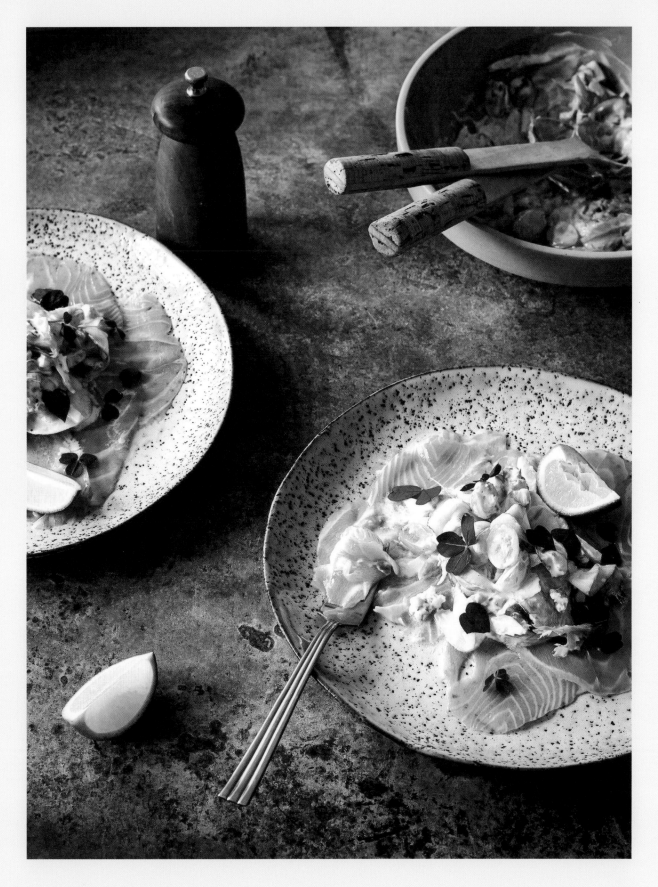

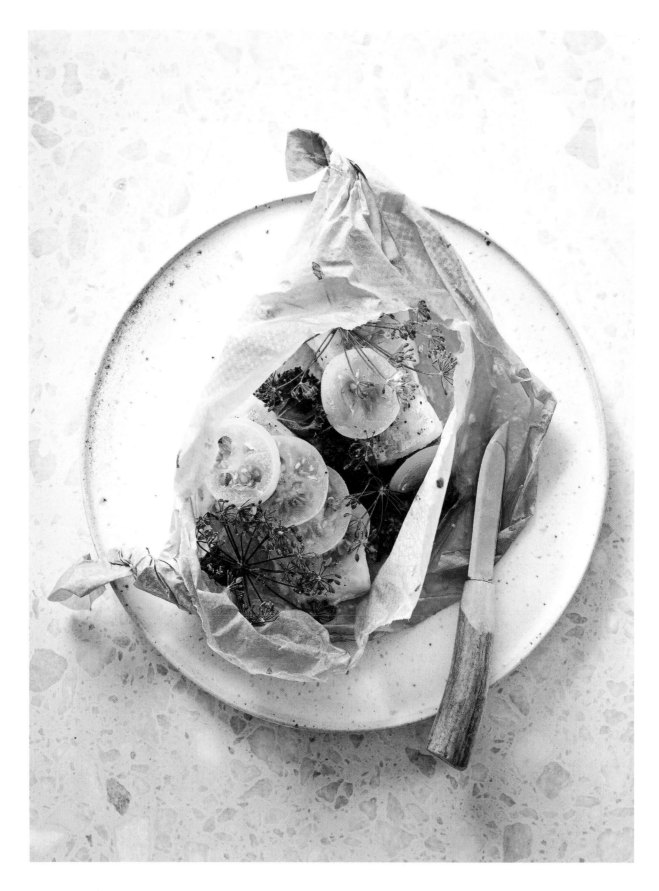

COD EN PAPILLOTE WITH GREEN TOMATOES & DILL

This French technique of steaming is one of my favourite ways to cook fish. Anything can be encased in the paper to impart flavour – it's quick, healthy and creates little mess.

This year, whether the outcome of a poor summer or the result of planting them out too late, our tomatoes remained green. But in the true Nordic spirit of making the best of climate adversity we transformed them into these tart slithers, which serve to do the job of lemon and accompany the dill perfectly. Crown dill, the flower head of the dill herb, has a more liquorice and intense flavour than the leaves. If you can't find it you can replicate the flavour by using fresh dill and a very light dusting of liquorice root powder instead.

SERVES 2

PREPARATION TIME: 5 MINUTES
COOKING TIME: 15 MINUTES

Preheat the oven to 180°C (350°F/Gas 4). Fold a 40 cm x 30 cm (16 in x 12 in) sheet of baking paper in half. Cut off the corners to create round edges with scissors, then fold the baking paper out to give you a heart-shaped piece ready to cook with.

Place the fish in the centre of the prepared baking paper and top with the tomatoes, chopped cabbage and crown dill or dill sprigs and liquorice powder. Sprinkle over the sea salt and drizzle over the olive oil, then fold over the paper to form a parcel. Crimp the edges and twist the paper at both ends to seal the deal.

Place the parcel on a tray in the middle of the oven and bake for 12–15 minutes, or until cooked through.

Unwrap and eat straight from the paper or transfer to serving plates. Enjoy with some crispbread or a brussels sprout slaw (see page 117) as part of a light meal.

— 2 x 150 g (5½ oz) cod fillets or other firm white fish fillets

— 2 small green tomatoes, thinly sliced into discs

— 20 g (¾ oz) green cabbage, roughly chopped (or other greens such as asparagus or leeks)

— 3 crown dill heads or dill sprigs

— pinch of liquorice powder (if using dill sprigs)

— 1 teaspoon smoked or regular sea salt flakes

— 1 teaspoon olive oil

KOMBUCHA GRAVLAX, BURNT CHIVE, KOHLRABI

This is so simple and delicious. Essentially the salmon is macerated, or lightly cooked in the citrus juice like ceviche, but it also takes on a sweetness from the kombucha akin to traditionally cured gravlax. The burnt chives counter this nicely and the watery kohlrabi brings some needed freshness and crisp texture.

Kombucha is a Japanese fermented fizzy drink derived from tea, widely regarded for its health benefits. It can be found in health food stores.

SERVES 2 WITH LEFTOVERS

PREPARATION TIME: 5 MINUTES
COOKING TIME: 30 MINUTES

Remove the salmon or trout fillet from the freezer and leave it on a clean work surface to thaw a little, this will take at least 20–25 minutes.

Preheat the oven to 200°C (400°F/Gas 6). Line a baking tray with foil.

Using a very sharp knife, and starting at the narrow end of the fillet, slice it into very thin slices on a 45° angle (this will give each slice the maximum amount of surface area). Put the fish slices in a bowl, add the lemon juice, sea salt flakes and enough kombucha to cover and mix together well. Leave to sit for 10 minutes, then remove from the liquid and set aside.

Meanwhile, spread the chives over the prepared baking tray and arrange so that none are overlapping, transfer to the oven and cook for 30 minutes, or until burnt. Remove the chives from the oven and slide the chives off the foil onto a plate to cool.

Thinly slice the kohlrabi into a bowl of cold water using a mandoline. Add a pinch of salt to the bowl, stir to dissolve and leave to sit for 5–10 minutes.

To serve, layer slices of the salmon on serving plates between slices of the kohlrabi and drizzle over the rapeseed oil. Crumble over the burnt chives and spoon over some mustard seed caviar to finish.

- 300 g (10½ oz) super-fresh salmon or ocean trout fillet, sealed in a zip-lock bag and frozen (it's best to buy a larger fillet and leave it in the freezer for multiple occasions)
- juice of 1 lemon
- 1 teaspoon sea salt flakes
- approx. 125 ml (4 fl oz/½ cup) kombucha (or enough to cover the fish slices)
- 25 g (1 oz) chives
- 400 g (14 oz) whole kohlrabi, peeled
- pinch of salt
- 1 tablespoon cold-pressed rapeseed oil (or nut oil of your choice)
- Mustard Seed Caviar (page 198) to serve

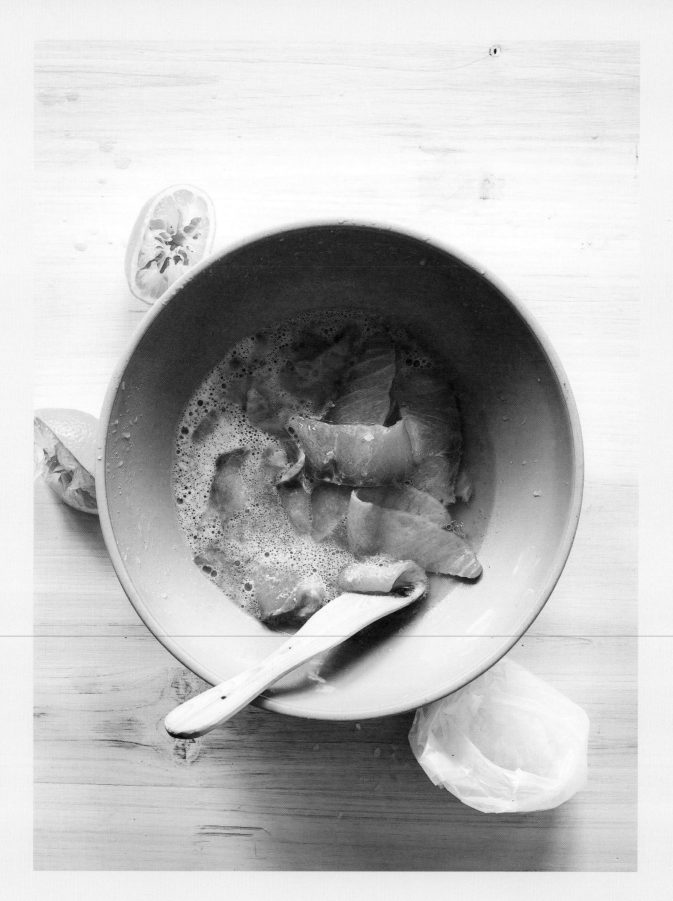

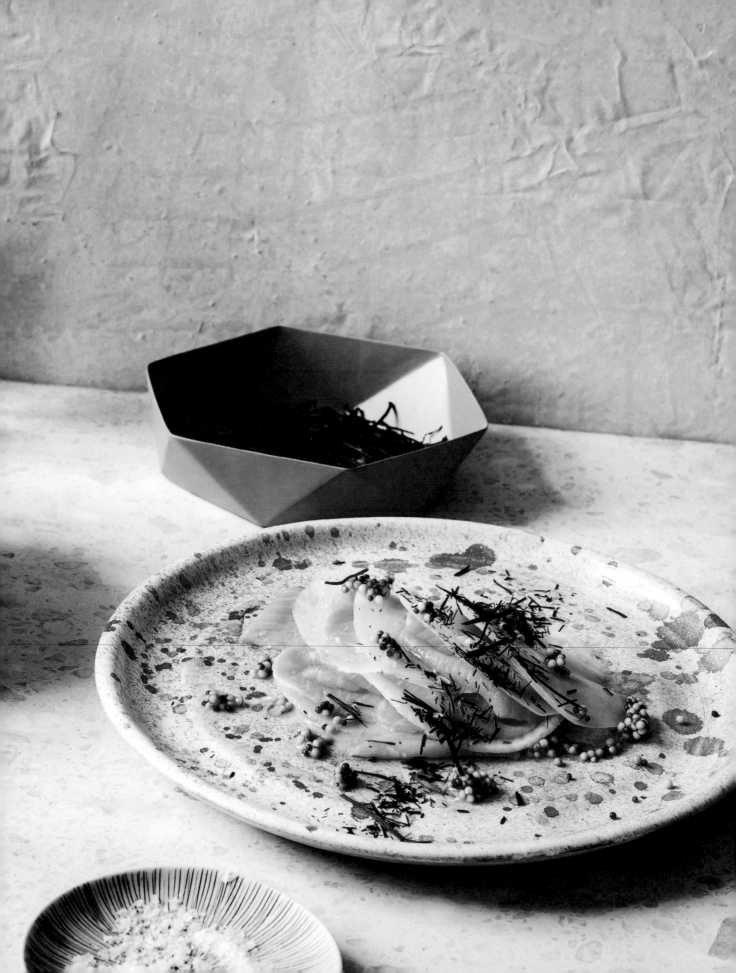

VENISON, PICKLED CHANTERELLES & MUSTARD RYE CRUMBLE

Venison, like all game, is a very lean meat. It goes well with bitter and sweet flavours, and in many traditional Nordic recipes it's cooked as a stew with cream. I love it cured or served rare and cold as it is here. Left-over venison can be added to salads or served on crispbread.

It's best to prepare these pickled chanterelles at least a day in advance, so that the mushrooms can settle in the pickling solution.

SERVES 2 WITH LEFTOVERS

PREPARATION TIME: 25 MINUTES PLUS PICKLING
COOKING TIME: 30 MINUTES

For the pickling solution, put all the ingredients in a saucepan along with 200 ml (7 fl oz) of cold water. Bring to a boil then reduce the heat and simmer gently, stirring, for 2 minutes, until all the sugar has dissolved. Remove from the heat and set aside to cool.

Place the chanterelles in a non-reactive bowl and pour over the cooled pickling liquid. Leave for at least 30 minutes, preferably overnight.

When ready to cook, add the potatoes to a saucepan of boiling water and cook them until they are tender and easily pierced with the point of a knife. Drain, add the butter and tarragon and toss together. Keep warm with the lid on.

Preheat the oven to 180°C (350°F/Gas 4). Line a baking tray with baking paper.

To make the mustard rye crumble, combine all the ingredients in a bowl. Arrange spoonfuls of the mixture on the prepared baking tray and bake for 5–8 minutes, until golden brown. Remove from the oven and leave to cool and crisp up.

Season the venison fillet well with sea salt and freshly ground black pepper. Heat the oil in an ovenproof frying pan or cast-iron grill pan over a high heat, add the venison and fry for 30 seconds on each side to seal the meat. Transfer to the oven to cook through. How long it needs will depend on the thickness of the meat and how well it was sealed in the pan; 8–10 minutes is usually enough. You want the meat to be quite rare so it should just spring back when you press it. Remove from the oven and place on a board. Cover with foil and leave to rest in a warm place for 10 minutes.

To serve, cut the rested venison fillet into very thin slices and divide between serving plates. Top with the mustard rye crumble, pickled mushrooms and tarragon sprigs and serve with the potatoes and rosehip ketchup.

- 100 g (3½ oz) chanterelles, cleaned with a brush and larger mushrooms torn in half
- 300 g (10½ oz) small new potatoes
- 15 g (½ oz) salted butter
- 3 tarragon sprigs, leaves picked, plus extra to garnish
- 1 x 400 g (14 oz) venison fillet
- 1 tablespoon rapeseed oil
- Rosehip Ketchup (page 196) to serve

LIGHT PICKLING SOLUTION
- 300 ml (10 fl oz) apple-cider vinegar
- 150 g (5½ oz) caster (superfine) sugar
- 1 teaspoon salt
- 3 dried juniper berries
- 2 allspice berries
- 2 bay leaves

MUSTARD RYE CRUMBLE
- 125 g (4½ oz/1 cup) rye flakes
- 2 tablespoons rapeseed oil
- 1 teaspoon dijon mustard
- 1 teaspoon honey

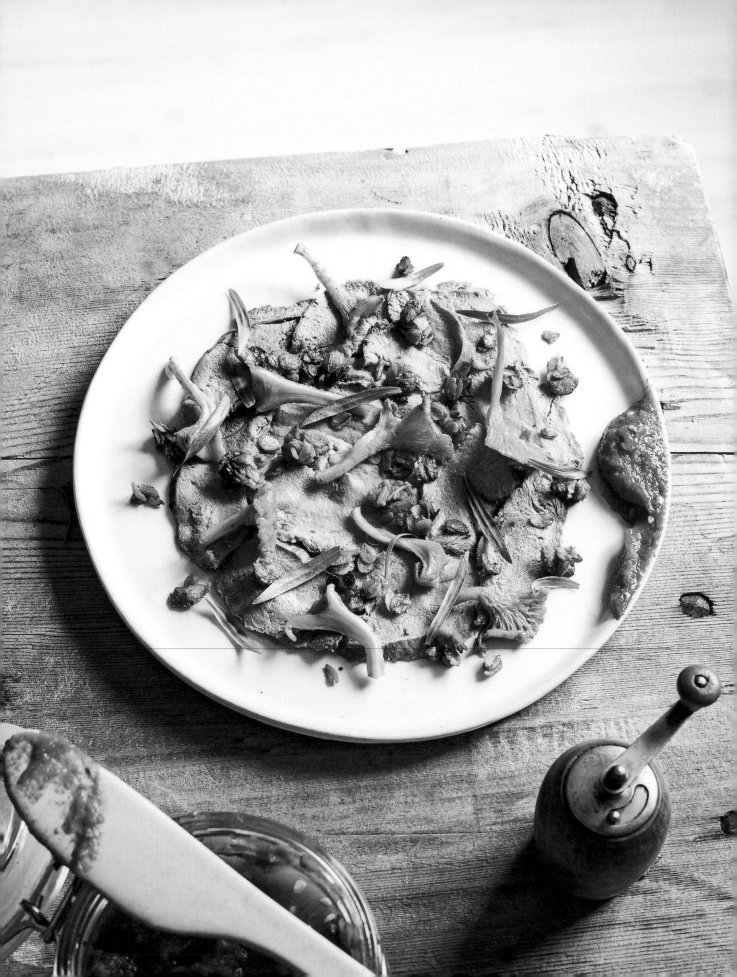

CHAPTER FOUR

FIKA
FOOD

Fika – the culture of taking a break over a warm drink with something sweet – is popular in Nordic countries. Although the word itself comes from Sweden, you'll find Scandinavians pausing to take coffee and cake all the way from Denmark's Bilund to Norway's Kirkenes. Commonly *fika* is taken after lunch, though it can be enjoyed at any time of the day. Most importantly, it's about switching off for at least 15 minutes and savouring a steaming cup and its accompaniment. On a cold winter's morning, if peckish, there is nothing better.

Given that almost all *fika* items are considered a treat, they tend to be high in sugar and butter content! In the chapter ahead I have experimented with creating a range of more 'guilt-free' savoury and sweet options for complementing your coffee break.

LINSEED & POPPY CRISPS

These guaranteed crunchy wafers are great served with salad, while crumbled up they can go with yoghurt or on top of soups in place of croutons. They are very moreish, so don't leave them out on the kitchen bench!

MAKES ABOUT 8–10 CRISPS

PREPARATION TIME: 10 MINUTES
COOKING TIME: 15 MINUTES

Preheat the oven to 200°C (400°F/Gas 6). Put the linseeds in a spice grinder or small food processor and blitz into roughly cracked pieces.

Add the cracked linseed to a large bowl with the remaining ingredients and mix together well. Pour over 125 ml (4 fl oz/½ cup) of water and mix well until the dough is wet and sand-like in consistency, then take some plastic wrap and press down on the mix to firm and compact it. Leave to rest on the work surface for 5 minutes.

Working carefully, divide the mixture out in six even dollops over a 45 cm x 35 cm (18 in x 14 in) rectangular sheet of baking paper. Place another sheet of baking paper on top and then roll the mixture out so that the pieces press together to make an even layer. Lift the top sheet of paper and use the edges to patch in any gaps, then re-position the paper and roll out again as evenly and thinly as you can without producing any holes. (The consistency of this mix can be tricky to work with, but persevere because the result is delicious.)

Remove the top sheet of baking paper and slide the rolled-out dough on its sheet of baking paper on to a baking tray. Bake in the oven for 15 minutes until the edges of the crispbread are brown and there are visible cracks in the middle (you may need to rotate the oven tray for even cooking).

Transfer to a wire rack to cool completely then break into shards. The crisps will keep in a sealed container for up to 1 week.

— 225 g (8 oz/1½ cups) golden or brown linseeds (flax seeds)

— 80 g (3 oz/½ cup) poppy seeds

— 3 tablespoons potato flour or cornflour

— ½ teaspoon salt

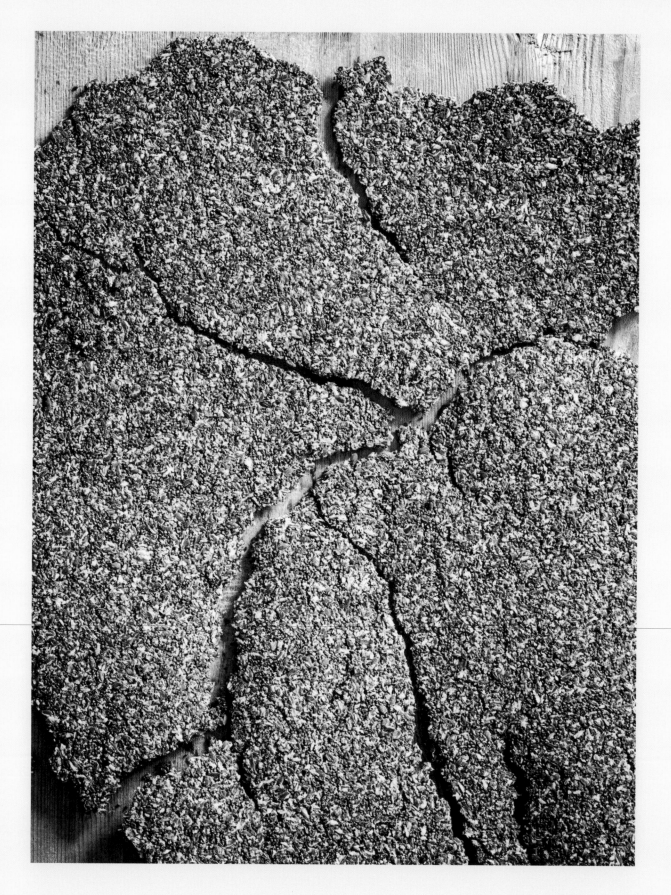

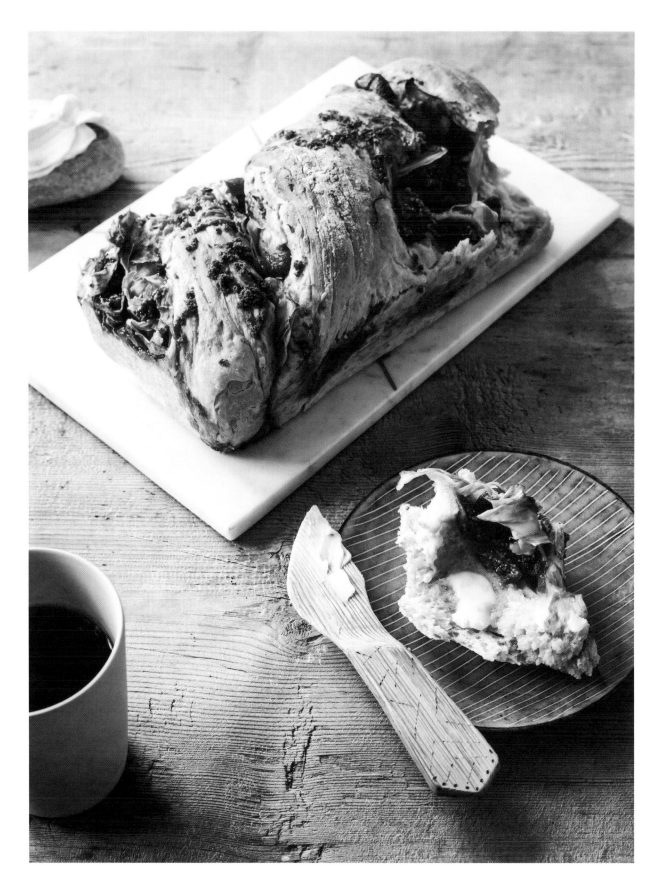

FIG & FENNEL
PULL-APART BREAD

Nordic countries have a closer association with the Mediterranean than many would imagine, with retirees and young families alike spending plenty of time down south topping up their vitamin D levels. I can only imagine that's how this flavour combo was born. Two great bakeries I know of in Stockholm who make the best traditional cinnamon buns do so with these flavours – here they are incorporated into a more savoury dough to be enjoyed with butter and black coffee.

MAKES 1 X 800 G (1 LB 12 OZ) LOAF

PREPARATION TIME: 15 MINUTES PLUS RISING
COOKING TIME: 40 MINUTES

Mix the yoghurt, egg and olive oil together in a bowl with 170 ml (6 fl oz/⅔ cup) of water until well combined. Stir in the instant yeast to dissolve.

Gradually add the flours, sugar and salt and mix everything together to form an elastic dough, then tip onto a clean floured work surface and knead for 2–3 minutes until smooth. Transfer the dough to a lightly greased bowl, cover with a clean tea towel and leave to rise for 30 minutes.

While the dough is rising, prepare the filling by putting all the ingredients in a bowl and gently tossing together.

Once risen, transfer the dough to the work surface and form into a snake-shaped log about 60 cm (24 in) long. Fold the log back on itself to create a 'U' shape with a trough running down the middle of the dough.

Line the trough with the filling ingredients then, holding the end of the dough with two ends, twist the opposite end clockwise three times on itself. Filling will go everywhere, but you can stuff it back in the right places once you have your basic twisted shape. Place the shaped loaf in a greased and floured 25 cm x 12 cm (10 in x 4½ in) loaf tin and set aside to rise for another 15 minutes.

Preheat the oven to 180°C (350°F/Gas 4).

Once risen, transfer the loaf tin to the oven and bake for approximately 40 minutes, or until the loaf is lightly golden and sounds hollow when tapped. Turn out and serve warm, spread with butter and accompanied by a pot of coffee.

— 125 g (4½ oz/½ cup) Greek-style yoghurt

— 1 large egg, at room temperature

— 3 tablespoons olive oil

— 2 teaspoons dried instant yeast

— 225 g (8 oz/1½ cups) plain (all-purpose) flour, plus extra for dusting

— 225 g (8 oz/1½ cups) wholemeal (whole-wheat) flour

— 1 tablespoon raw sugar

— ½ teaspoon salt

FILLING
— 185 g (6½ oz/1 cup) soft dried figs, chopped

— 30 g (1 oz) butter, melted

— 100 g (3½ oz) fennel bulb, very thinly sliced

— 1 teaspoon crushed fennel seeds

— 1 teaspoon sea salt

— 2 tablespoons dark brown sugar

PEAR, SAGE & HAZELNUT BREAD

I don't understand why pears are not more often consumed. Perhaps it's because their 'sweet spot' is a little less consistent than their rivals. A beautifully ripe pear is my favourite fruit. When baking with pears, I recommend using them ripe.

SERVES 8

PREPARATION TIME: 15 MINUTES
COOKING TIME: 1 HOUR

Preheat the oven to 180°C (350°F/Gas 4). Spread the chopped hazelnuts on a baking tray and bake for 4 minutes, or until lightly golden. Watch carefully as they will burn easily. Set aside to cool.

Lower the oven to 170°C (340°F/Gas 3½). Grease a 25 cm x 10 cm (10 in x 4 in) loaf tin with butter.

Melt the butter in a saucepan over a medium heat together with the sage leaves. You don't want to burn the butter here, just heat it until it starts to brown and the sage leaves turn a little crispy. Remove from the heat but keep in a warm place so that the butter remains liquid.

In a large bowl, mix together the cooled toasted hazelnuts with the remaining dry ingredients. Break the eggs into a separate bowl, add the grated pear, buttermilk, warm sage butter and vanilla extract and whisk together well. Gradually add the dry mixture to the wet, stirring together well, to form a heavy, wet dough halfway between a thick cake batter and a bread dough. Add a little more flour if the dough is looking a bit wet or a little extra buttermilk if too dry.

Spoon the dough into the prepared loaf tin and smooth the top of the dough with the back of a spoon. Arrange the pear slices on top and sprinkle over a few teaspoons of dark brown sugar. Bake in the oven for 1 hour.

Serve warm or at room temperature, spread with butter and alongside coffee. This toasts beautifully the next day, like banana bread, and will keep for up to a week in a sealed bag in the refrigerator.

- 120 g (4½ oz/1 cup) chopped hazelnuts
- 50 g (1¾ oz) unsalted butter
- 5 sage stalks, leaves stripped
- 60 g (2¼ oz/¾ cup) rolled (porridge) oats
- 250 g (9 oz/1⅔ cups) plain (all-purpose) flour
- 200 g (7 oz/1⅓ cups) wholemeal (whole-wheat) flour
- ¼ teaspoon bicarbonate of soda (baking soda)
- 2 teaspoons baking powder
- ½ teaspoon ground cardamom
- ¼ teaspoon freshly grated nutmeg
- 1 tablespoon dark malt powder
- 95 g (3¼ oz/½ cup) dark brown sugar, plus extra for sprinkling
- ¾ teaspoon salt
- 2 eggs, beaten
- 3 x 150 g (5½ oz) ripe pears, peeled and cored, 2 grated and 1 sliced to decorate
- 250 ml (9 fl oz/1 cup) buttermilk or plain yoghurt
- 1½ teaspoons natural vanilla extract

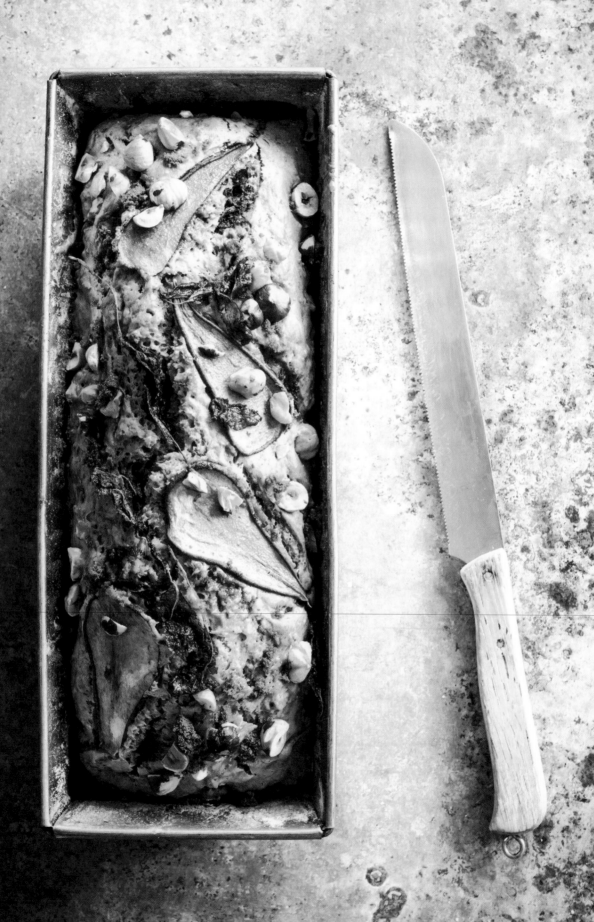

FLOURLESS RHUBARB & THYME BUNS

Relatively instant bread with rhubarb – why not? I love the way rhubarb cuts through things. Any flourless bread walks the tightrope but these savoury buns do the trick and have a surprisingly good consistency a day or two after baking. They are perfect served with coffee alongside a slice of sharp cheese.

MAKES 4 BUNS

PREPARATION TIME: 5 MINUTES
COOKING TIME: 30–35 MINUTES

Preheat the oven to 180°C (350°F/Gas 4). Lightly grease a 20 cm (8 in) cake tin.

Whisk together the eggs, olive oil and yoghurt in a large bowl. In a separate bowl, mix together the ground almonds, linseeds, sunflower kernels, psyllium husks, salt and baking powder. Tip the dried ingredients into the wet mixture and stir together with a wooden spoon to form a dough. Leave to rest in the bowl for 5 minutes.

While the dough is resting, cut the rhubarb batons into thirds and toss them together with the sugar in a separate bowl.

Once rested, divide the dough into four even-sized pieces. Shape each piece into a ball and place them in the prepared cake tin so that they press snugly up against each other. Arrange three rhubarb pieces over each bun, top with the onion slices and thyme and bake for 30–35 minutes until lightly golden. Serve warm with butter or leave to cool and keep for 2–3 days.

— 2 large eggs

— 2 tablespoons olive oil

— 125 g (4½ oz/½ cup) plain yoghurt

— 125 g (4½ oz/1 cup) ground almonds

— 2 tablespoons golden or brown linseeds (flax seeds), lightly crushed

— 3 tablespoons sunflower kernels

— 4 tablespoons psyllium husks

— 1 teaspoon salt

— 1 teaspoon baking powder

— 2 thin rhubarb stalks, cut into 10 cm (4 in) batons

— 1 tablespoon dark brown sugar

— 1 small red onion, thinly sliced

— 8 thyme sprigs, leaves stripped if woody

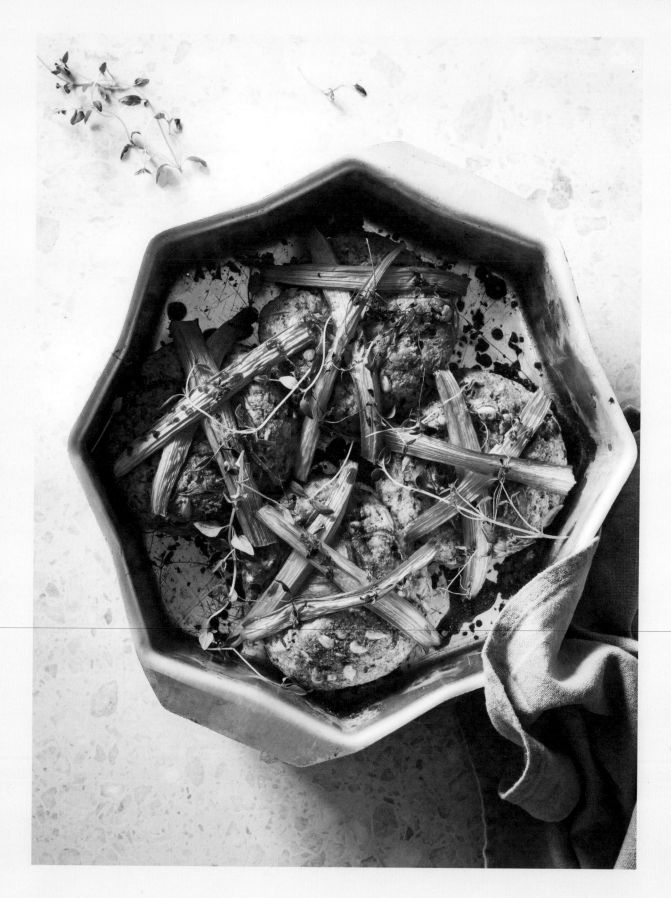

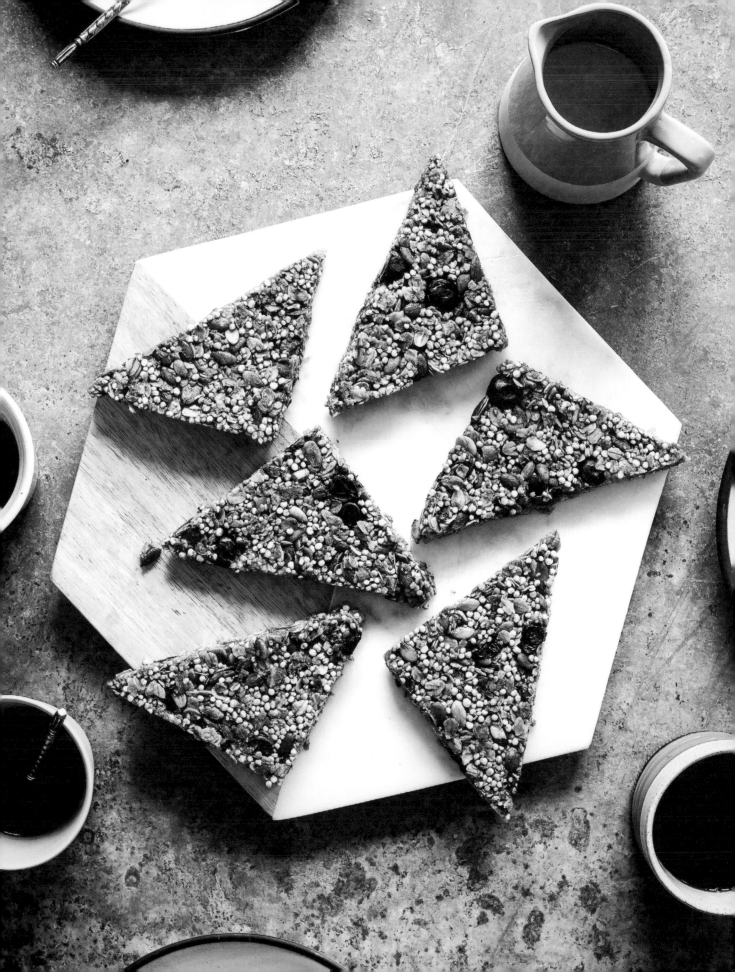

MATCHA, QUINOA & BLUEBERRY SAILS

Seeds and grains play an important role in the new Nordic cooking ideology and the range that can be found in the supermarkets of Nordic countries is very impressive. Puffing grains is tricky to do at home, so here you need to buy the quinoa prepared. Other puffed grains such as amaranth and millet can be used in place of the quinoa – just be sure to measure out the same volume as opposed to weight. These are a perfect *fika* snack for packing on the go.

MAKES AT LEAST 12 SAILS

PREPARATION TIME: 15 MINUTES PLUS CHILLING
COOKING TIME: 15 MINUTES

Preheat the oven to 160°C (325°F/Gas 3). Line a 20 cm x 15 cm (8 in x 6 in) baking tin with baking paper.

Arrange the oats and pepitas on a baking tray in an even layer and bake for 10–15 minutes, or until the oats are golden and have a nutty aroma and the pepitas are toasted. Set aside to cool completely.

In a small saucepan over a low heat, stir together the grape syrup, honey, matcha powder, coconut oil and vanilla extract until the coconut oil has melted and the ingredients are well combined.

Pour the syrup mixture into a large bowl. Add the cooled oats, puffed quinoa grains and pepitas to the bowl and quickly stir together to coat them in the liquid, then gently stir through the blueberries. Pour the mixture into the lined tin, pressing firmly into the corners, and transfer to the refrigerator for 1–2 hours to chill and firm up.

To serve, lift the chilled mixture from the baking tin and cut into six squares, then cut the squares diagonally into 12 triangles. These sails will keep well in the refrigerator in a sealed container for up to 2 weeks.

— 160 g (5¾ oz/2 cups) rolled (porridge) oats

— 175g (6 oz/1 cup) pepitas (pumpkin seeds)

— 100 ml (3½ fl oz) grape syrup

— 3 tablespoons honey

— 1½ tablespoons matcha green tea powder (or to your taste)

— 3 tablespoons coconut oil

— 1 teaspoon natural vanilla extract

— 40 g (1½ oz/1½ cups) unsweetened puffed quinoa grains

— 155 g (5½ oz/1 cup) fresh blueberries

SAFFRON, PISTACHIO & COCONUT PINES

Saffron is widely used in Sweden in the lead up to Christmas and with its high price tag it is common to see 'need saffron?' signs taped to the supermarket checkout cashiers, where it is kept under lock and key. Unlike elsewhere, it's not going into paella or risotto Milanese, rather baked goods. This adaptation of a macaroon uses no sugar and is delicious.

MAKES 6 PINES

PREPARATION TIME: 10 MINUTES PLUS CHILLING
COOKING TIME: 15 MINUTES

In a small bowl, mix together the honey, vanilla extract, coconut oil and saffron threads to combine. Set aside.

Put the eggwhites in a large whisking bowl with the salt and whisk together until soft peaks form. Gradually fold the desiccated coconut into the eggwhites, then fold through the honey mixture. Chill in the refrigerator for 30 minutes.

Preheat the oven to 180°C (350°F/Gas 4) and line a baking tray with baking paper. Lightly oil a 6-hole muffin tray or six 200 ml (7 fl oz) moulds – I used some cone-shaped moulds but they can be any shape as long as they are around this volume (it's preferable also that they are non-stick for the purposes of tipping upside-down).

For the base, mix the eggwhite, potato flour, honey and pistachios together in a medium bowl.

Once chilled, divide the coconut and eggwhite mixture evenly between the individual moulds or tray. Spoon over the base mixture in an even layer and press it down firmly with a spoon to compact everything together.

Flip over the moulds or tray and tap if needed so the pines slide out, then arrange the pines on the prepared baking tray and bake in the oven for 15 minutes, or until dark brown at the edges. Leave to cool on the tray before eating. The pines will keep stored in a sealed container for up to 3 days.

— 115 g (4 oz/⅓ cup) honey

— 2 teaspoons natural vanilla extract

— 2 tablespoons coconut oil

— ½ teaspoon saffron threads

— 4 eggwhites

— pinch of salt

— 180 g (6 oz/2 cups) desiccated (shredded) coconut

BASE
— 1 eggwhite

— 1 teaspoon potato flour

— 1 teaspoon honey

— 100 g (3½ oz/¾ cup) chopped pistachios

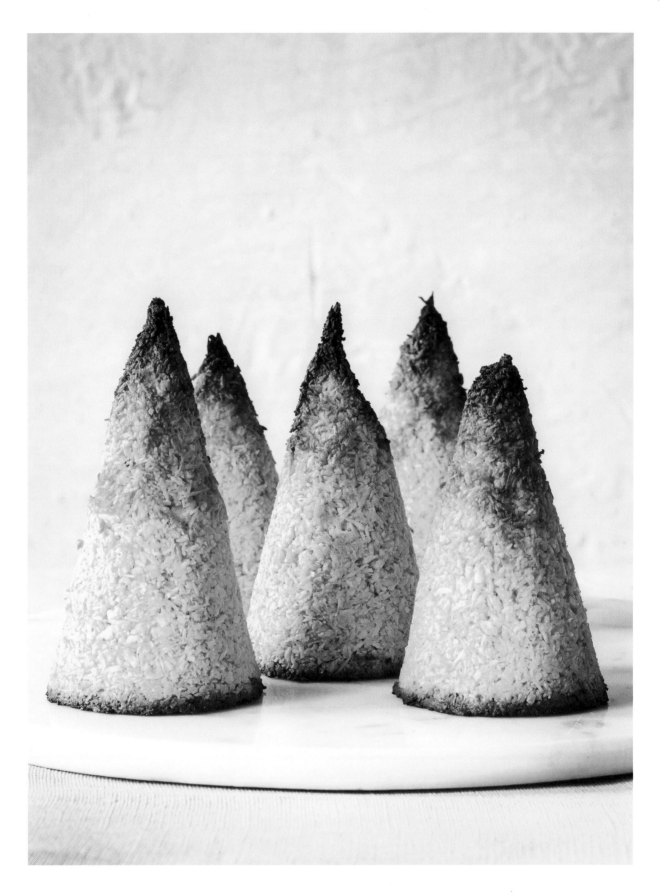

WHITE CHOCOLATE, BLACKBERRY & ROSEMARY MUD SLICE

This slice was inspired by the lovely Sollá, who runs a chain of vegetarian and raw food restaurants in Iceland and who helped me appreciate the potential of vegetarian and raw cooking through her delicious dishes. It was a pleasant surprise to see the popularity of health and raw foods in Reykjavik, with almost every supermarket stocking an impressive range of products. Indeed, with her five restaurants Sollá has had more success in Reykjavik than the famous golden arches, who were forced to close their doors in 2009.

Sollá's original recipe calls for the use of black beans and cacao, which I have adapted here to reflect new Nordic cuisine's penchant for white chocolate.

MAKES 16 SLICES

PREPARATION TIME: 15 MINUTES
COOKING TIME: 55 MINUTES

Preheat the oven to 180°C (350°F/Gas 4). Lightly grease a 28 cm x 22 cm (11 in x 8½ in) baking tin with butter.

Arrange the walnut halves on a baking tray in an even layer, transfer to the oven and bake for 5 minutes until lightly toasted. Leave to cool, then chop into roughly 1 cm (½ in) pieces. Leave the oven on.

Put the chia seeds in a small blender or spice grinder and whiz together for 20 seconds to form a powder. Tip the ground chia into a bowl, pour over 150 ml (5 fl oz) of water and stir together to form a paste. Set aside.

Place the butterbeans in a food processor and blend together until smooth, then add the chia paste, sugar, coconut oil, ground almonds, baking powder, vanilla extract and sea salt and blitz together to form a smooth batter.

Add the chocolate, half the rosemary, the blackberries and walnuts to the food processor and pulse for 2–3 seconds to combine, then pour the batter into the prepared baking tin. Scatter over the remaining rosemary leaves and bake for 50 minutes, or until it is just set in the middle and the edges are raised and cracked.

Remove from the oven and allow to cool, then cut into squares and serve, or transfer to an airtight container and store in the refrigerator for up to 5 days (they taste even better the next day).

— 75 g (2½ oz/¾ cup) walnut halves

— 40 g (1½ oz/⅓ cup) chia seeds

— 400 g (14 oz) tinned butterbeans (giant white beans), rinsed and drained

— 250 g (9 oz) granulated sugar

— 80 ml (2½ fl oz/⅓ cup) coconut oil, melted

— 100 g (3½ oz/1 cup) ground almonds

— 1 teaspoon baking powder

— 1 teaspoon natural vanilla extract

— ¼ teaspoon sea salt flakes

— 150 g (5½ oz) white chocolate, broken into 1 cm (½ in pieces)

— 2 rosemary sprigs, leaves stripped

— 130 g (4½ oz) frozen blackberries

CHAPTER FIVE

BOWL

FOOD

Throwing together an assortment of ingredients in a bowl is a great way to avoid taking on too much protein or carbohydrate, whether it be blending up vegetables for a bowl of soup or putting together a salad to be eaten as a main dish rather than a complementary side. The architecture of salad balances your consumption of vegetables, dairy, protein and grains by default. A bit of this, a bit of that, all topped off with a dressing. I have a particular love of making yoghurt dressings. You can adjust them as needed with water for consistency, they have a natural acidity and the flavour combinations are endless.

Where in the past I might have considered protein as the prime component of a dish, I now focus first on the vegetable element and how I might prepare it in a new or unique way. Inspiration to work this way has come from what I see in Nordic restaurants, where chefs have a heightened appreciation of vegetables. Once considered mundane, veggies (in particular cold climate veggies) are having their well-deserved time in the sun!

Many of the recipes in the chapter ahead are designed to give you leftovers that will keep well for other occasions, so don't be put off by the prep involved – it'll be worth it.

YOGHURT
DRESSINGS

All food needs sauce but unfortunately 99 per cent of bought sauces or dressings contain ingredients such as thickeners, preservatives and sugars that we should try to avoid. Home-made sauces are a different matter, but many take a lot of time to make. A red wine sauce, the king of sauces, takes days to prepare properly, and who spends their time whipping up the unhealthy-but-thoroughly-delicious treat that is a hollandaise sauce in the morning at home?

These yoghurt sauces are great because they are quick to make and easy to vary, as well as providing us with all of the good natural bacteria found in yoghurt. I don't consume a lot of milk – I'm not intolerant, I just feel better consuming less of it and I believe these dressings paired with cheeses make up the right amount of dairy consumption for me.

While these dressings will keep okay for a few days in the refrigerator, I suggest making only as much as you need for the meal you are preparing. I also suggest using a small food processor or smoothie blender to make these – the sharp blade aerates the yoghurt and gives them the perfect consistency for dressing.

ALL DRESSINGS SERVE 4

JAFFA

— 250 g (9 oz/1 cup) plain yoghurt
— zest of 1 orange
— 1 tablespoon cacao nibs
— ½ teaspoon cacao powder
— ¼ teaspoon salt
— pinch of white pepper

Briefly blitz all the ingredients together in
a food processor.

HORSERADISH
& APPLE

— 1 granny smith apple
— 250 g (9 oz/1 cup) plain yoghurt
— 1 tablespoon freshly grated horseradish
 (or from a jar)
— ¼ teaspoon salt

Peel and core the apple, then add to a food processor
together with the remaining ingredients. Blitz
together briefly to combine.

JUNIPER & PINK
PEPPER

— 1 teaspoon pink peppercorns
— 3 dried juniper berries
— 250 g (9 oz/1 cup) plain yoghurt
— ¼ teaspoon salt

Crush the peppercorns and juniper berries together in
a mortar and pestle. Add the peppercorn and berry
mixture to a food processor together with the yoghurt
and salt and blitz together briefly to combine.

FETA CREAM

— 250 g (9 oz/1 cup) plain yoghurt
— 50 g (1¾ oz) creamy (Danish) feta
— ¼ teaspoon salt
— 1 tablespoon chopped chives
— pinch of white pepper

Briefly blitz all the ingredients together in
a food processor.

TAHINI, LEMON
& DILL

— 250 g (9 oz/1 cup) plain yoghurt
— zest and juice of 1 small lemon
— 1 tablespoon tahini
— 1 tablespoon chopped dill
— ¼ teaspoon salt

Briefly blitz all the ingredients together in
a food processor.

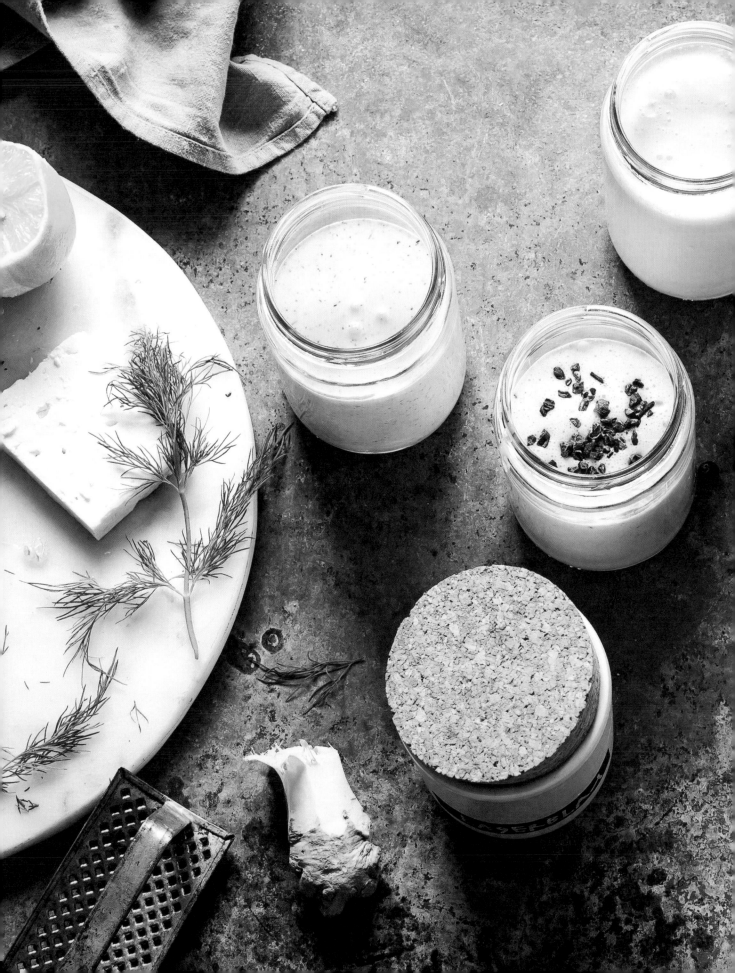

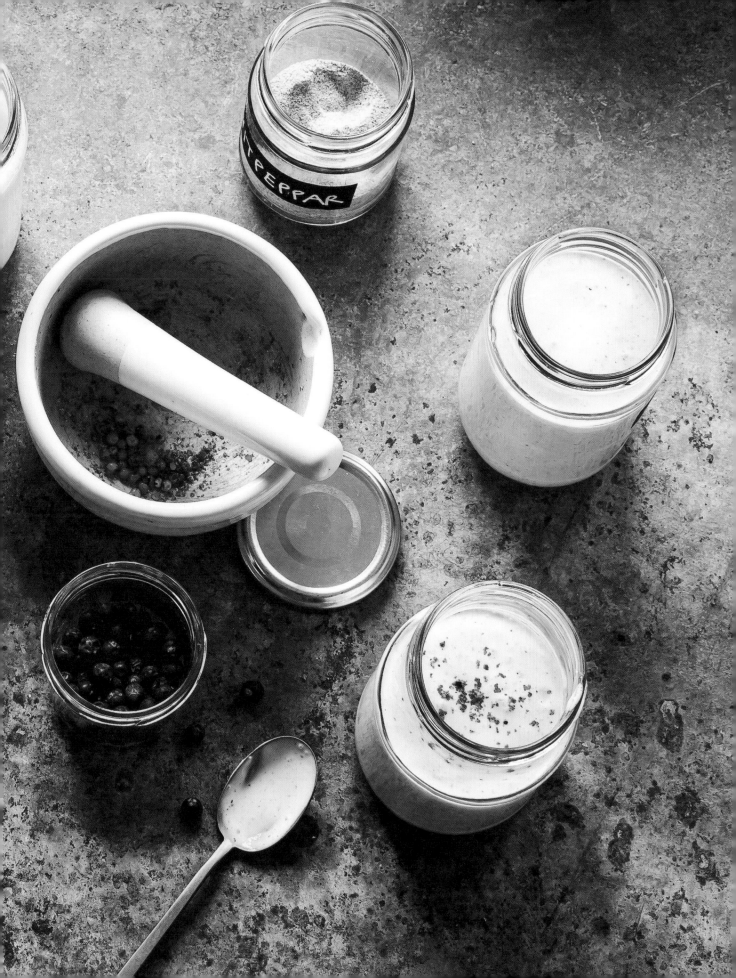

ZUCCHINI, GOAT'S CHEESE & YMERDRYS

Traditionally used in classical French cookery to remove bitterness from eggplants, degorging is the process of drawing moisture from a vegetable by applying salt. It can also be used to soften vegetables and give them a less raw texture, which makes it a great technique for those wanting to look at cooking their food less – here I have adapted it a little to do its thing in water before refreshing the zucchini and serving.

SERVES 4

PREPARATION TIME: 5 MINUTES PLUS SOAKING

Add the salt and half the lemon juice to a large bowl together with 1 litre (36 fl oz/ 4 cups) of water. Stir gently to dissolve the salt, then add the zucchini pieces and leave to degorge for 10 minutes.

Drain the water from the bowl and fill it again with very cold water (add a few ice cubes here if necessary). Leave the zucchini pieces to refresh for a further 10 minutes, then drain the water and pour over the oil and remaining lemon juice.

Divide the zucchini pieces between bowls, top with the *ymerdrys* and pepitas and crumble over the goat's cheese or feta. For a little extra sweetness, serve with some red cabbage chutney or a drizzle of honey.

— 1 tablespoon salt

— juice of 1 lemon

— 300 g (10½ oz) zucchini (courgette), cut into 4 mm (¼ in) matchsticks

— 1 tablespoon olive oil

— 100 g (3½ oz/1 cup) *Ymerdrys* (page 50)

— 50 g (1¾ oz/⅓ cup) toasted pepitas (pumpkin seeds)

— 100 g (3½ oz) goat's cheese or creamy (Danish) feta

— honey or Red Cabbage Chutney (page 191) to serve (optional)

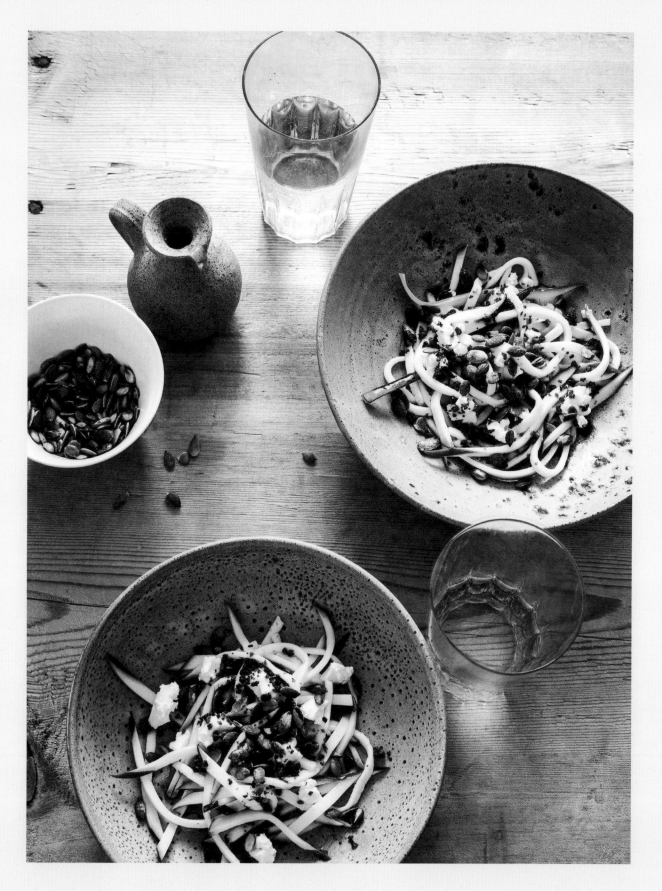

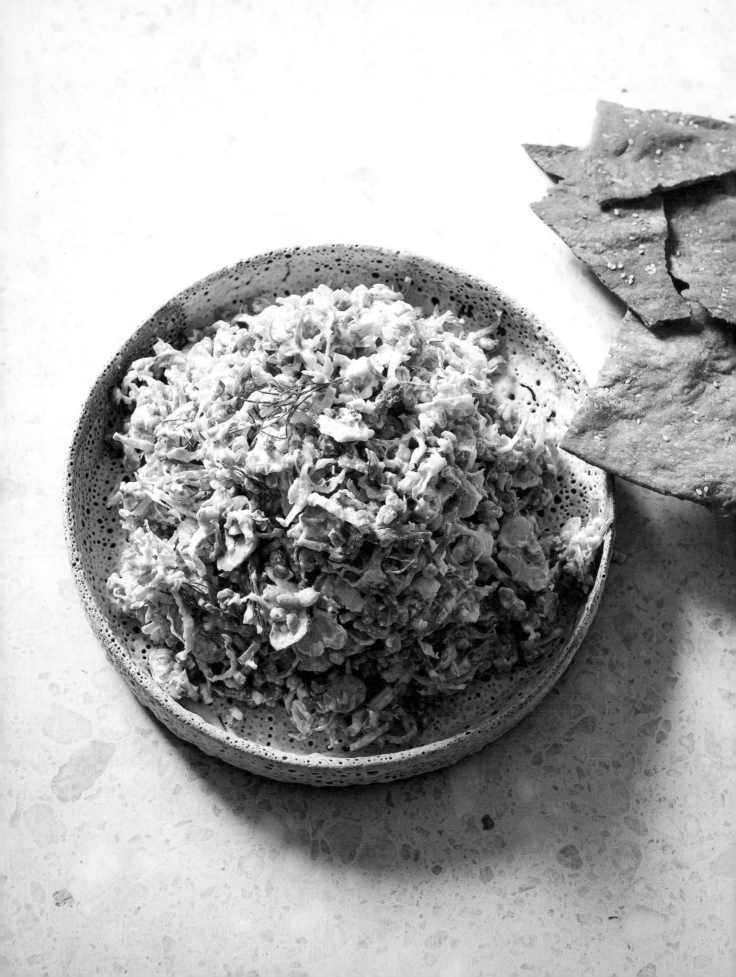

FARRO, CHESTNUT & BRUSSELS SPROUT SLAW

This makes either a lovely light meal on its own or a great accompaniment to other dishes. The chestnuts and farro have an earthiness about them that complements each other, while a sharp feta and yoghurt dressing balances this nicely.

You can serve this slaw straight after making, though I prefer it after a few hours once the sprouts have broken down a little and tenderised – or better still, the following day after being covered in plastic wrap and stored in the refrigerator.

SERVES 4

PREPARATION TIME: 10 MINUTES
COOKING TIME: 30 MINUTES

Add the rinsed farro grains to a saucepan together with a pinch of salt, pour over 1 litre (36 fl oz/4 cups) of water and bring to the boil over a high heat. Reduce the heat to low, cover with a lid and simmer for 25–30 minutes, until the farro grains are softened but still chewy. Drain off any liquid still remaining (you can save this and add it to the dressing for extra flavour), drizzle the olive oil over the farro and gently fluff up the grains with a fork.

Add the vinegar and salt to a large bowl together with 1 litre (36 fl oz/4 cups) of water. Shave the brussels sprouts into the water by gripping the stem end of each sprout with your fingers and using a mandoline to slice them as thinly as possible. Set aside.

Meanwhile, roast the chestnuts. Preheat the oven to 200°C (400°F/Gas 6). Make an x-shaped incision in the side of each chestnut with a serrated knife and place them on a baking tray or in a roasting tin. Roast for about 30 minutes, or until the skins crack open exposing the insides. Leave the chestnuts to cool before peeling off the skins and cutting the kernels into thin slices.

To assemble the salad, drain the liquid from the sprouts, pour over the dressing and toss to combine. Stir through the sliced chestnuts and berries and serve immediately, or transfer to the refrigerator and keep for up to 2 days to allow the flavours to develop. Serve with beetroot crispbread or Icelandic flatbread.

— 345 g (12 oz/1½ cups) farro, rinsed

— 1 tablespoon olive oil

— 2 tablespoons apple-cider vinegar

— 2 teaspoons salt

— 300 g (10½ oz) brussels sprouts

— 250 g (9 oz) chestnuts

— 185 ml (6½ fl oz/¾ cup) Feta Cream Dressing (page 111)

— 2 tablespoons dried cranberries or goji berries

— Beetroot Crispbread (page 57) or Icelandic Flatbread (page 53) to serve

QUINOA CAVIAR, FRESH CHEESE & GREEN SALAD

Quinoa has a great texture that works well in salads. You could bind this mixture with whisked egg to turn it into patties for cooking if you wanted to. I like to garnish this salad with edible flowers and dehydrated berries, but you could use currants or other finely chopped dried fruit instead.

SERVES 4

PREPARATION TIME: 5 MINUTES
COOKING TIME: 15 MINUTES

Put the beetroot juice in a saucepan over a high heat, add the salt and bring to a boil. Add the quinoa to the pan, cover with a lid and simmer over a medium–low heat for 15 minutes, or until the beetroot juice has been completely absorbed and the quinoa is tender. Remove from the heat, stir in the vinegar and set aside to cool slightly.

Mix the sugar and lemon juice together in a bowl until well combined. Add the red onion, mix again and set aside to macerate for 5 minutes, until the onion softens.

Divide the salad leaves between serving bowls. Crumble over the fresh cheese and top with the red onion and large spoonfuls of the quinoa. Drizzle over the elderflower vinaigrette and sprinkle over a few edible flowers and dehydrated berries to serve.

— 200 ml (7 fl oz) beetroot (beet) juice

— pinch of salt

— 150 g (5½ oz/¾ cup) quinoa, rinsed

— 2 teaspoons sherry vinegar

— 1 teaspoon caster (superfine) sugar

— juice of ½ lemon

— ½ red onion, very thinly sliced

— 2 baby cos (romaine) lettuces or 1 super-fresh butter lettuce head, leaves separated and washed

— 120 g (4½ oz/⅔ cup) Fresh Cheese (page 203)

— 2 tablespoons Elderflower Vinaigrette (page 127)

TO SERVE
— nasturtiums or daisies (optional)

— dehydrated berries

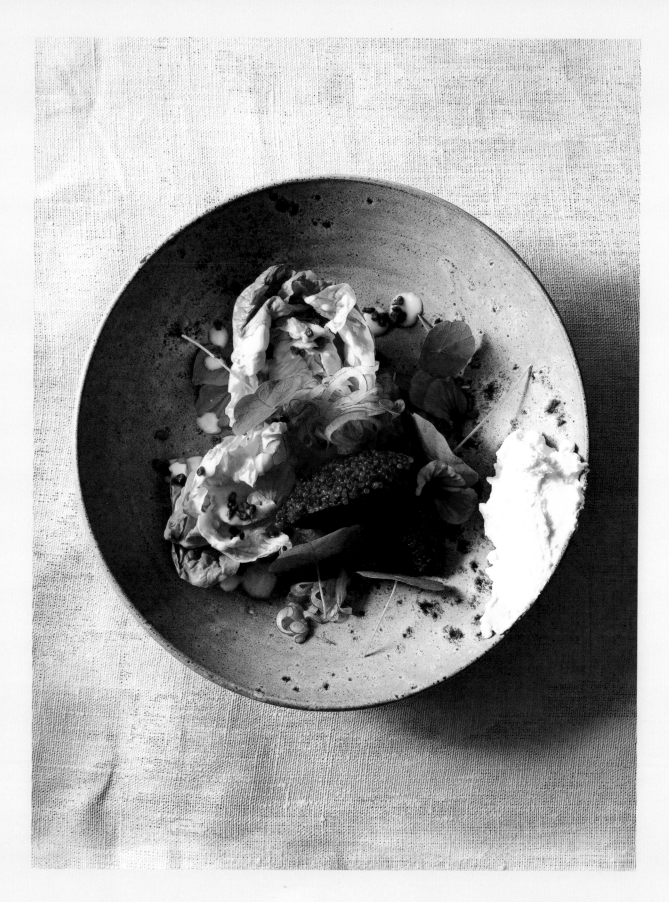

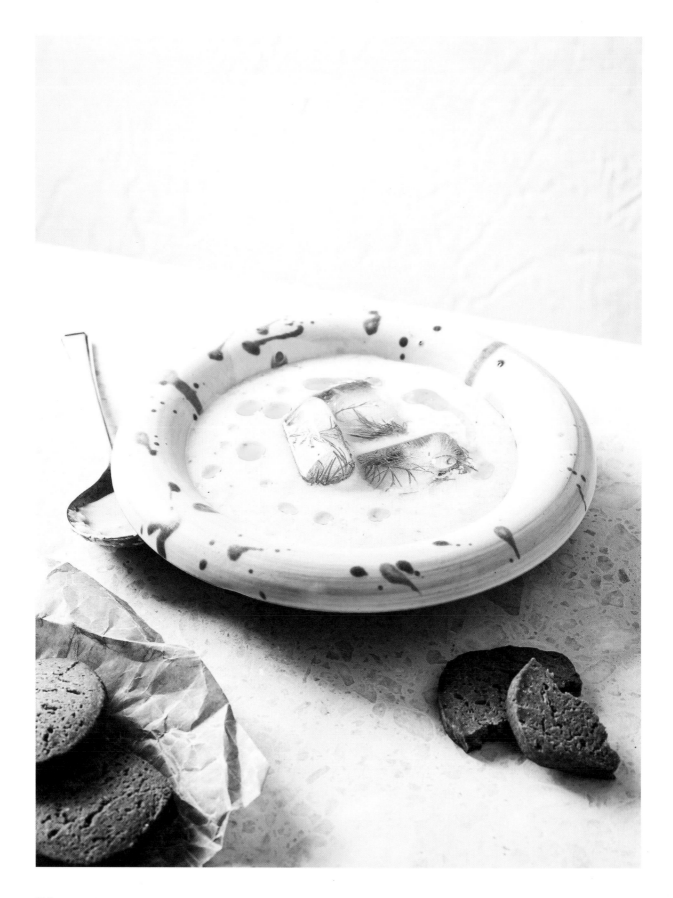

CUCUMBER & BUTTERMILK SOUP WITH CHICKPEA SHORTBREAD

I believe cold soups are underrated. There is no light meal more refreshing on a hot summer's day. Chervil, thyme, parsley and dill all make great herbs to freeze in the ice, though you can use any herb really, it serves to preserve them while adding a unique visual element. I discovered chickpea flour recently and love it – it's similar to quinoa flour in that it's very short and when combined with the oil it makes a beautiful savoury biscuit similar to shortbread.

SERVES 4

PREPARATION TIME: 15 MINUTES PLUS FREEZING
COOKING TIME: 20–25 MINUTES

To make the herb ice, simply place the herb leaves in the moulds of a couple of ice cube trays, cover with water and freeze until solid.

For the chickpea shortbread, mix together the chickpea flour, flour, spirulina, salt, white pepper, västerbotten and mint in a large bowl. Add the olive oil and combine with a whisk or fork, then gradually pour over 125 ml (4 fl oz/½ cup) of water, stirring with a wooden spoon as you go. Mix everything together with your hands to form a dough, adding a little extra water if necessary, then shape the dough into a log approximately 10 cm (4 in) in diameter. Wrap the dough up in plastic wrap, twisting the ends to seal, and chill in the refrigerator for 10 minutes.

Preheat the oven to 190°C (375°F/Gas 5). Line a baking tray with baking paper.

Unwrap the chilled dough and cut it into 1 cm (½ in) slices. Place the shortbread on the prepared baking tray and bake for 20 minutes, until they have cracked on top and are golden brown at the edges. Transfer to a wire rack to cool.

To make the soup, put the cucumber, buttermilk, white pepper and salt in a food processor and blitz together for a minute or so until smooth and aerated. Taste and adjust the seasoning as necessary.

To serve, divide the ice cubes between serving bowls, pour over the soup and drizzle over the rapeseed oil, if using. Serve with the chickpea shortbread.

— 1 handful chervil, thyme, parsley or dill leaves

— 2 telegraph (long) cucumbers, roughly chopped

— 500 ml (18 fl oz/2 cups) buttermilk

— ¼ teaspoon white pepper

— 1 teaspoon salt

— 1 tablespoon cold-pressed rapeseed oil (optional)

CHICKPEA SHORTBREAD

— 75 g (2¾ oz/½ cup) chickpea flour

— 150–225 g (5½–8 oz/1–1½ cups) plain (all-purpose) flour

— ½ teaspoon spirulina

— 1 teaspoon salt

— ⅛ teaspoon white pepper

— 25 g (1 oz) västerbotten cheese or other hard, salty cheese such as parmesan, grated

— 1 teaspoon dried mint

— 60 ml (2¼ fl oz/¼ cup) olive oil

SMOKED SALMON TAILS, CAULIFLOWER COUSCOUS & NIGELLA SEEDS

Being one of the oiliest parts of the salmon, smoked salmon tails have an intense flavour and are very moist. Smoked salmon tails may be tricky to find outside the Nordic countries but any hot-smoked salmon will work well here as a substitute. For the cauliflower couscous I like to use a purple cauliflower to give the dish a great visual impact, but it's not essential.

SERVES 4

PREPARATION TIME: 15 MINUTES
COOKING TIME: 5 MINUTES

Remove the stem and leaves from the cauliflower and place in a food processor. Pulse briefly, scraping down the sides of the processor as you go, until the texture resembles that of couscous or rice. Be careful not to over-mix it, you want an even texture (you may have to do this in batches).

Stir the fennel seeds through the cauliflower. You now have two options: you can either eat the cauliflower raw if you like – in which case add the lemon juice at this stage to help break it down a little – or you can cook the cauliflower and then chill it.

If cooking the cauliflower, heat the olive oil in a flameproof casserole dish over a medium heat. Add the cauliflower, cover with a lid and sauté for 5 minutes, uncovering and stirring regularly to allow for even cooking. Tip the cooked cauliflower into a bowl and transfer to the refrigerator for 10 minutes to cool.

When ready to serve, drizzle the rapeseed oil over the cauliflower. Squeeze over the lemon juice if you haven't already used it and season to taste with salt and pepper.

Divide the cauliflower between serving bowls. Top with the salmon tails or fillet and the apple slices, drizzle over the yoghurt dressing and scatter over the nigella seeds. Garnish with dill and serve with crispbreads.

— 800 g (1 lb 12 oz) whole coloured or regular cauliflower

— 1 teaspoon crushed fennel seeds

— juice of 1 lemon

— 1 teaspoon olive oil (optional)

— 1 tablespoon rapeseed oil

— 300 g (10½ oz) hot-smoked salmon tails or fillet

— ½ granny smith apple, peeled, cored and cut into thin slices

— 125 ml (4 fl oz/½ cup) Horseradish & Apple Yoghurt Dressing (page 111)

— 1 tablespoon nigella seeds or black sesame seeds

— dill, to garnish

— Linseed & Poppy Crisps (page 90) to serve

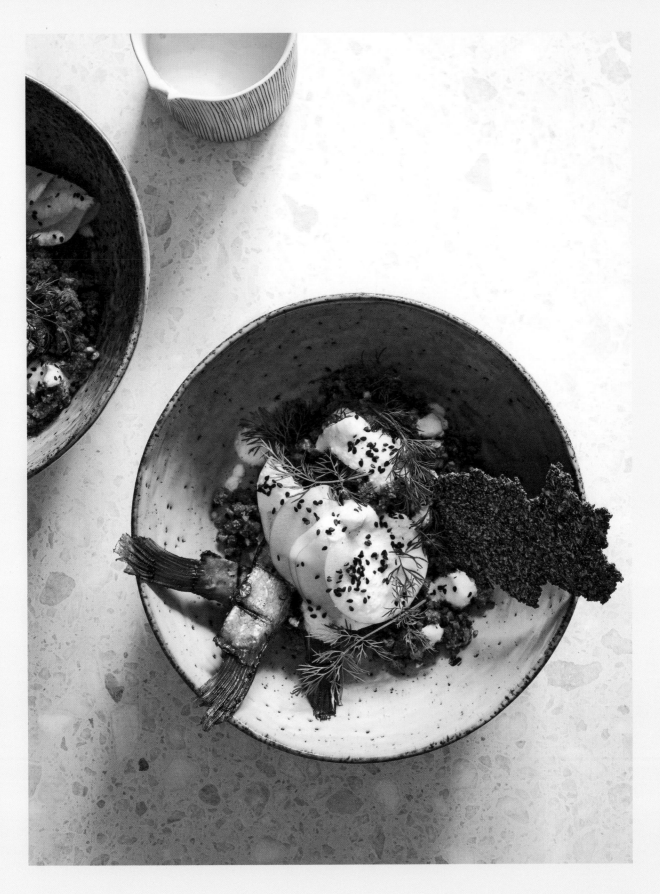

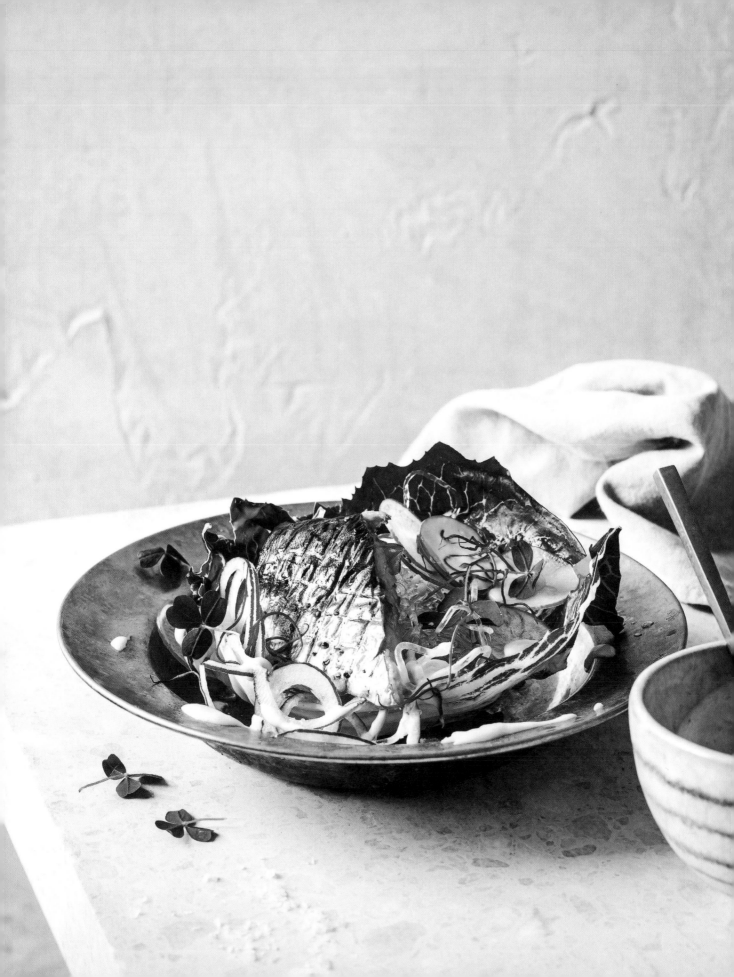

KELP NOODLES, MACKEREL, RADISH & ELDERFLOWER VINAIGRETTE

On a recent trip to Iceland I was surprised to see the popularity of these noodles, which are easy to prepare and are great for those suffering from gluten intolerances. While there aren't many food products that are commonly used in both Asia and Iceland, both places obviously share a greater appreciation of seaweed than the rest of the world. The elderflower vinaigrette is a wonderfully sweet dressing perfect for green salads – keep the excess in a sealed jar in the refrigerator and give it a shake before using.

SERVES 4

PREPARATION TIME: 10 MINUTES PLUS SOAKING
COOKING TIME: 5 MINUTES

Rinse the noodles under cold running water, then place them in a bowl filled with water and leave to soak for 10 minutes. Drain, then cut the noodles in half with kitchen scissors and add to a large bowl.

For the vinaigrette, whisk together all the ingredients, except the oil, in a small bowl to combine. Continue to whisk, adding the oil in a slow, steady stream, until the dressing is creamy and the oil is emulsified.

If using smoked fish, halve each fillet. If using fresh fish, coat the fillets in polenta and pan-fry over a medium heat in the oil for 1 minute on each side, until the polenta has formed a crunchy crust.

Add 2 tablespoons of the vinaigrette and the radishes to a large bowl with the noodles and toss together well. Season to taste with salt and pepper and add an extra tablespoon of vinaigrette, if you like.

Drain the radicchio leaves and divide them between serving bowls. Spoon the noodle and radish mixture between the radicchio 'cups' and top with the fish pieces. Scatter over a few redwood sorrel leaves to garnish and serve with crispbreads.

— 200 g (7 oz) kelp noodles

— 2 x 100 g (3½ oz) smoked mackerel fillets or 300 g (10½ oz) fresh mackerel or sardine fillets

— 75 g (2¾ oz/½ cup) fine polenta (if using fresh fish)

— 1 tablespoon rapeseed oil (if using fresh fish)

— 75 g (2¾ oz/½ cup) radishes, thinly sliced

— ½ radicchio head, leaves separated and placed in cold water

— redwood sorrel leaves to garnish

ELDERFLOWER VINAIGRETTE

— 100 ml (3½ fl oz) elderflower cordial

— 2 tablespoons apple-cider vinegar

— 2 teaspoons dijon mustard

— ¼ teaspoon salt

— 125 ml (4 fl oz/½ cup) rapeseed oil

SMOKED CHICKEN, CELERIAC & BUTTERMILK DRESSING

Smoked chicken breasts are lean, tasty and perfect for salads, sandwiches and soups as they retain moisture a lot better than regular cooked chicken breasts, which tend to dry out. Similarly to yoghurt, buttermilk gives a dressing a natural sourness as well as having the perfect creamy consistency for tossing through salads or vegetables. Here it breaks down the celeriac ever so slightly to make it more palatable, like the traditional French remoulade which uses mayonnaise to the same effect.

SERVES 4

PREPARATION TIME: 15 MINUTES

Add the salt and a squeeze of lemon juice to a bowl together with 1 litre (36 fl oz/ 4 cups) of water and stir to dissolve the salt.

Peel the celeriac and cut it in half lengthways. Using a mandoline or vegetable peeler, slice the celeriac pieces as thinly as possible into long ribbons and add to the bowl of acidulated water. Remove excess starch from the celeriac pieces by gently agitating them with your hands.

To make the dressing, put all the ingredients in a food processor and whiz together to combine. Season to taste with salt.

Drain the celeriac ribbons and return them the bowl together with the dressing, chicken slices, dates and herbs, then toss gently to combine. Drizzle over a little mustard seed caviar, if you like, and serve with crispbreads.

— 1 teaspoon salt

— squeeze of lemon juice

— ½ celeriac (about 400 g/14 oz)

— 2 x 200 g (7 oz) smoked boneless, skinless chicken breasts, cut into 1 cm (½ in) thick slices

— 5 pitted dates, finely sliced

— 1 small handful flat-leaf parsley

— 1 small handful dill

— Mustard Seed Caviar (page 198) to serve (optional)

BUTTERMILK DRESSING

— 125 ml (4 fl oz/½ cup) buttermilk

— 125 g (4½ oz/½ cup) Greek-style yoghurt

— 1 tablespoon apple-cider vinegar

— ¼ teaspoon white pepper

— 1 teaspoon nutritional yeast

— ½–1 teaspoon finely grated fresh ginger, to taste

— 1 teaspoon honey

— juice of ½ lemon

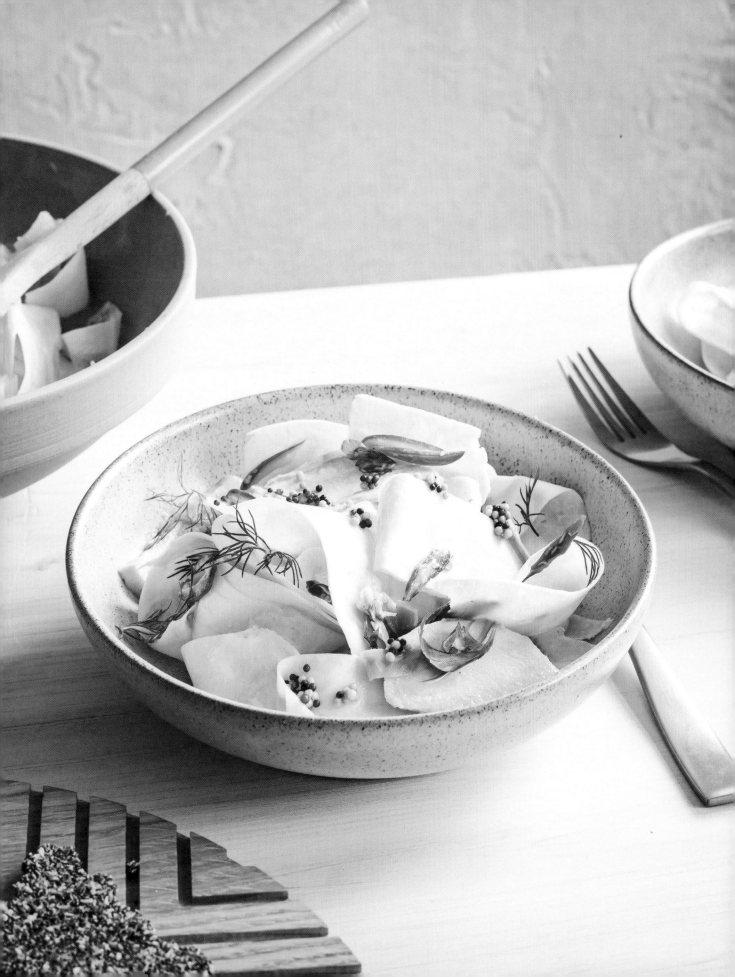

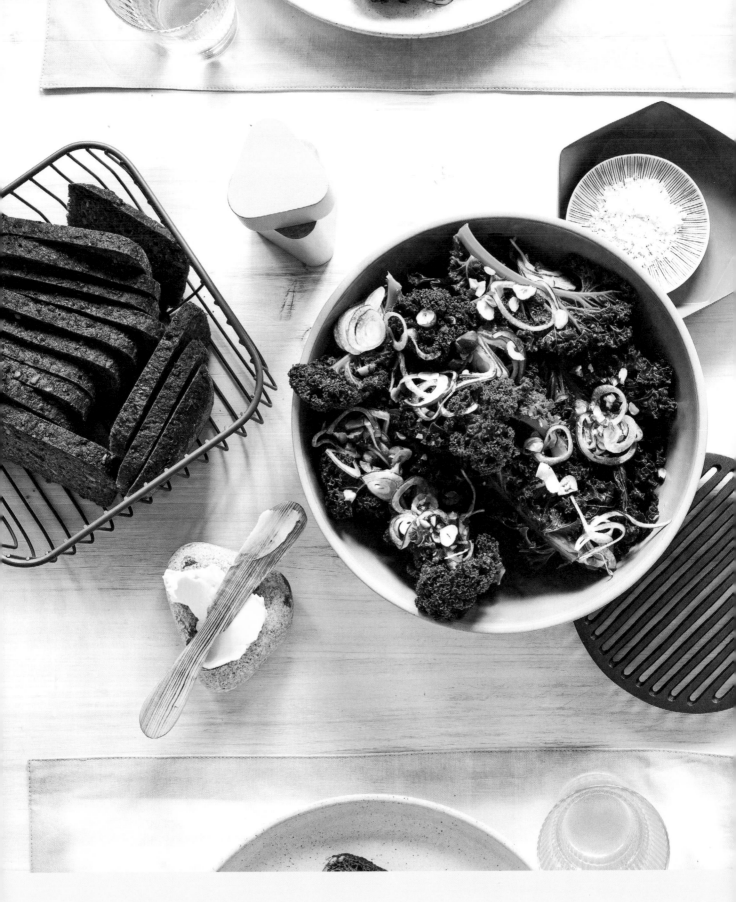

CHAPTER SIX

FOOD FOR MANY

It would be a shame to let a healthier agenda get in the way of sensory celebration with family and friends. For me such gatherings create the best food memories. The recipes ahead aim to give you this with a nod to the North, while attempting to avoid the rich, failsafe ingredients we usually bring to the dining table on such occasions. It seems silly to make food for many individual serves, so many of the dishes are share plates or sides to share.

Almost all Nordic celebrations offer up a buffet known in other countries as *smörgåsbord*. Because the assortment is normally so large, the offering is rarely on the actual dining table but at another table nearby where you take as many visits as you want to fill your plate. It's a great way to eat as it frees up space on the table... for more drinks perhaps! And quite often it prompts some fun banter about the number of visits and choice of food each person takes. If cooking for many I recommend you try it with recipes from the chapter ahead.

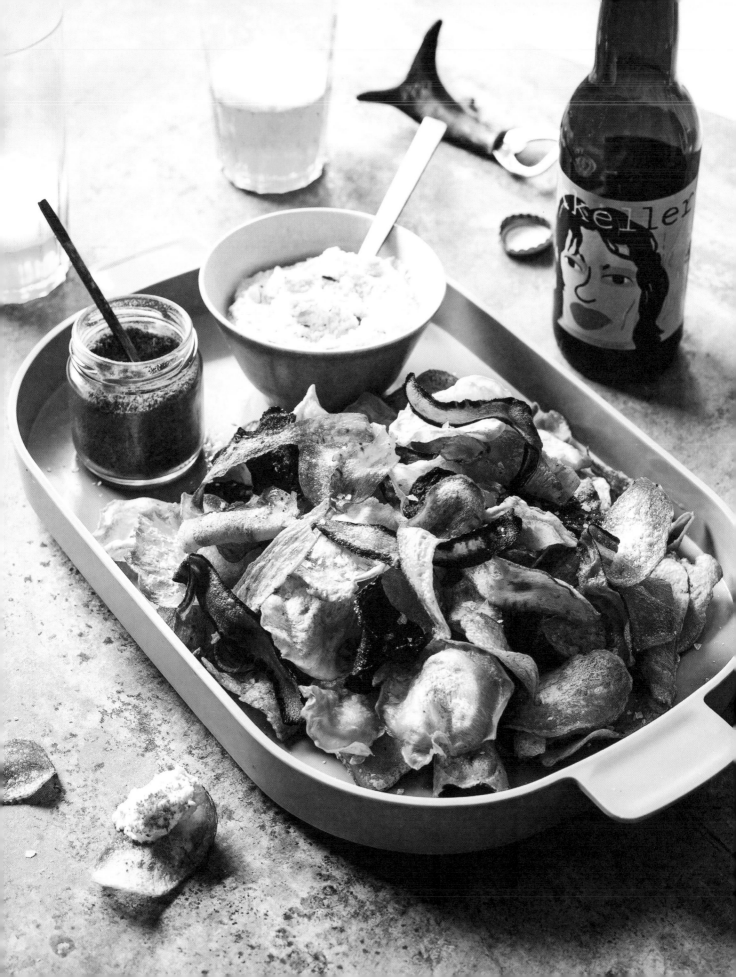

VEGGIE CHIPS WITH HORSERADISH CREAM & BOTTARGA

Although bottarga is essentially a Mediterranean product, the compressed salted fish roe has a yeasty, salty, fishy flavour that is very Scandinavian. Like most products of this nature it's important to use it sparingly and balance it with other flavours. Speaking of which, while I know deep-frying is not a healthy way of cooking – even if it is root veggies – sometimes exceptions have to be made. Life is all about balance, after all.

SERVES 8

PREPARATION TIME: 30 MINUTES
COOKING TIME: 10 MINUTES

Peel the veggies then slice them very thinly into long strips using a mandoline.

Half-fill a large heavy-based saucepan or fryer with oil and heat until the temperature reaches 180°C (350°F), or until a cube of bread browns in 30 seconds.

Carefully lower the veggies into the hot oil in batches and fry for 3–4 minutes, turning halfway during cooking, until the veggies are floating on the surface of the oil and the bubbling has reduced to almost nil. Transfer to paper towel to drain off the excess oil and sprinkle generously with sea salt.

Put the horseradish cream in a shallow dish and place the bottarga in a separate bowl or small jar for the guests to add at will. Serve the veggie chips alongside the horseradish cream for dipping. If you find the chips crack under the weight of the cream, then simply spoon a little on top of each chip.

— 2 parsnips

— 2 carrots

— 2 beetroot (beets)

— 1 sweet potato

— 2 potatoes

— sunflower oil, for deep-frying

— sea salt flakes

— 250 g (9 oz/1½ cups) Horseradish Cream (page 25)

— 2 teaspoons grated bottarga

ONION & CIDER SOUP

Sweet, soft onions are so underrated! The bitter taste from charring the onions and the yeasty cider are welcome additions to this classic soup.

SERVES 6

PREPARATION TIME: 5 MINUTES
COOKING TIME: 1 HOUR 15 MINUTES

In a large heavy-based saucepan, sauté the sliced onions in the butter over a low–medium heat until soft and brown – this can take up to 45 minutes, lowering the heat towards the end. Add the cider to deglaze the pan, then add the salt and stock, bring to a simmer and cook, covered, for 30 minutes.

Meanwhile, heat a chargrill pan or cast-iron frying pan until almost smoking. Turn your ventilation up as high as possible or open your window, as this will get quite smoky. Halve the remaining whole onion, leaving the skin intact, and place the halves, cut side down, in the pan. Cook for 5–8 minutes, or until the flesh is blackened and charred and the centre of the onion is soft. Remove the onion from the pan and leave to cool, then peel off the skin and separate the onion layers into petals.

To serve, divide the soup between serving bowls, top each with a few of the onion petals and garnish with a few tarragon sprigs.

— 1 kg (2 lb 4 oz) onions, halved and thinly sliced, plus 1 extra whole onion

— 150 g (5½ oz) unsalted butter, cut into cubes

— 375 ml (13 fl oz/1½ cups) dry cider

— 1½ teaspoons sea salt

— 1.5 litres (54 fl oz/6 cups) Vegetable Stock (page 190)

— tarragon sprigs to garnish

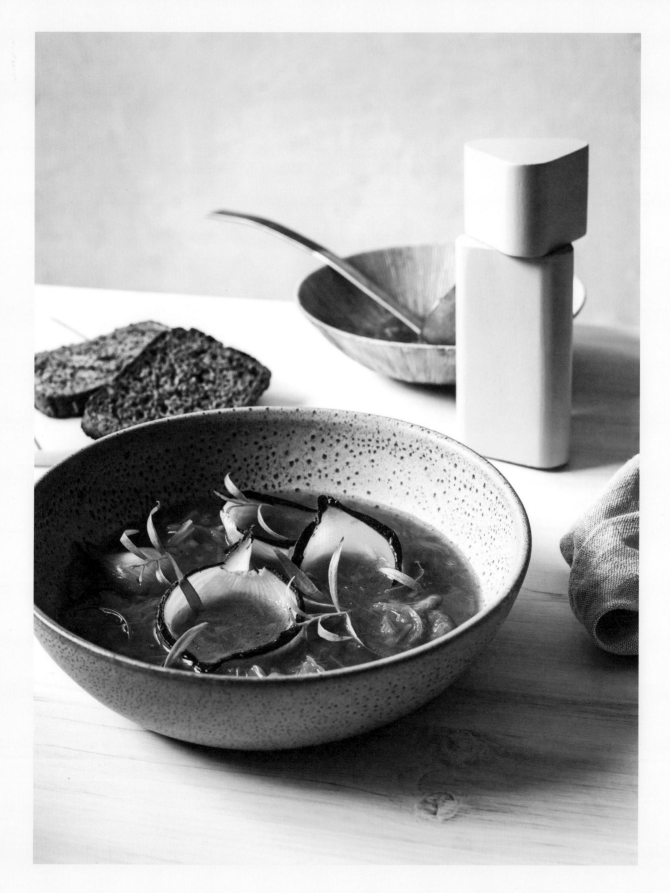

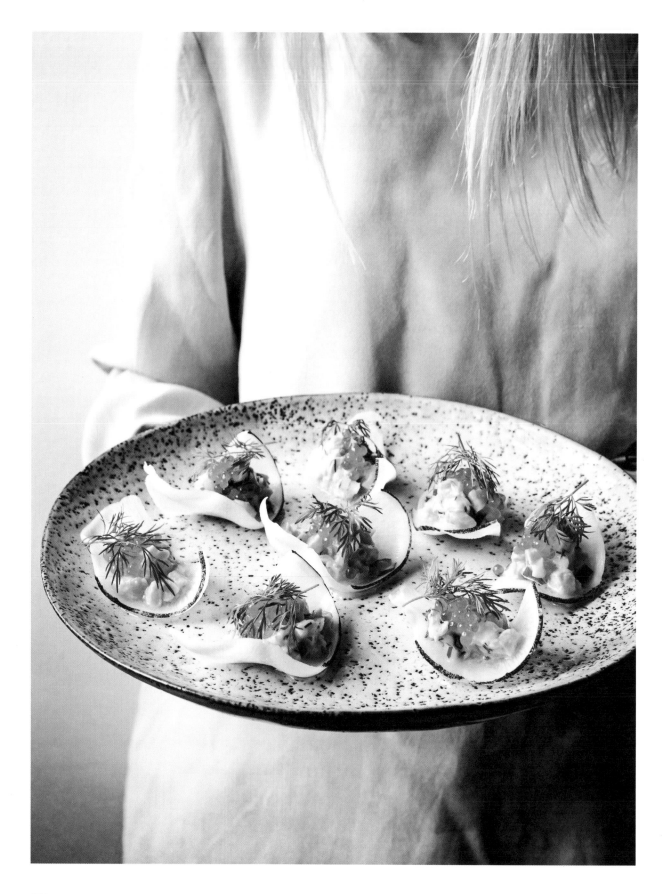

BLACK RADISH, SALMON & DILL TARTARE

Similar to the lunch plate recipe on page 80, this is essentially macerated fish with some crisp, watery vegetable, and is perfect as an appetiser. Black radishes have a similar texture to kohlrabi that is full of water and crunch when refreshed in icy cold water, though they also have a great peppery kick.

SERVES 8

PREPARATION TIME: 20 MINUTES

Add the lemon juice and salt to a large bowl filled with cold water and stir to dissolve the salt. Using a mandoline, slice the radish halves into the water in very thin discs. Leave the slices to sit in the water for about 20 minutes, until they begin to curl up at the corners.

Meanwhile, mix together the onion, lime juice and sugar in a separate bowl. Leave to sit for 5 minutes. Add the salmon pieces, dill and rice milk and stir together to ensure everything is well mixed.

Remove one of the radish discs from the water and place a teaspoonful of the tartare in its centre. Add a small amount of roe or caviar on top and garnish with a few dill sprigs, then transfer to a serving platter. Repeat with the remaining ingredients until you've run out of tartare – any left-over radish slices can be saved in the water to make a crispy, peppery salad later. Enjoy with a glass of Champagne.

— juice of ½ lemon

— 1 tablespoon salt

— 1 black radish (about 200 g/7 oz), trimmed and halved lengthways

— ½ red onion, finely diced

— juice of 1 lime

— 1 teaspoon granulated sugar

— 250 g (9 oz) salmon fillet, cut into 5 mm (¼ in) cubes

— 1 tablespoon chopped dill, plus extra sprigs to garnish

— 2 tablespoons rice milk

— 2 tablespoons salmon roe or caviar

BUCKWHEAT POLENTA, SHALLOT GRAVY & BEETROOT

This is a hearty winter bowl, perfect for a cold night. The earthy buckwheat and lemon zest make for a delicious flavour contrast, while any leftovers of the gravy can be used with meats. If you can't find broken or 'cracked' buckwheat groats, use whole ones and crush them with a pestle and mortar after toasting or give them a quick spin in a food processor instead.

SERVES 6

PREPARATION TIME: 15 MINUTES
COOKING TIME: 35 MINUTES

To make the beetroot salad, using a mandoline or vegetable peeler, shave the beetroot as thinly as possible into a large bowl of cold water. Mix the remaining ingredients together in another large bowl to make a dressing. Drain the beetroot slices, then add them to the bowl with the dressing and stir through. Set aside.

Preheat the oven to 170°C (340°F/Gas 3½).

For the shallot gravy, heat the butter and oil in a heavy-based casserole dish, add the shallots and sauté over a medium heat for about 4 minutes, or until the shallots are starting to soften. Add the grated carrot and cook for 2–3 minutes until soft, then add the flour and a pinch of salt. Cook, stirring, for 30 seconds or so to toast the flour slightly, then pour over the wine, stock and vinegar and add the thyme. Cover with a lid, reduce the heat to low and leave to simmer for 30 minutes.

While the gravy is cooking, make the polenta. Put the buckwheat groats in an ovenproof dish or on a baking tray lined with baking paper and toast in the oven for 5 minutes. Add the vegetable stock, a good pinch of salt and 1 litre (36 fl oz/ 4 cups) of water to a large saucepan and bring to the boil, then add the toasted groats and cook for 12 minutes. Whisk in the polenta and cook for 5 minutes more, stirring regularly (watch out as it can spit), until thick and creamy. Stir in the lemon zest, cheese and milk, remove from the heat and season to taste.

To finish the gravy, remove the lid and simmer for 5 minutes or so, until thickened and reduced.

To serve, spoon the polenta into bowls and pour over the gravy, then top with the mushrooms and sumac. Serve with the beetroot salad.

Ingredients

- 160 g (5¾ oz) cracked buckwheat
- 1 litre (36 fl oz/4 cups) Vegetable Stock (page 190)
- 175 g (6 oz/1 cup) instant polenta
- zest of 1 lemon
- 100 g (3½ oz) västerbotten or other hard salty cheese, grated
- 400 ml (14 fl oz) milk

SHALLOT GRAVY

- 30 g (1 oz) butter
- 1 tablespoon rapeseed oil
- 500 g (1 lb 2 oz) shallots, peeled
- 2 carrots, grated
- 2 tablespoons plain (all-purpose) flour
- 250 ml (9 fl oz/2 cups) spiced red wine or regular red wine
- 250 ml (9 fl oz/2 cups) Vegetable Stock (page 190)
- 2 tablespoons balsamic vinegar
- 4 thyme sprigs

POLKA BEETROOT SALAD

- 600 g (1 lb 5 oz) polka or chioggia beetroot
- 6 thyme sprigs, leaves stripped
- 4 tablespoons apple-cider vinegar
- 2 tablespoons olive oil
- 1 teaspoon each fennel and cumin seeds, toasted and ground

TO SERVE

- 150 g (5½ oz) chestnut mushrooms, thinly sliced
- 1 tablespoon sumac

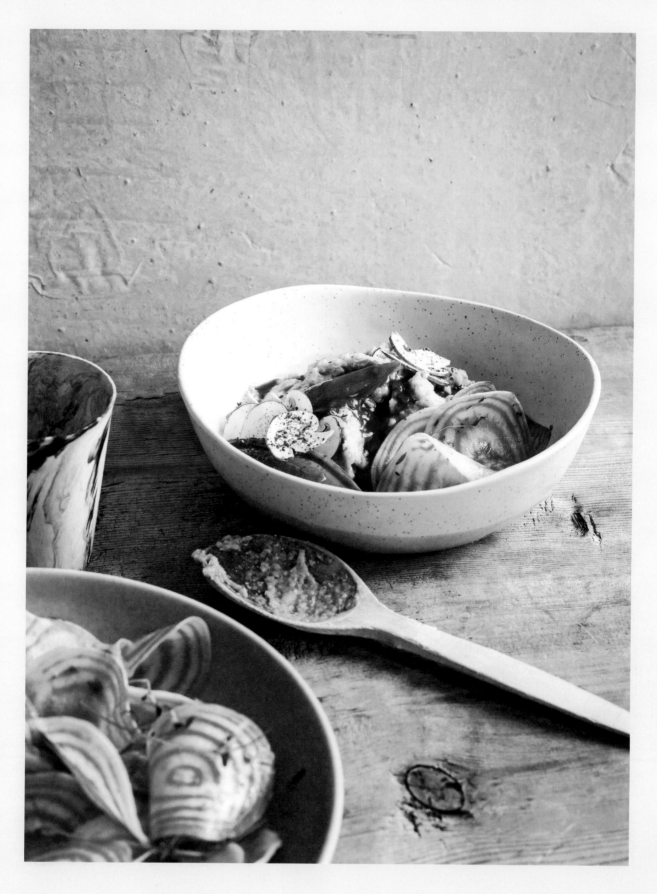

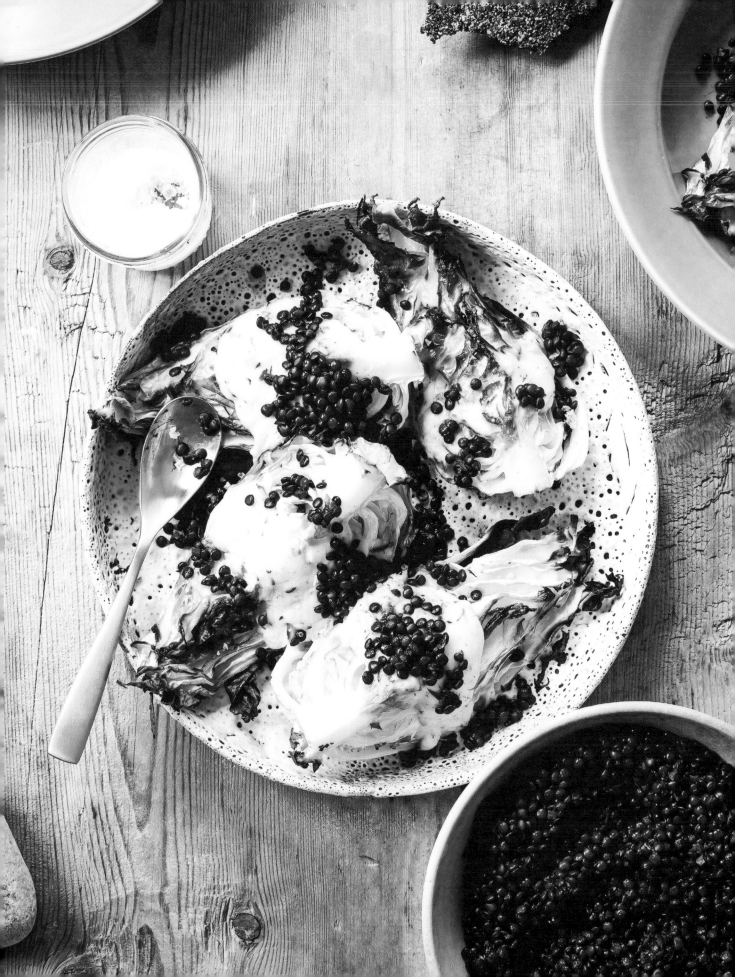

BAKED POINTED CABBAGE, BELUGA LENTILS & SMOKED CHEESE

It's great that high-end restaurants are now offering up things like cabbage wedges as a main course. That was un-imaginable in the past. Pointed cabbage, also known as hispi or sweetheart cabbage, is a sweet, soft cabbage perfect for roasting. This can be eaten as a main or served as a side to meat dishes.

SERVES 6

PREPARATION TIME: 20 MINUTES
COOKING TIME: 45 MINUTES

Preheat the oven to 200°C (400°F/Gas 6).

Crush the juniper berries together with the salt in a pestle and mortar. Arrange the cabbage wedges on a baking tray, brush with the oil and sprinkle over the juniper–salt mix. Roast the cabbage wedges in the oven for 30 minutes, turning them over 20 minutes into cooking.

While the cabbage is roasting, prepare the lentils and the smoked cheese sauce. Add the lentils to a saucepan together with the salt and 500 ml (18 fl oz/2 cups) of cold water, bring to a boil and cook for 20 minutes until soft (I like them nutty and al dente, but if you prefer them cooked more, add a little water towards the end and cook a little longer). Drain and return to the pan together with the oil and shallots. Stir through the vinegar, cover with a lid and keep warm.

For the cheese sauce, combine the butter and flour in a separate heavy-based saucepan over a low heat, to form a roux. Whisk in the milk and continue to cook over a low simmer, whisking all the while, for 8–10 minutes, or until the sauce has thickened. Stir through the cheese and set aside.

Once the cabbage has cooked for 30 minutes, remove it from the oven and spoon over half of the cheese sauce. Return to the oven and cook for a further 10 minutes, until the sauce is lightly golden in places.

Remove the wedges from the oven and arrange on a serving platter. Top with a generous scattering of the lentils and serve with bowls of the lentils and cheese sauce for extra helpings.

— 3 dried juniper berries

— 1 teaspoon salt

— 2 x 500 g (1 lb 2 oz) pointed cabbage heads, each cut into 4 wedges

— 2 tablespoons rapeseed oil

LENTILS

— 200 g (7 oz/1 cup) dried beluga (small black) lentils, rinsed

— 1 teaspoon salt

— 1 tablespoon extra-virgin olive oil

— 3 shallots, finely diced

— 2 tablespoons best-quality balsamic, sherry or raspberry vinegar

SMOKED CHEESE SAUCE

— 20 g (¾ oz) salted butter

— 20 g (¾ oz) plain (all-purpose) flour

— 500 ml (18 fl oz/2 cups) milk

— 100 g (3½ oz) smoked cheese such as gouda or cheddar

GRILLED FENNEL, ROASTED BLACK BEANS & JAFFA DRESSING

I have always loved fennel and orange together and the bitterness of the cacao nibs in the yoghurt dressing makes this work, even though it does sound odd! Roasted beans are delicious, and make a great salted snack on their own.

SERVES 6

PREPARATION TIME: 15 MINUTES PLUS OVERNIGHT SOAKING
COOKING TIME: 30 MINUTES

Add the black beans to a saucepan filled with water and bring to the boil. Boil for 45 minutes, or until cooked through, then drain.

Meanwhile, add the fennel pieces to another large pot of boiling water and boil until soft, about 8–10 minutes. Drain and return to the pot and stir through the garlic and 1 tablespoon of olive oil. Season with salt and pepper. Set aside.

Preheat the oven to 180°C (350°F/Gas 4). Line a baking tray with with baking paper.

Pat the drained black beans with a clean tea towel (it's important to remove as much water as possible without crushing them) and spread them over the prepared baking tray in a single layer. Drizzle over 2 tablespoons of olive oil and mix it through evenly, then season with salt and pepper. Bake for 20 minutes, or until the beans have split and you can see them foaming. Remove from the oven and leave to cool on the tray.

Heat up a chargrill pan or plate over a high heat until smoking. Brush the fennel with some oil and grill for 5 minutes on each side.

Arrange the fennel wedges on a serving platter, top with the roasted beans and blood orange segments and spoon over the yoghurt dressing.

— 250 g (9 oz) dried black beans, soaked in water overnight then drained

— 2–3 whole fennel bulbs (about 800 g/1 lb 12 oz), each cut into 6 wedges

— 1 garlic clove, thinly sliced

— 3 tablespoons olive oil

— 1 blood orange, peeled and segmented

— 1 x Jaffa Yoghurt Dressing (page 111)

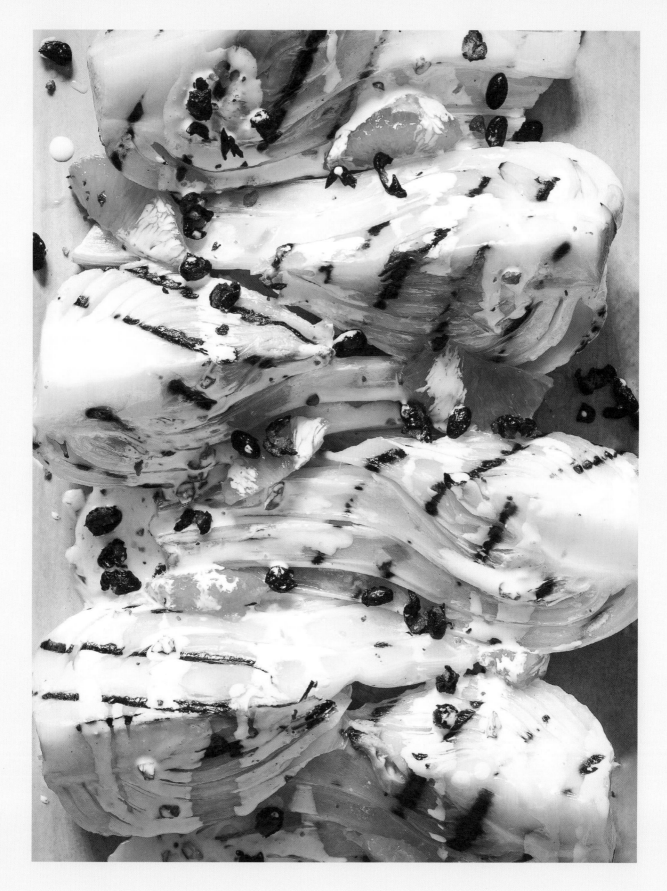

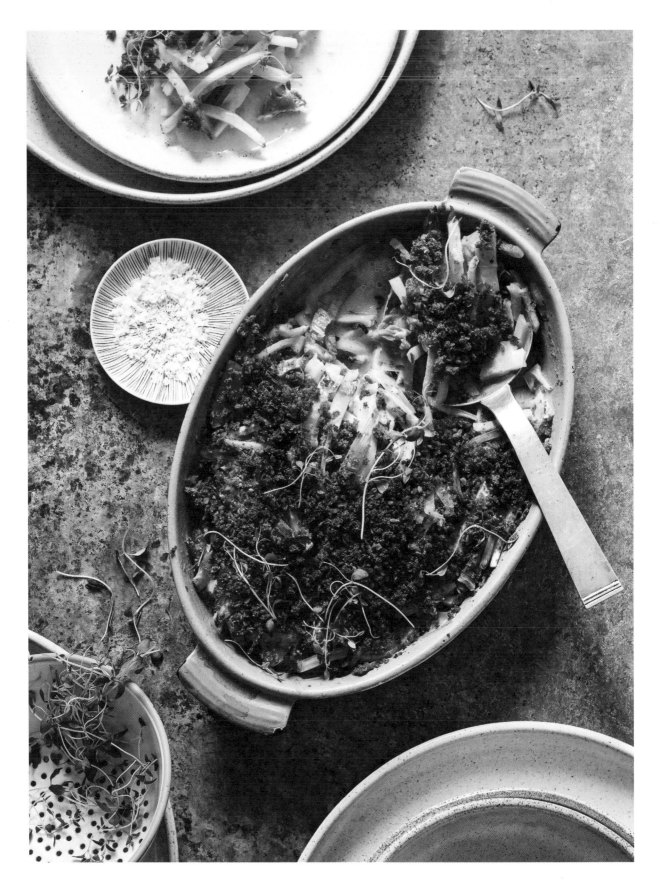

HAM HOCK & ROOT VEGETABLE FRESTELSE

Ham hock is a great product that seems to sit in the shadows. It's full of flavour and is very versatile – the closest thing you'll find to those pre-prepared slow cooked pulled meats, but without any of the nasty additives. Janssen's *frestelse* (also known in English as Janssen's Temptation) is a classic Swedish dish that cooks matchstick potatoes with Nordic anchovies and cream. It's delicious. With a similar form, this dish is a little nod to that. This will make two large trays, so it can be easily halved if making for fewer people. It keeps well and tastes even better reheated.

SERVES 8

PREPARATION TIME: 35 MINUTES
COOKING TIME: 1 HOUR 30 MINUTES

Preheat the oven to 200°C (400°F/Gas 6).

Peel all the vegetables, except the leek, and cut into matchsticks. This is easily done using a food processor fitted with a julienne disc, a mandoline or another slicing device. Cut the leek into 2 cm x 8 cm (¾ in x 3¼ in) batons.

For the white sauce, combine the butter and flour in a large heavy-based saucepan over a low heat to form a roux. Whisk in the milk and continue to cook over a low simmer, whisking all the while, for 8–10 minutes, or until the sauce has thickened. Add the nutmeg.

Pour the white sauce into a bowl and stir in the ham pieces, garlic, mustard seeds, salt and pepper. Add the vegetable pieces and mix together well, then divide the mixture between two 20 cm x 15 cm (8 in x 6 in) roasting tins.

Cover the tins tightly with foil and bake for 1 hour, then remove from the oven and discard the foil. Top with the breadcrumbs and knobs of butter, return to the oven and bake for a further 20–30 minutes – it's ready when the veggies are soft and the breadcrumbs are golden. To serve, place the dishes in the centre of the table and top with some fresh herbs.

— 2 parsnips

— 200 g (7 oz) salsify

— 200 g (7 oz) celeriac

— 200 g (7 oz) beetroot

— 300 g (10½ oz) potatoes

— 200 g (7 oz) turnip

— ½ leek, white part only

— 300–350 g (10½–12 oz) smoked ham hock meat, shredded

— 2 garlic cloves, finely diced

— 1 teaspoon mustard seeds

— 1½ teaspoons salt

— pinch of white pepper

— 50 g (1¾ oz/½ cup) rye breadcrumbs or regular breadcrumbs

— 50 g (1¾ oz) salted butter

— 2 handfuls roughly chopped thyme or parsley to serve

WHITE SAUCE

— 40 g (1½ oz) unsalted butter

— 45 g (1¾ oz) plain (all-purpose) flour

— 1 litre (36 fl oz/4 cups) milk

— ½ teaspoon freshly grated nutmeg

RYE TART WITH CHARD, ROE & SUNNY-SIDE EGGS

This dish is perfect for plonking in the middle of the table. Just make sure your share has a bit with the oozy egg yolk and lots of salty exploding roe – delicious! If you find that the centre of the tart has lost too much moisture during baking, serve it together with the Tahini, Lemon & Dill Yoghurt Dressing on page 111.

SERVES 6

PREPARATION TIME: 1 HOUR
COOKING TIME: 45 MINUTES

For the tart base, put the ingredients together with 120 ml (4 fl oz/½ cup) of ice-cold water in the bowl of a stand mixer or food processor with the dough hook attachment added. Mix together to form a smooth dough, adding a little extra water if the dough is looking a little crumbly.

Roll the dough out on a sheet of plastic wrap into a 10 cm x 20 cm (4 in x 8 in) rectangle. Cover with a second layer of plastic wrap, seal the edges and transfer to the refrigerator for 20 minutes to rest.

Preheat the oven to 180°C (350°F/Gas 4).

While the pastry is resting, cook the chard in batches. Heat a third of the olive oil in a large frying pan over a medium heat. Add a third of the chard, leek and garlic, season with salt and sauté for 4 minutes, or until wilting. Remove the mixture from the pan and set aside, then repeat the process twice more with the remaining chard, leek, garlic and oil. Set aside.

Take the pastry from the refrigerator, remove the top layer of plastic wrap and flip it over onto a sheet of baking paper. Wait 5 minutes for the dough to become workable, then, working quickly, roll it out into a rectangle approximately 20 cm x 35 cm (8 in x 14 in).

Spread the chard and leek mixture over the centre of the tart base, leaving a border of about 6 cm (2½ in) from the edges and leaving behind any moisture that may have leached from the wilted chard. Fold over the edges roughly and bake for 40 minutes. Crack over the eggs, return to the oven and bake for a further 5 minutes, until the eggwhites have just set. To serve, top with the roe and accompany with a simple green salad.

- 600 g (1 lb 5 oz) chard (or a mixture of chard, silverbeet and kale), chopped
- 2 tablespoons olive oil
- 1 leek, middle-third only, thinly sliced
- 2 garlic cloves, finely sliced
- 4–6 eggs
- 4 tablespoons salmon roe

TART BASE
- 250 g (9 oz/2½ cups) rye flour
- 220 g (8 oz/1½ cups) plain (all-purpose) flour, plus extra for dusting
- 1 teaspoon salt
- 1 teaspoon dill or fennel seeds, toasted and ground
- 150 g (5½ oz) unsalted butter

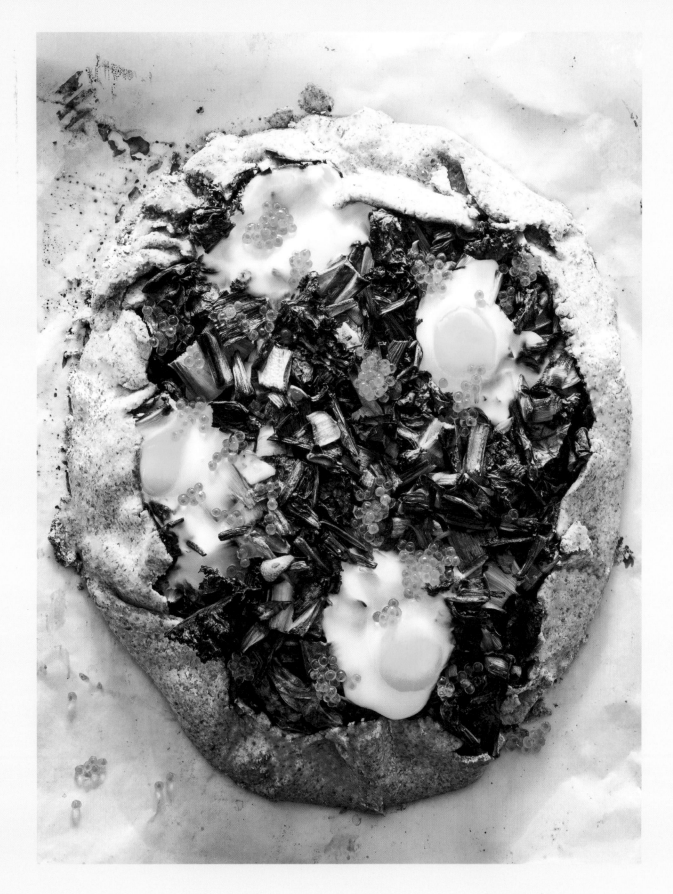

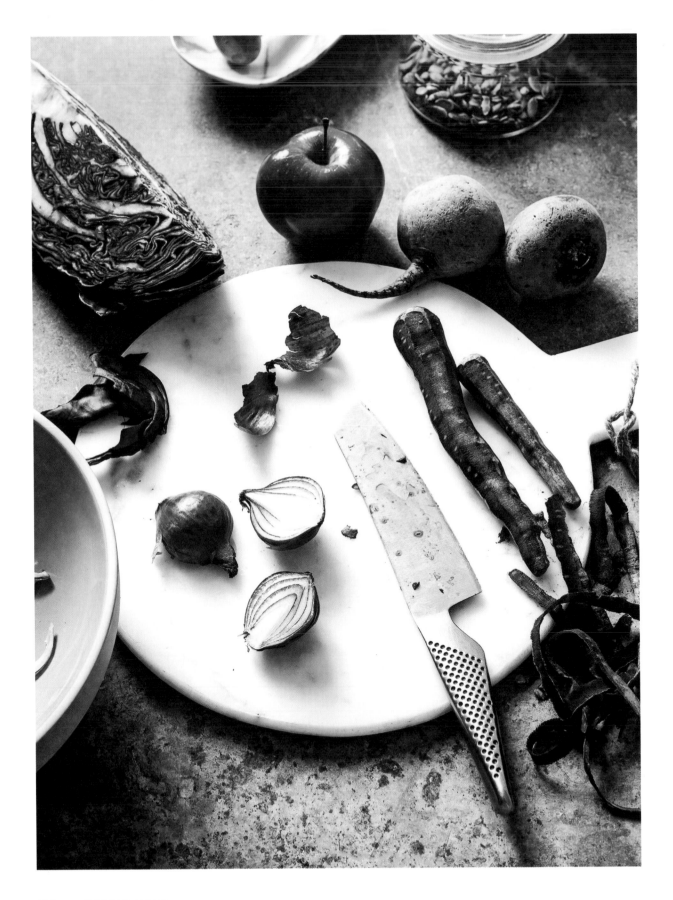

ONE-SIDED SALMON WITH AUTUMN SLAW

I love this dish because it gives you the best two flavours of salmon.

You get that almost raw, delicate flavour from the undercooked pink flesh as well as that concentrated fishy flavour from the crispy, oily base. It's so simple and quick and you can serve it with any side you like.

Because salmon has such an intense flavour compared to most fish, in Nordic countries it's often paired with ingredients other fish wouldn't be seen near. I suggest you get creative with your salmon pairings – go crazy.

SERVES 6

PREPARATION TIME: 40 MINUTES
COOKING TIME: 10–15 MINUTES

To make the slaw, mix together the yoghurt, honey, mustard, vinegar and herbs in a large bowl. Add the prepared vegetables and apple and mix thoroughly, then set aside at room temperature to allow the vegetable pieces to soften and the flavours to meld together.

Heat the oil in a large frying pan over a medium heat. Lay the salmon fillet carefully into the pan (depending on the size of your pan you may have to halve the fillet to fit) and cook for 1 minute, then reduce the heat to low and leave for 10–15 minutes, until cooked through to your liking. If you would like the top section a little more cooked without drying out the bottom you can place a lid over the frying pan, leaving it slightly ajar, to slightly steam the top of the salmon as it cooks for the last 5 minutes (I like to cook a 1.4 kg/3 lb fillet for 15 minutes, covering it slightly at the end as described).

To serve, place the salmon on a large serving platter. Scatter the toasted sunflower kernels and pepitas over the slaw and accompany with lime wedges for people to help themselves.

— 1 tablespoon rapeseed oil

— 1 x 1–1.4 kg (2 lb 4 oz–3 lb) skinless salmon fillet

— 2 limes, cut into wedges

AUTUMN SLAW

— 125 g (4½ oz/½ cup) plain yoghurt

— 1 tablespoon honey

— 2 tablespoons dijon mustard

— 1 tablespoon apple-cider vinegar

— 3 tablespoons chopped flat-leaf (Italian) parsley

— 1 tablespoon chopped dill

— 400 g (14 oz) celeriac, peeled and julienned or grated

— 2 carrots, peeled and julienned or grated

— 400 g (14 oz) red cabbage, very thinly sliced

— 1 medium beetroot (beet), peeled and grated

— 1 small red onion, thinly sliced

— 1 large red apple, peeled, cored and very thinly sliced

— 2 tablespoons toasted sunflower kernels

— 2 tablespoons toasted pepitas (pumpkin seeds)

MUSSELS, BROWN BUTTER, DILL & APPLE

In this simple dish, the sweetness and nuttiness of brown butter complements the pure, salty flavour of mussels beautifully, while the apple-cider vinegar does a great job of replacing the traditional lemon juice. Try to hunt down the best quality vinegar you can find – the cloudy, uglier, unpasteurised variety being better than the crystal clear kind as it retains its nutrients.

SERVES 6

PREPARATION TIME: 5 MINUTES
COOKING TIME: 5–8 MINUTES

Discard any broken mussels, or open ones that don't close when tapped on the bench. Scrub and pull out the hairy beards and rinse well. When cooked, discard any unopened mussels.

Melt the butter in a heavy-based saucepan and cook for 2–3 minutes, until it is foaming, turning brown and you can smell a nutty aroma. Remove the pan from the heat and transfer it to a cold surface to stop the cooking. The butter will continue to cook in the pan, so if you feel like it is getting too dark, pour it into another vessel. Set aside.

Heat the oil and shallots in a lidded pot over a low–medium heat until the shallots are translucent and slightly soft, about 4 minutes. Add the mussels, vinegar and sea salt, increase the heat to the high, cover with the lid and cook for 3 minutes. Give the pot a good shake to try and bring those mussels that are at the bottom of the pot to the top and cook for a further 3 minutes. Once almost all the mussels have opened, stir through the brown butter, dill and apple and cook for 30 seconds more. Serve immediately with a good lager and some dark rye bread.

- 2 kg (4 lb 8 oz) blue mussels
- 150 g (5½ oz) unsalted butter
- 2 tablespoons rapeseed oil
- 4 shallots, finely diced
- 3 tablespoons apple-cider vinegar
- 1 tablespoon sea salt flakes
- 3 tablespoons chopped dill
- 1 granny smith apple, peeled, cored and grated

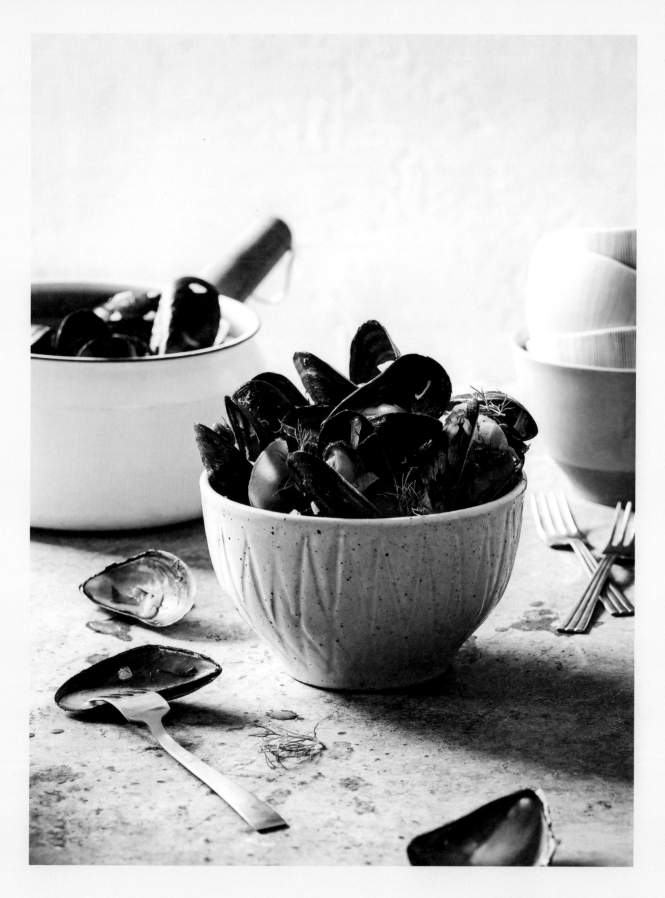

MILK POACHED CHICKEN, APPLE, TARRAGON & HAZELNUTS WITH CAVOLO NERO & BARLEY

Relatively speaking, chicken is not widely consumed in the Nordic countries, at least not in comparison to places like the Americas and Australasia. While the combination of tarragon and chicken is a classic one, I love to add to it here with the typical Nordic pairing of hazelnuts and apples. Mustard seed caviar (see page 198) makes a great accompaniment to this.

SERVES 6

PREPARATION TIME: 20 MINUTES PLUS SOAKING
COOKING TIME: 20 MINUTES

Preheat the oven to 180°C (350°F/Gas 4). Spread the hazelnuts on a baking tray and bake for 6 minutes, or until the skins are dark brown and beginning to split. Tip the nuts off the tray onto a clean tea towel and rub gently in the tea towel to remove the skins. Leave to cool, then roughly chop and set aside.

For the salad, add the drained barley to a large saucepan of boiling water and cook for about 35 minutes, until tender.

While the barley is cooking, poach the chicken. Heat the milk in a saucepan over a medium heat together with the tarragon stems, garlic and apple until just simmering. Lower the chicken breasts into the poaching liquid and return to a simmer, then lower the heat to 80–90°C (176–194°F) or until the milk is just steaming. Leave to poach for 15–18 minutes, then remove the chicken breasts from the poaching liquid and wrap them in foil. Strain the poaching liquid and set it aside.

Add the cavolo nero to a saucepan with a steamer inserted, cover and steam for 2 minutes. Drain and refresh with cold water, then chop into quarters and set aside.

When the barley is cooked, drain it and refresh it under cold running water, then tip it into a bowl and stir through the vinegar and oil. Add the cavolo nero, sunflower kernels and mulberries or raisins and toss together. Season with salt to taste.

Shred the chicken into long strands with your hands and transfer to a serving platter. Spoon over 250 ml (9 fl oz/1 cup) of the poaching liquid and top with the hazelnuts, apple slices and tarragon (and a little mustard seed caviar, if you have some on the go). Serve with the barley and cavolo nero salad.

— 70 g (2½ oz) hazelnuts

— 750 ml (27 fl oz/3 cups) milk

— 1 bunch tarragon, leaves stripped and stems reserved

— 1 garlic clove, thinly sliced

— 2 large green apples, 1 cored, peeled and diced, 1 cored and thinly sliced

— 4 x 200–250 g (7–9 oz) boneless, skinless chicken breasts

— Mustard Seed Caviar (page 198) to serve (optional)

CAVOLO NERO & BARLEY SALAD

— 190 g (7 oz/1 cup) sorghum barley, soaked for at least 3 hours then drained

— 100 g (3½ oz) cavolo nero (black kale)

— 3 tablespoons apple-cider vinegar

— 3 tablespoons extra-virgin olive oil

— 2 tablespoons toasted sunflower kernels

— 40 g (1½ oz/⅓ cup) dried white mulberries or raisins, chopped

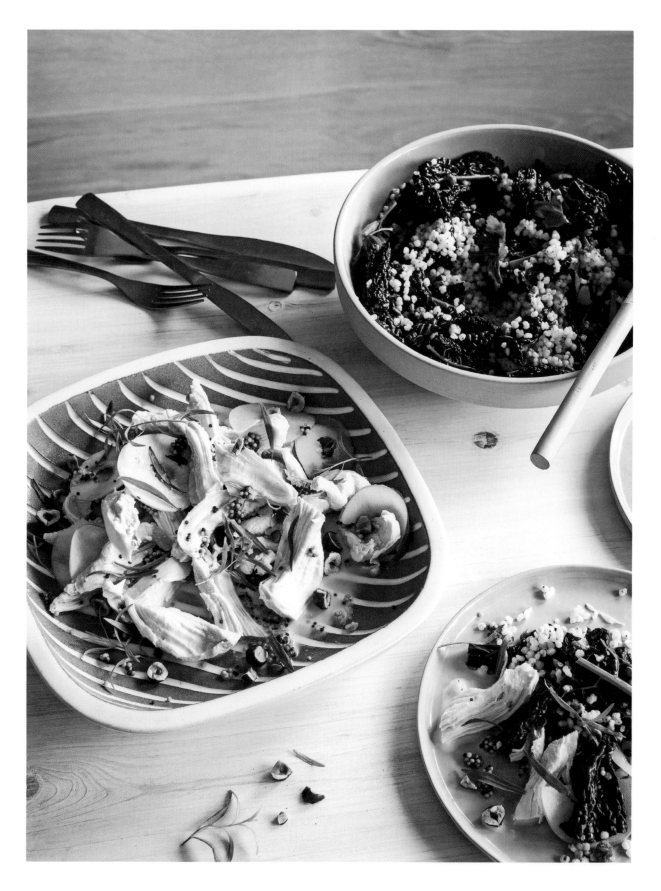

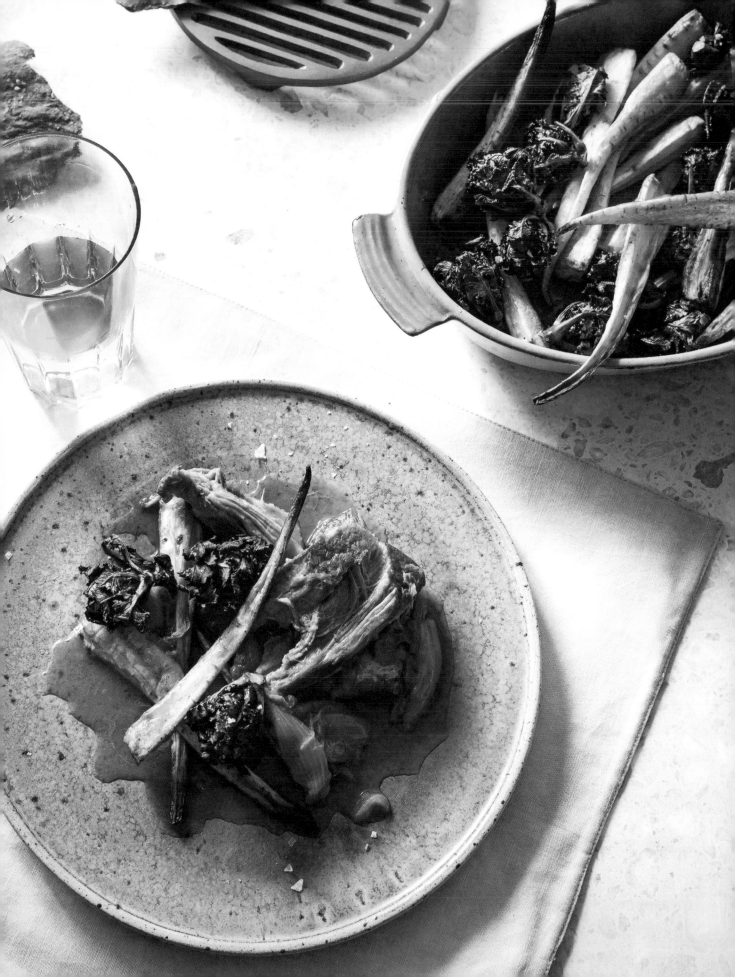

RHUBARB BRAISED PORK, ROASTED PARSNIPS & FLOWER SPROUTS

I love a pot roast lamb shoulder with vinegar and onions but this does the same thing, the natural acidity of the rhubarb providing the perfect match for this delicious slow-roast pork. Pair it with the earthy parsnips and serve it with Rosehip Ketchup or Mustard Seed Caviar (pages 196 and 198), if you like. Similar to brussels sprouts (although a lot less dense) flower sprouts (also known as rosetti sprouts) roast well, giving a result similar to roasted kale or cabbage wedges, both of which make good substitutes.

SERVES 6

PREPARATION TIME: 20 MINUTES
COOKING TIME: 1 HOUR 30 MINUTES

Preheat the oven to 180°C (350°F/Gas 4) and season the pork shoulder generously with salt and pepper.

Heat the rapeseed oil in a large frying pan, add the pork shoulder and brown on all sides. Transfer the browned pork to a large casserole dish together with the rhubarb, onions, garlic, paprika and salt. Cover the dish first with foil and then the lid and cook in the oven for 40 minutes.

Remove the casserole from the oven, uncover and remove the foil. Turn the pork shoulder over and give the rhubarb and onion mixture a stir through. Re-cover, return to the oven and cook for another 40 minutes, or until the pork is tender, juicy and falling apart.

While the pork is cooking, toss the parsnips, sprouts, oil and nutmeg together in a bowl to coat. Add to a roasting tin and roast in the oven for the final 30 minutes of the pork cooking time.

To serve, use a pair of forks to separate the pork meat into shreds. Divide the shredded meat between serving plates, spoon over the pork cooking juices and the rhubarb and onion mixture and serve with the roasted veggies.

- 1 x 800 g (1 lb 12 oz) boneless pork shoulder

- 1 tablespoon rapeseed oil

- 400 g (14 oz) rhubarb stalks, cut into thirds

- 2 red onions, peeled and cut into eighths

- 3 garlic cloves, thinly sliced

- ½ teaspoon smoked paprika

- ½ teaspoon salt

PARSNIPS & FLOWER SPROUTS

- 6–8 small parsnips (600 g/1 lb 5 oz), peeled and quartered lengthways

- 100 g (3½ oz) flower sprouts or 200 g (7 oz) brussels sprouts, halved

- 1 teaspoon rapeseed oil

- ¼ teaspoon freshly grated nutmeg

CHAPTER SEVEN

AFTER
DINNER

I am happy to confess I have a sweet tooth. It's fair to say I was born with it, my grandmother made the best chocolate hedgehog known to man which, somehow, even managed to age well, like her – she lived to 102! My other grandparents had the Southern hemisphere's best selection of Swiss-made slabs adorning the top shelf of their pantry and they weren't reserved for special occasions. Well, I guess every night is special...

Making desserts without sugar sounds like a tall order, but it is possible. I don't care for artificial sweeteners so it's over to honey, fresh and dried fruits and natural syrups to do the job. They can be surprisingly dynamic, and, while nothing can replicate a French parfait or an Italian pannacotta made with cream and caster sugar, for example, there is fun to be had in trying. How about silken tofu to help set an oat milk parfait? It proved surprisingly effective, without altering the taste, in the recipe that follows.

The inventiveness of raw chefs doesn't need to stop at the genius that a frozen banana can offer, there has to be more. There is more – go find it!

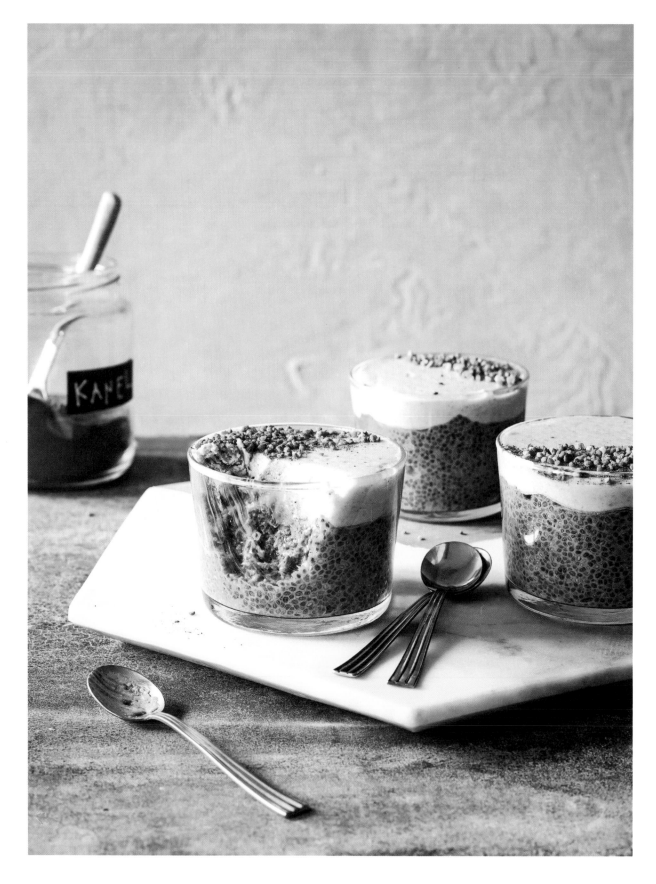

CARROT CAKE
CHIA PUDDING

Carrot cake has to be my favourite traditional Swedish cake. This recipe brings together all the same flavours in an easy-to-make, delicious dessert.

SERVES 6

PREPARATION TIME: 10 MINUTES PLUS SETTING

Put the chia seeds in a bowl, add the carrot juice, spices, honey and coconut cream and stir together, then leave to soak for 10 minutes. Stir together again, then spoon the chia seed mixture into six 200 ml (7 fl oz) serving glasses.

To make the icing, put all the ingredients together in a small food processor and blend together well.

Top the chia puddings with the icing and chill in the refrigerator for 3 hours to set. Sprinkle over the bee pollen and dust with cinnamon before serving.

- 165 g (5¾ oz/1⅓ cups) chia seeds
- 500 ml (18 fl oz/2 cups) carrot juice
- ½ teaspoon ground cardamom
- ½ teaspoon ground cinnamon, plus extra to serve
- 1 tablespoon honey
- 300 ml (10 fl oz) coconut cream
- 2 tablespoons bee pollen to serve

ICING (FROSTING)
- 40 g (1½ oz) unsalted butter
- 100 g (3½ oz) cream cheese
- 70 g (2½ oz/½ cup) walnuts
- 2 teaspoons lemon juice
- 2 tablespoons honey

HASSELBACK APPLES, FROZEN CHESTNUT CREAM & DRUNK MULBERRIES

Many consider cinnamon to be the king of Nordic baking but in actual fact it's cardamom that sits quietly on the throne. It's often included without mention in the cinnamon buns that Sweden has become famous for and it takes the classic buttery shortbread to the next level. At Christmas it can be found in hot wine and, really, I reckon it deserves to be everywhere – it's delicious. It goes particularly well with chocolate, coffee, pears and apples. Hasselback potatoes are a Swedish classic where the incisions on the top of the potatoes give them a distinctive crispy texture – here they open up the apples for quicker cooking and provide a place for the topping to melt into.

SERVES 6

PREPARATION TIME: 20 MINUTES PLUS FREEZING
COOKING TIME: 35 MINUTES

Place the mulberries in a bowl together with the the aquavit and sugar. Stir to dissolve the sugar and set aside (the longer these are left, the more they will absorb the flavour and soften – so it's best to prepare them a few hours ahead).

Line a 900 g (2 lb) loaf tin with plastic wrap.

For the chestnut cream, whip the cream in a mixing bowl until soft peaks form. Whisk in the dulce de leche and chestnut purée and continue to beat until fully combined. Spoon the mixture into the prepared loaf tin and freeze for at least 1 hour, or until set.

Preheat the oven to 180°C (350°F/Gas 4).

Core and peel the apples, being careful not to split them, then cut each apple in half. Cutting to a depth of about 2 cm (¾ in), thinly slice the apple halves on the round side crossways along their length as closely together as possible.

Place the apple halves in an ovenproof dish, add a splash of water and cover with foil. Bake for 10 minutes, then remove them from the oven, discard the foil and drain off any liquid.

Mix together the ground almonds, butter, cardamom, oats and honey in a bowl and spread the mixture over the apples, then return them to the oven and bake for a further 20–25 minutes, until the almond coating is browned.

Remove the frozen chestnut cream from the freezer and slice into portions with a warmed knife. Divide the slices between bowls, top each with a hasselback apple and spoon over the drunk mulberries.

- 3 large pink lady apples
- 2 tablespoons ground almonds
- 50 g (1¾ oz) unsalted butter, at room temperature
- 1 teaspoon cardamom seeds, crushed (open the pods to remove the seeds inside)
- 30 g (1 oz) rolled (porridge) oats
- 1 tablespoon honey

FROZEN CHESTNUT CREAM

- 500 ml (18 fl oz/2 cups) thick cream (double/heavy)
- 300 g (10½ oz/1 cup) dulce de leche
- 240 g (9 oz/1 cup) unsweetened chestnut purée

SOAKED MULBERRIES

- 50 g (1¾ oz) dried white mulberries
- 75 ml (2½ fl oz) spiced aquavit
- 1 tablespoon soft brown sugar

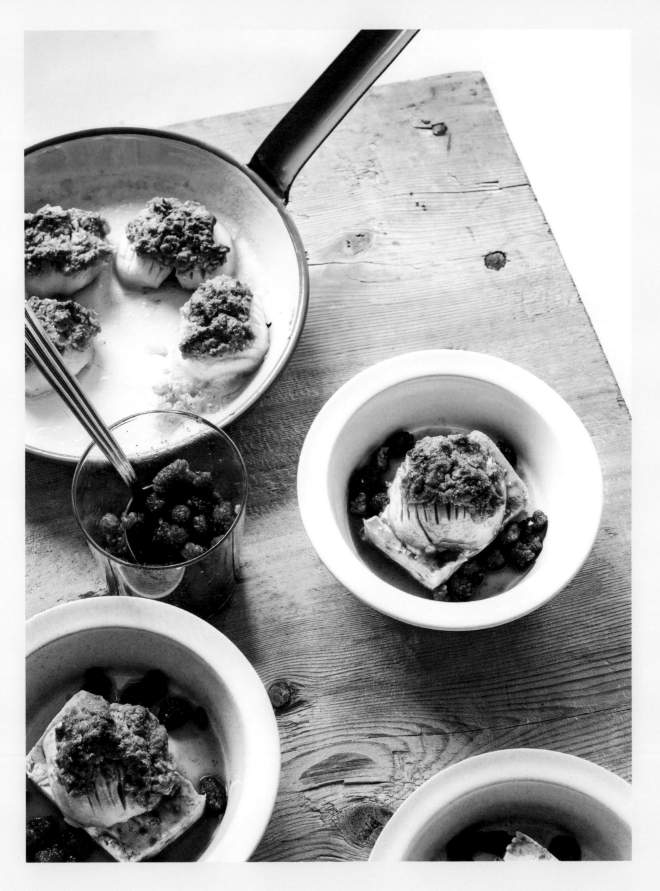

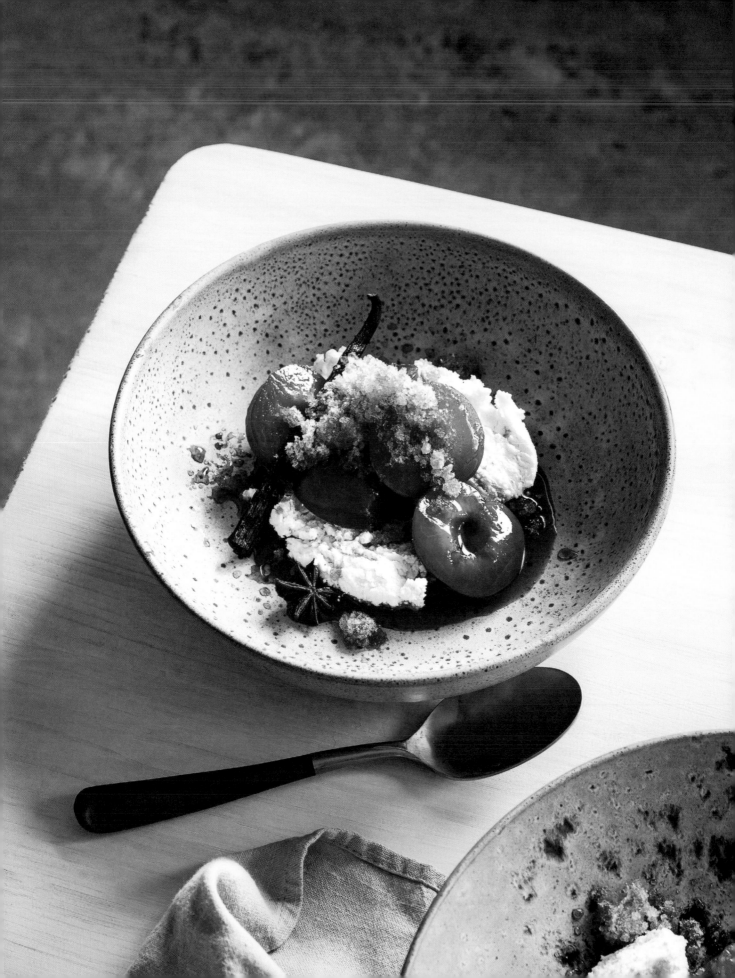

CHRISTMAS SPICED PLUMS, RICOTTA & COFFEE ICE

There's something very Nordic about the smell of Christmas spices, when cloves, star anise, cardamom and cinnamon come together to create that distinct aroma. These spices feature in mulled wine, which is a treat in the cold but has its uses in the kitchen too – as a marinade for meat, for example, or for poaching fruits for a dessert as here.

You could always replace the ricotta with mascarpone or vanilla ice cream in this recipe but I do like how the savoury ricotta balances the sweetness of the poached plums. Left-over plums can be kept in the syrup and served with yoghurt and granola.

SERVES 6

PREPARATION TIME: 30 MINUTES PLUS FREEZING
COOKING TIME: 30 MINUTES

For the coffee ice, pour the coffee into a bowl, add the honey and stir to dissolve. Soak the gelatine leaf in a bowl of ice-cold water for a couple of minutes, then remove and squeeze out the excess water. Whisk the leaf into the warm coffee mixture until dissolved.

Pour the mixture into a large, flat dish to a depth of no more than 3 cm (1¼ in), cover with plastic wrap and place in the freezer. Make a note of the time and move on to preparing the poached plums.

Warm the wine, honey, star anise and vanilla seeds in a saucepan over a medium heat. Add the plums and bring to a simmer, then reduce the heat to low and cook, covered, for 20–25 minutes, or until soft. (The ripeness of the plums will dictate how long this takes – you want them to be soft but not falling apart.) Transfer the plums and stones to a bowl using a slotted spoon and reduce the poaching liquid, over a medium heat, by half.

After 45 minutes, check on the coffee ice – as soon as it starts to solidify around the edges, stir it with a fork, mixing the solid ice into the liquid. Repeat this process about every half an hour until you have a light cloud of crystals.

When you're ready to serve, mash the ricotta a little with the back of a fork to soften it and scrape the surface of the ice to create 'snow'. Spoon the ricotta into bowls and top with the plums, reduced poaching liquid and coffee ice 'snow'.

— 500 ml (18 fl oz/2 cups) mulled wine, *glühwein*, or *glogg*

— 1 tablespoon honey

— 2 star anise

— 1 vanilla bean, split lengthways and seeds scraped

— 500 g (1 lb 2 oz) black or amber plums, halved or stones removed

— 250 g (9 oz/1 cup) soft ricotta

COFFEE ICE

— 500 ml (18 fl oz/2 cups) black filter coffee, kept warm

— 1 tablespoon honey

— 1 gelatine leaf

NUTMEG CREAM POTS WITH RHUBARB & PUFFED SPELT

Growing up in South Australia meant treating ourselves to the custard pies from the bakery stalwart Balfours. And what a treat – a pastry so sweet it was almost dripping in sugar syrup and a custard that was often cold and somehow managed to be refreshing in the dry, hot heat. But it was the nutmeg baked into the custard that I loved – that underrated spice, which rarely sees the light of day other than in béchamel sauce. This recipe brings it to the fore and uses rhubarb to cut through the creaminess.

Finding pre-prepared honey puffed spelt may be tricky but it's worth hunting down – it's a great product. Use it in cereal bowls or other desserts.

SERVES 4

PREPARATION TIME: 20 MINUTES PLUS SOAKING AND CHILLING
COOKING TIME: 30 MINUTES PLUS OVERNIGHT DRYING

For the puffed spelt, drain the soaked grains and add them to a saucepan of simmering water over a medium heat. Cook for 20 minutes, until the grains are beginning to soften but are still only partially cooked. Drain, then spread the grains out on a baking tray and leave them to dry overnight.

The next day, preheat the oven to its highest temperature. Add the dried grains and bake for 3 minutes, or until the grains have popped, then tip them into a bowl, add the honey and mix together well. Return the grains to the tray and bake for a further 2–3 minutes, until lightly golden. Remove from the oven and set aside to cool.

For the cream pots, soak the gelatine leaves in a bowl of ice-cold water for a couple of minutes, then remove and squeeze out the excess water. Stir the milk, nutmeg, honey and gelatine together in a small saucepan over a very low heat for 10 minutes, until the milk is warm and the gelatine has dissolved. Remove from the heat and leave to cool to room temperature, whisking occasionally (you can transfer the mix to the refrigerator to speed up this process). Whisk the mixture one final time before pouring into four 250 ml (9 fl oz) moulds, then refrigerate for at least 3 hours, until set.

While the cream pots are setting, prepare the rhubarb. Add the rhubarb and sugar to a small saucepan over a low heat and stir together. Cover and cook for 5 minutes, stirring halfway through, until the rhubarb pieces have softened and collapsed. Remove from the heat and leave to cool.

When ready to serve, spoon the rhubarb over the cream pots and top with the puffed spelt. Alternatively, serve the puffed spelt alongside the cream pots if not eating straight away (if the grains sit in the rhubarb liquid too long they can get soggy). Enjoy.

- 6 gelatine leaves
- 750 ml (27 fl oz/3 cups) milk
- 1 teaspoon freshly grated nutmeg, plus extra to garnish
- 4 tablespoons honey
- 300 g (10½ oz) rhubarb stems, cut into 8 cm (3¼ in) batons
- 115 g (4 oz/½ cup) caster (superfine) sugar

PUFFED SPELT

- 200 g (7 oz/1 cup) spelt grains, soaked in water overnight (wheat or rye grains also work well)
- 1 tablespoon honey

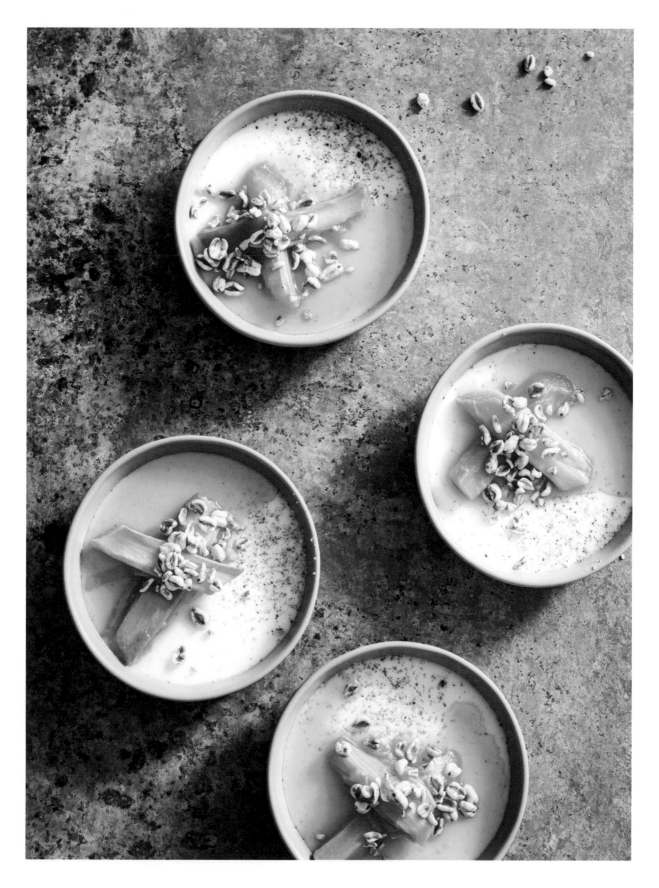

BLACKBERRY & GINGER CHEESECAKE

A true cheesecake has to be one of the least healthy cakes out there, so I can understand any reluctance in believing a healthy cheesecake can work. This then is for the non-believers. Surprisingly, the combination of healthy ingredients in this recipe is so rich in flavour that you'll find you can't go wrong.

SERVES 8

PREPARATION TIME: 30 MINUTES PLUS SETTING

For the base, put all the ingredients in a food processor and blitz together to a chunky crumb-like consistency. Press the mixture into a 22 cm x 30 cm (8½ in x 12 in) cake tin.

Add the cashew nuts, coconut, honey, lemon zest and lemon juice to the food processor and whiz together for 1 minute, until everything is well combined and the mixture is smooth and creamy. Add the coconut oil, yeast and vanilla extract and whiz again for 30 seconds.

Spoon half the creamy mixture over the base and spread it out evenly.

Add the blackberries and ginger to the remaining mixture and blend together, then spread this over the cheesecake. Smooth down the top of the cheesecake with a spoon and leave to set in the refrigerator for at least 2 hours.

When ready to serve, remove the cheesecake from the tin, transfer to a serving plate and slice into portions. This also makes a great snack to take with you – simply store it in the refrigerator in a sealed bag or wrapped in plastic wrap to prevent it from being tainted by other flavours.

— 310 g (11 oz/2 cups) cashew nuts

— 120 g (4½ oz/1¼ cups) desiccated (shredded) coconut

— 290 g (10¼ oz) honey

— zest and juice of 2 lemons

— 150 ml (5 fl oz) coconut oil, melted

— 2 tablespoons nutritional yeast flakes

— 1 teaspoon natural vanilla extract

— 100 g (3½ oz) blackberries, fresh or frozen

— 1 teaspoon freshly grated ginger

BASE

— 100 g (3½ oz/1 cup) walnut halves

— 12 pitted dates

— 2 teaspoons cacao powder

— 1 teaspoon ground cinnamon

— ¼ teaspoon salt

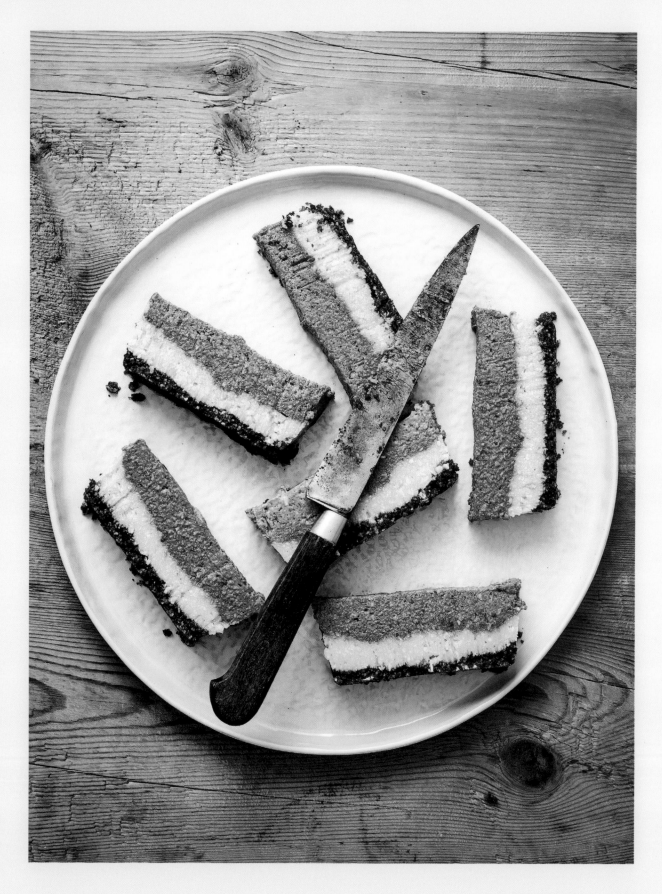

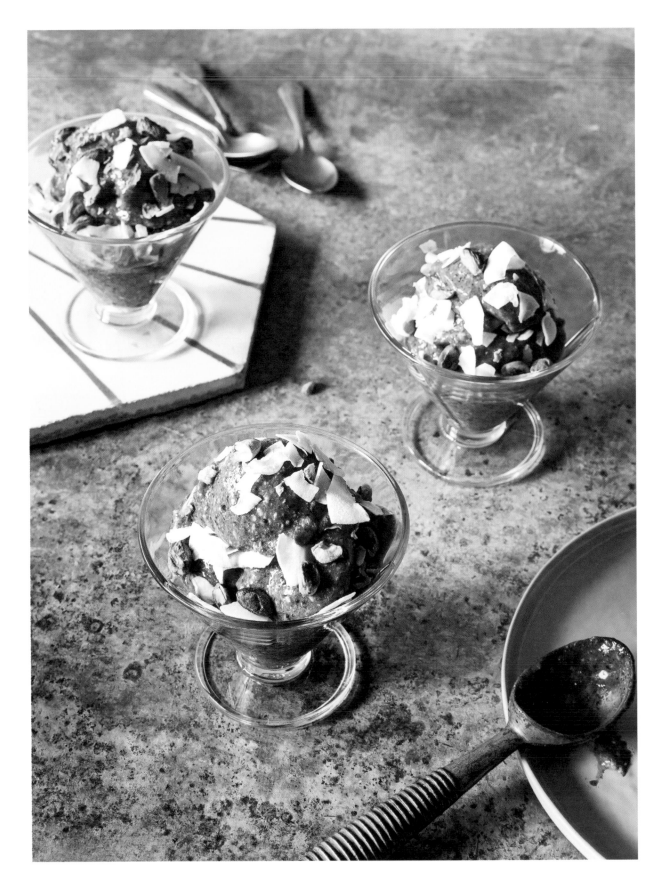

CHOCOLATE, CHERRY & COCONUT ICE CREAM

The Cherry Ripe is my favourite chocolate bar, which is odd considering I don't like glacé cherries. With these chocolate bars unavailable in the Nordic countries, this recipe was born. It's quick, easy and delicious.

SERVES 4

PREPARATION TIME: 10 MINUTES PLUS FREEZING
COOKING TIME: 8 MINUTES

Preheat the oven to 170°C (340°F/Gas 3½). Spread the desiccated coconut out on one baking tray and the pistachios on another and bake for 8 minutes, or until lightly golden. Watch carefully as they will burn easily. Set aside to cool.

Pour the coconut cream into a shallow container, transfer to the freezer and freeze for 2–3 hours, or until solid.

Remove the bananas and coconut cream from the freezer and leave to sit at room temperature for 10 minutes to thaw slightly, then remove the cherries from the freezer. Break up the coconut cream into small pieces by thumping it with a rolling pin (it should slide out of the container after being thumped and having melted a little). Peel and quarter the bananas.

Place the toasted desiccated coconut and coconut cream in a food processor. Whiz together until the coconut cream pieces are no more than half the size of what you started with, then add the fruit, honey or maple syrup and whiz together again, stopping the machine and scraping down the sides occasionally as you go to ensure everything is combined (this is important because you don't want to make a soup of the cherries which break down faster than the coconut). Add the chocolate pieces and pulse together briefly, then spoon the ice cream into bowls and top with the toasted pistachios and coconut flakes.

- 35 g (1¼ oz) desiccated (shredded) coconut

- 50 g (1¾ oz/⅓ cup) chopped pistachios

- 200 ml (7 fl oz) coconut cream

- 2 bananas, frozen (unpeeled or peeled and stored in a sealed bag)

- 500 g (1 lb 2 oz) frozen stoned cherries

- 3 tablespoons honey or maple syrup

- 50 g (1¾ oz) dark chocolate (70% cocoa solids), broken or chopped into bits

- 55 g (2 oz/1 cup) toasted coconut flakes to serve

OAT MILK PARFAIT, MALT SYRUP & 'BACI'

I love this dessert – it's like a sweet, but frozen, oat and banana porridge, while the maple and malt makes an awesome sauce that resembles a caramel sauce. Paired with hazelnuts and dark chocolate you can't go wrong.

SERVES 8

PREPARATION TIME: 20 MINUTES PLUS OVERNIGHT FREEZING
COOKING TIME: 25–35 MINUTES

Line a 600 g (1 lb 5 oz) loaf tin with plastic wrap.

First make the parfait. Add the oat milk to a heavy-based saucepan, bring to a simmer and cook over a low heat for 20–30 minutes, or until reduced by two-thirds. Remove from the heat, strain through a fine-mesh sieve and transfer to the refrigerator to cool (this will take at least 20 minutes).

Once cool, pour the reduced milk into a food processor, add the tofu, honey, cinnamon and bananas and blend everything together until very smooth. Spread into the prepared loaf tin and freeze overnight.

The next day, preheat the oven to 180°C (350°F/Gas 4).

For the 'baci', spread the hazelnuts on a baking tray and bake for 5 minutes, or until the skins are dark brown and beginning to split. Watch carefully as they will burn easily. Tip the nuts off the tray onto a clean tea towel and rub gently in the tea towel to remove the skins. Leave to cool.

Put the chocolate in a heatproof bowl, set it over a saucepan of simmering water and stir gently until the chocolate has melted. Add the whole hazelnuts, coat well and then pour out onto a sheet of baking paper. Sprinkle over the pollen, transfer to the refrigerator and chill for 10 minutes to set. Once set, use a knife to break the chocolate into chunks.

When ready to serve, make the syrup by putting the malt powder and maple syrup in a food processor or blender and blitzing together until smooth and free of lumps.

Remove the parfait from the freezer and slice into portions with a warmed knife (place the knife under warm water). Divide the parfait slices between serving plates, add some chunks of 'baci' and drizzle over the syrup to serve.

— 1 litre (36 fl oz/4 cups) oat milk

— 300 g (10½ oz) silken tofu, drained

— 175 g (6 oz/½ cup) runny honey

— ¼ teaspoon ground cinnamon

— 2 bananas, peeled and cut into thirds

'BACI'

— 100 g (3½ oz) hazelnuts

— 100 g (3½ oz) dark chocolate (70% cocoa solids), broken into rough pieces

— 1 tablespoon bee pollen

SYRUP

— 1 tablespoon dark malt powder

— 100 ml (3½ fl oz) maple syrup

HEALTHIER CHOCOLATE CREAM, ROASTED BARLEY, PEAR

As a lover of dark, bitter chocolate this dessert works for me, the sweetness coming from the dates and the creaminess from the avocado. Should you have any, left-over chocolate cream will keep in the refrigerator for a few days, with the flavours actually benefitting from having this extra time to meld together and develop further.

<u>SERVES 4</u>

**PREPARATION TIME: 30 MINUTES PLUS DRYING AND COOLING
COOKING TIME: 3 HOURS**

For the roasted barley, add the pearl barley to a saucepan, cover with water and bring to a simmer over a medium heat. Cook for 40 minutes, then drain and rinse well. Strain, tip onto a baking tray in an even layer and leave to dry (this will take at least an hour depending on the climate in your kitchen).

Preheat the oven to 110°C (225°F/Gas ¼) and line three large baking trays with baking paper.

For the pears, place the sugar on a plate and press the pear slices into it to coat evenly on both sides. Arrange the slices on two of the prepared trays and bake for 1 hour, then turn over and cook for a further 1 hour, until lightly caramelised. Leave to cool on wire racks for 15–20 minutes until crisp.

Increase the oven temperature to 180°C (350°F/Gas 4). Mix together the dried barley with the remaining ingredients in a bowl and arrange teaspoon-sized mounds of the mixture on the remaining lined baking tray. Bake for 20 minutes, until crispy and golden. Remove from the oven and leave to cool completely.

To make the chocolate cream, put the dates, avocados, cacao powder, coconut oil, espresso, honey and lemon juice in a food processor and blend together until smooth.

Put the chocolate in a heatproof bowl, set it over a saucepan of simmering water and stir gently until the chocolate has melted. Pour the melted chocolate into the food processor and blend together with the other ingredients until the chocolate is evenly incorporated and the consistency is that of thick Greek-style yoghurt. If it's a little too thick you can add a tablespoon or two of milk to thin it down. Spoon the chocolate cream into a bowl and chill in the refrigerator for 15 minutes to completely cool and set.

To serve, spoon the chocolate cream into serving bowls and top with the barley clumps and dried pear slices.

— 4 pitted dates

— 2 avocados, stones removed

— 2 tablespoons cacao powder

— 1 tablespoon coconut oil

— 1 tablespoon espresso or cold brewed coffee (optional)

— 1 tablespoon honey

— a squeeze of lemon juice

— 100 g (3½ oz) dark chocolate (70% cocoa solids)

— 1–2 tablespoons milk (optional)

ROASTED BARLEY

— 110 g (4 oz/½ cup) pearl barley

— 1 teaspoon dark malt powder

— 1 teaspoon dark brown sugar

— 1 tablespoon coconut oil, melted

PEAR

— 110 g (4 oz/½ cup) white granulated sugar

— 1 sensational or beurre bosc pear, thinly sliced lengthways on a mandoline

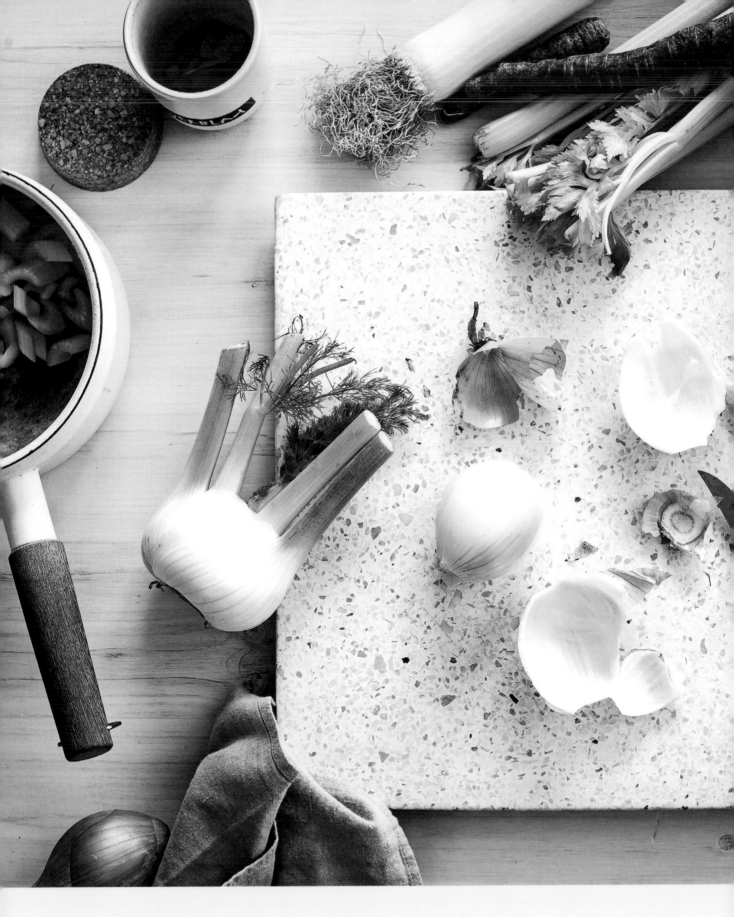

CHAPTER EIGHT

WEEKEND FOOD

This could really be called 'project food' because it's an investment. The recipes ahead are rewarding because they set you up for the week or weeks ahead, and what better time to don the apron than at the weekend?

Capturing something in its prime and bottling it is incredibly satisfying. The concept of preserving is an age-old premise of Nordic cooking. But we don't have to preserve just because our fish may turn, or because a long, cold winter awaits. We can preserve ripe, plump peaches because they are at the height of their season, as economical as they will ever be and in their best form.

It's sad to see how globalisation offers us ripe cherries in spring. Thankfully it feels like there is a backlash towards this 'buy everything and anything year-round' attitude as consumers worldwide gain a better understanding of seasonal eating and its associated benefits. But it's not just in-season produce that can be prepared for multiple uses – preparing grains and seeds to be used as garnishes and components for other dishes or making granola (see page 17) can also help us understand how investing a little time in the kitchen can reap rewards.

VEGETABLE STOCK

A homemade vegetable stock is a good thing to have to hand; it makes soups taste so much better and adds flavour to other cooked vegetable dishes. It's worth making a big batch and dividing it up between small, sealed bags or large ice cubes to be stored in the freezer for handy use at a later date.

MAKES APPROX. 3 LITRES (100 FL OZ/12 CUPS)

PREPARATION TIME: 5 MINUTES
COOKING TIME: 20 MINUTES

Heat the olive oil in a large heavy-based saucepan over a medium heat, add all the remaining ingredients and sweat down for 3 minutes, or until soft. Cover with 3 litres (100 fl oz/12 cups) of water, bring to a simmer and cook for 15 minutes.

Strain the vegetables from the stock and use immediately, keep refrigerated in sealed bags for 2–3 days, or freeze as large ice cubes for future use.

— 1 tablespoon olive oil

— 4 celery stalks, roughly chopped

— 2 carrots, roughly chopped

— 2 onions, roughly chopped

— 2 bay leaves

— 1 teaspoon black peppercorns

— 3 thyme sprigs

— any non-starchy vegetable or herb scraps such as dill stems, fennel tops, green leek parts or mushroom stems

RED CABBAGE CHUTNEY

Cabbage, that unsung hero, is finally getting its time in the sun. For a long time it was prepared using the most simple of methods, but that's changing. Cooking it down in a soft mass really brings out its sweetness, making it perfect for chutneys and relishes. The spices added below are suggestions, so feel free to freestyle it a little here.

MAKES 2 X 500 G (1 LB 2 OZ) JARS

PREPARATION TIME: 20 MINUTES
COOKING TIME: 1 HOUR 10 MINUTES

Preheat the oven to 100°C (200°F/Gas ⅛). Sterilise the glass jars by washing them thoroughly in soapy water, rinsing well, then putting them on a baking tray in the oven for 20 minutes. Leave to cool.

Warm the oil in a heavy-based saucepan over a medium heat, add the onion, tomatoes, garlic, ginger, dill, spices, salt and pepper and sauté for about 8 minutes, until the onion is soft and translucent. Add the vinegar and stir to deglaze, then add the cabbage and apple, reduce the heat to low and cook, covered, for 1 hour 20 minutes, stirring occasionally to prevent it from sticking to the bottom of the pan. Add 250 ml (9 fl oz/1 cup) of water and cook for a further 10 minutes. At this point the mixture will have collapsed into a sweet, wet, soft mass. If it is still a little dry, add a little more water. Season to taste with salt and pepper.

If you like a smooth relish, transfer the chutney to a food processor and pulse until smooth. Otherwise, spoon it straight into the prepared jars and store in the refrigerator for up to 3 months.

— 2 tablespoons rapeseed oil

— 1 red onion, finely chopped

— 2 tomatoes, diced

— 6 garlic cloves, finely diced

— 1 teaspoon grated fresh ginger

— 2 tablespoons chopped dill

— 1½ teaspoons mustard seeds

— ½ teaspoon ground turmeric

— 2 teaspoons salt

— ¼ teaspoon white pepper

— 125 ml (4 fl oz/½ cup) apple-cider vinegar

— 1.2 kg (2 lb 10 oz) red cabbage, finely sliced

— 1 granny smith apple, peeled, cored and diced

BRUSSELS SPROUT KIMCHI

Fermenting is a preservation method that has been used in Nordic countries since the time of the Vikings and a worthwhile endeavour, particularly given it also produces alcohol and vinegar. For many it may be hard to differentiate between a pickled cabbage and a fermented one but the difference is there and it's a beautiful thing.

MAKES 3 X 400 G (14 OZ) JARS

PREPARATION TIME: 30 MINUTES PLUS DRAINING AND FERMENTING

Preheat the oven to 100°C (200°F/Gas ⅛). Sterilise the glass jars by washing them thoroughly in soapy water, rinsing well, then putting them on a baking tray in the oven for 20 minutes. Leave to cool.

Cut each brussels sprout into four thin discs. Combine the brussels sprout pieces and salt in a large bowl. Using your hands, massage the salt into the sprout pieces until they start to soften, then pour over enough tap water to cover. Place a plate over the sprout mixture and weigh it down with something heavy like a jar or food tin and leave to stand for 1–2 hours (this will help soften the sprouts and extract any bitterness).

Rinse and drain the sprouts. Rinse the sprouts under cold water three times and then soak again for 15–20 minutes.

In a large bowl, mix together the garlic, ginger, sugar, spirulina and fish sauce to form a smooth paste. Stir in the spices. Add the vegetables and mineral water to the paste and use your hands to mix and coat everything thoroughly (you can wear gloves here if you like).

Pack the kimchi into the jars, pressing it down with a spoon until the brine rises to fully submerge the vegetables, leaving at least 2.5 cm (1 in) of headspace between the sprouts and the top of the jars. Seal the jars with the lids.

Leave the jars at room temperature to ferment for 1–5 days. Check them daily to release any gases and press down on the vegetables with a clean finger or spoon to keep them submerged under the brine. Taste a little at this point, too! When the kimchi tastes ripe enough for your liking, transfer the jars to the refrigerator. You can eat it right away, but it's best after another week or two.

- 1 kg (2 lb 4 oz) brussels sprouts
- 35 g (1¼ oz) sea salt
- 5 garlic cloves, grated
- 1 tablespoon grated fresh ginger
- 1 tablespoon raw (demerara) sugar
- 2 teaspoons spirulina powder
- 1 tablespoon fish sauce
- 1 teaspoon dried chilli flakes, crushed (optional)
- 2 teaspoons fennel seeds
- 1 teaspoon white pepper
- 100 g (3½ oz) fennel, sliced into batons
- 4 spring onions (scallions), green parts only, trimmed and cut into 2 cm (¾ in) pieces
- 500 ml (18 fl oz/2 cups) mineral water

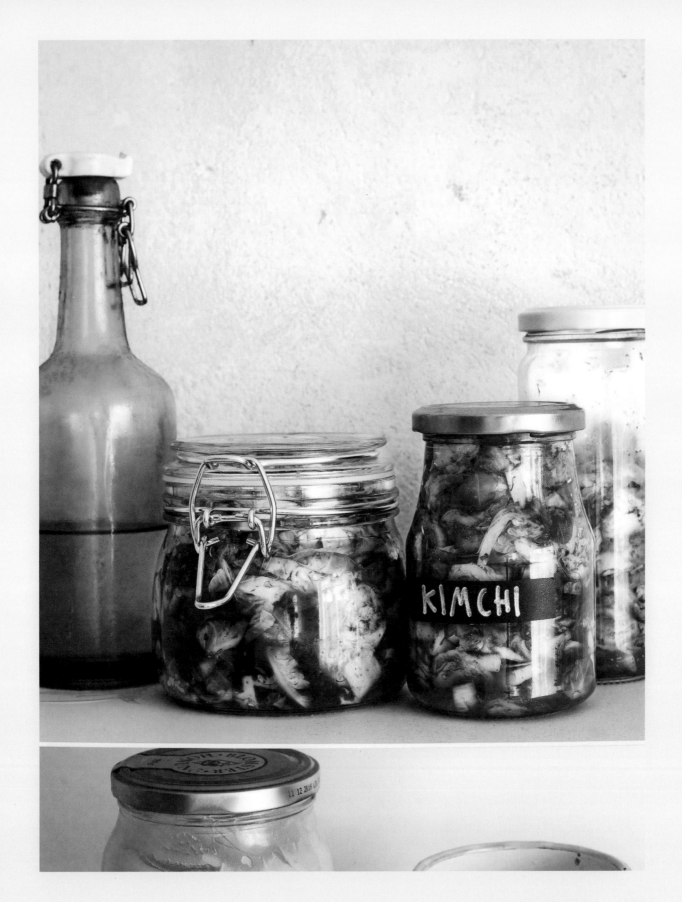

ROSEHIP KETCHUP

Rosehips are abundant towards the end of summer in Nordic countries. Many dwindle away on the branch to no use, but syrups and jams are marvellous products made from this interesting foraged ingredient.

It's difficult to describe the flavour of this ketchup – I suppose it's a mix between the earthiness of dried prune and the acidity of apple. It's a pleasant addition to cold meat dishes, in a cheese sandwich or with raw vegetables as a dip. For this recipe, try to pick rosehips that are plump, slightly soft and crush under the pressure of your fingers when pressed (be careful when applying this last test though – they can be prickly!).

MAKES 1 LARGE JAR (400–600 G/14 OZ–1 LB 5 OZ)

PREPARATION TIME: 10 MINUTES
COOKING TIME: 30–35 MINUTES

Preheat the oven to 100°C (200°F/Gas ⅛). Sterilise a glass jar by washing it thoroughly in hot soapy water, rinsing well, then putting it on a baking tray in the oven for 20 minutes. Leave to cool.

Pour 200 ml (7 fl oz) of water into a saucepan, add the rosehips, garlic and onion, cover with a lid and cook over a medium heat for 20–25 minutes, until the rosehips are soft to the centre when pressed hard (the exact timing will vary depending on the size of the rosehips – you may need to add more water as you're cooking if the pan looks like drying out).

Pass the rosehips through a sieve into a bowl in batches. This can be tedious, but the goal is to extract as much of the rosehip pulp from the seeds as possible. To extract more of the pulp, tip the seed mixture from the sieve back into the pan with an extra 100 ml (3½ fl oz) of water and heat again before sieving as before.

When all the flesh is extracted, return it to the saucepan together with the vinegar, sugar, cinnamon, cloves and allspice. Bring to a simmer over a medium heat and cook for 10 minutes, until the mixture turns a deep red and has the consistency of a thick sauce. If the ketchup seems too thick, add a splash of water.

Pour the ketchup into the prepared jar, seal and keep in the refrigerator for up to 2 months.

— 2 kg (4 lb 8 oz) rosehips, stems and tails attached

— 1 garlic clove, finely diced

— 1 large onion, finely chopped

— 100 ml (3½ fl oz) malt vinegar

— 60 g (2¼ oz/⅓ cup) brown sugar

— ½ teaspoon ground cinnamon

— 2 whole cloves

— ½ teaspoon ground allspice

MUSTARD SEED CAVIAR

While this preparation is a little tedious, it pays off. More than anything these little seeds provide a great texture, the mouth-feel of the pop you get when eating them is marvellous. Use this caviar sparingly and also consider using it as you would mustard – so in dressings and sauces or sprinkled over dishes to give them a little sweet, peppery, acidic kick.

Gold mustard seeds are much less bitter than brown mustard seeds, so use the gold variety only if you're not big on bitter flavours.

MAKES 125 ML (4 FL OZ/½ CUP)

PREPARATION TIME: 5 MINUTES
COOKING TIME: 20 MINUTES

Add the mustard seeds to a saucepan of boiling water. Cook for 3 minutes, then strain through a fine sieve. Repeat this process up to four times to remove the bitterness of the seeds.

Tip the drained seeds into a bowl and, while still warm, stir through the sugar and vinegar until well incorporated. Transfer to clean jars or tins and keep in the refrigerator for up to 1 month.

— 155 g (5½ oz/1 cup) brown and gold mustard seeds

— 2 teaspoons soft brown sugar

— 2 tablespoons apple-cider vinegar

SEEDY SESSIONS

The act of rediscovering ancient grains together with the inventing of new techniques to prepare them and other garnishes seems to be a common practice in the kitchens of new Nordic chefs, yet this idea can be very easily applied to the home kitchen with more readily available products also.

The following is a list of suggestions for applying some simple techniques to more typical ingredients to help you build up a supply of garnishes and condiments that will bring additional textures and flavours to your dishes. The range of possibilities you can come up with here is endless, so get your thinking hat on and develop some of your own ideas too...

BLENDED DRY FRUIT CRUMBLE

Using a food processor to blend dried fruits with little moisture content results in a nicely textured crumble that can be sprinkled over things. I suggest using banana chips, dried white mulberries or any dehydrated fruits. Soft dried fruits will only produce a paste if blended, so avoid these.

BURNT THINGS

Using ash to garnish a dish can give it the perfect finish, particularly if the dish features sweet or highly acidic components, as the bitter, earthy ash will stops things in their tracks. It's best to burn light greens that can easily have the water cooked out of them. Chives (see page 80) are a great, easy introduction to this.

TOASTING NUTS, GRAINS AND SEEDS

The possibilities here are extensive. When toasting nuts, bear in mind that generally the lower the temperature and the longer the cooking the better – it produces a more even cooking throughout and a better flavour once the nuts have cooled down. Always store toasted nuts, grains and seeds in a dry, cool place.

Mixing nuts, grains or seeds together with liquids before toasting can open up a whole range of flavours. Try mixing linseeds (flax seeds) and apple juice concentrate together before spreading them out on a baking tray and baking them in the oven. Other things I have tried are sunflower kernels in beetroot (beet) pickle brine and whole buckwheat mixed with sriracha and honey, while there's also a great vegan 'facon' recipe that tastes like bacon where smoked paprika, flaked coconut and tamari sauce are mixed together, formed into clumps and then toasted in the oven – it's incredibly similar! Try this but with the addition of turmeric and cayenne for a spicy, bright extra for your salads or other dishes.

BOOZY FRUIT

I like soaking dried fruits as on page 172. They give a fantastic finish to desserts or possibly an interesting kick-start to your morning bowl! Try mixing different fruits and liquors.

POPPED/PUFFED GRAINS

While it can be tricky to prepare these at home, many popped or puffed grain varieties can be found at health food stores and supermarkets. Look for popped amaranth, quinoa, millet and wheat – use them in cereal bowls or clump them together with coconut or vegetable oil or honey and bake them in the oven.

DEYHDRATED FRUIT

These crumbly, aerated bursts of flavour are becoming more readily available. You can make a dust with them, as on page 42, serve them in salads or in cereal bowls, or use them to garnish desserts.

CRUMBLES

Generally made for sweet dishes, crumbles can work on savoury dishes too (as the mustard rye crumble on page 84 demonstrates) and can be made with any type of flaked grain. The more traditional mix of flour, butter and sugar can be altered with spices or honey to make something more interesting. It's important to get the wet/dry consistency correct before baking.

PRE-BOUGHT TEXTURES

I love having cacao nibs, pollen, toasted sesame seeds and poppy seeds, among others, on hand in the pantry for scattering over dishes before serving.

FAUX CAVIARS

I love the texture you can achieve by mixing certain seeds or grains together with liquids. For example, the mustard seed caviar on page 196 or the quinoa caviar on page 118. Try finishing cooked tapioca pearls in a flavoured liquid such as carrot or tomato juice.

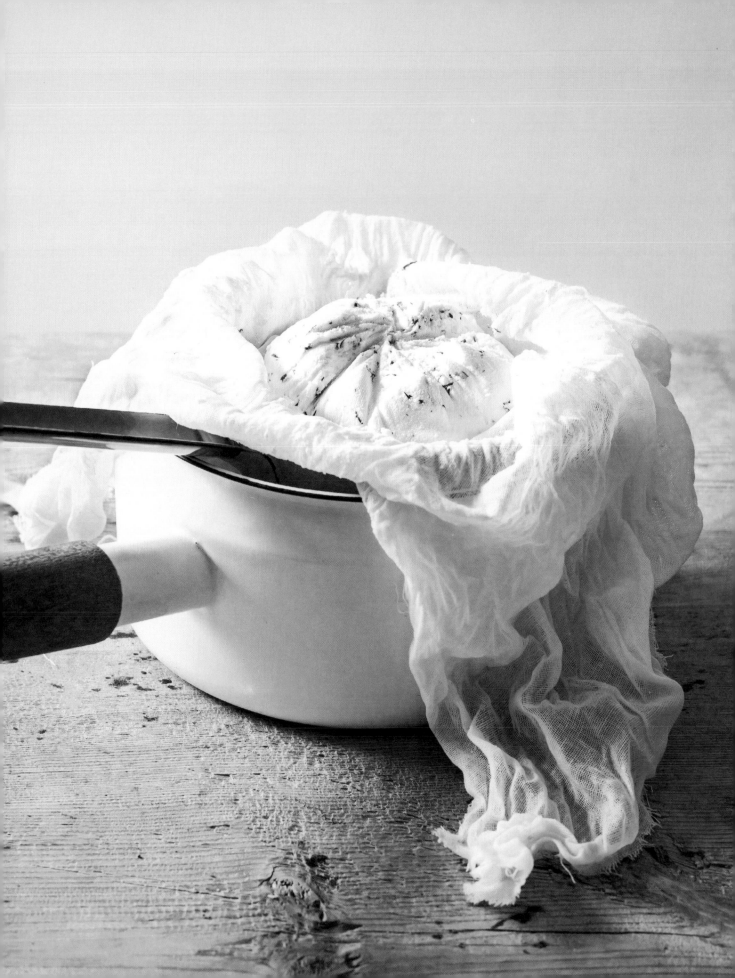

FRESH CHEESE

There's something special about making a product most of us have taken for granted our whole lives. Butter, cheese and yoghurt are all classic examples. This recipe for fresh cheese is simple and it accompanies many dishes in this book very well. Don't forget to reserve the whey. Although a little more mild, it can be used like vinegar, and is useful for dressing savoury dishes.

MAKES 1 X 500 G (1 LB 2 OZ) BALL OF CHEESE

PREPARATION TIME: 15 MINUTES PLUS DRAINING
COOKING TIME: 30 MINUTES

Gently warm the buttermilk in a large heavy-based saucepan over a low heat, stirring occasionally, until it has reached 70°C (158°F) and the whey has separated from the curd. Cover with a lid and set aside to cool to room temperature.

Line a sieve with a 50 cm x 50 cm (20 in x 20 in) piece of muslin (cheesecloth) and place over a large bowl. Strain the cooled curd and whey mixture through the muslin, gently stir in the dill and salt and set aside.

Pour the liquid whey into a jar and set aside for later use. Gather the still wet curds up in the muslin, twisting the excess cloth to squeeze out the extra whey, and form into a ball shape. Leave the curds in the sieve or hang them over the bowl (the contraption you use to do this is up to you) and leave to drain for up to 2 hours. This is up to personal preference, as the longer you leave it, the denser and firmer the cheese will be.

Unwrap the cheese once set to your liking and store in a sealed container or plastic bag in the refrigerator for up to 4 days. This fresh cheese is beautiful for finishing salads or served with fruits and nuts or vegetables.

— 1 litre (36 fl oz/4 cups) buttermilk

— 2 tablespoons chopped dill

— 1 tablespoon sea salt flakes

PLUM, VANILLA & ROSEMARY JAM

This is a great jam recipe which, unlike almost all jams, doesn't feature any sugar. The prunes give it a lovely deep flavour reminiscent of dried fruit, while the sweetness comes from the ripeness of the plums. If your plums aren't quite ripe enough the jam can end up tart, but don't despair – like this it makes a delicious sharp spread paired with savoury ingredients such as cheese or meat.

MAKES 3 X 400 G (14 OZ) JARS

PREPARATION TIME: 5 MINUTES
COOKING TIME: 3 HOURS 30 MINUTES

Preheat the oven to 100°C (200°F/Gas ⅛). Sterilise the glass jars by washing them thoroughly in soapy water, rinsing well, then putting them on a baking tray in the oven for 20 minutes. Leave to cool.

Halve the plums, keeping the stones in, and add to a large heavy-based saucepan together with the rosemary, split vanilla bean and seeds and prunes. Cook over a low heat for 2 hours, stirring occasionally to prevent the mixture sticking to the bottom of the pan. Remove the plum stones (these can be rinsed and kept to flavour vinegars) and continue to cook, stirring regularly, for a further 1½ hours, until you have a sticky, deep-red jam. Towards the end of this time the jam will be wanting to stick to the bottom of the pan, so keep an eye on it and be sure to keep stirring to make sure this doesn't happen.

Once cooked, leave the jam to cool, then spoon it into the sterilised jars. The jam will keep for up to 3 months – to keep it for longer, freeze it in a suitable container and defrost it when needed.

- 2 kg (4 lb 8 oz) over-ripe plums, washed (black or amber plums are perfect for this)
- 2 rosemary stalks
- 1 vanilla bean, split lengthways and seeds scraped
- 250 g (9 oz) dried pitted prunes, roughly chopped

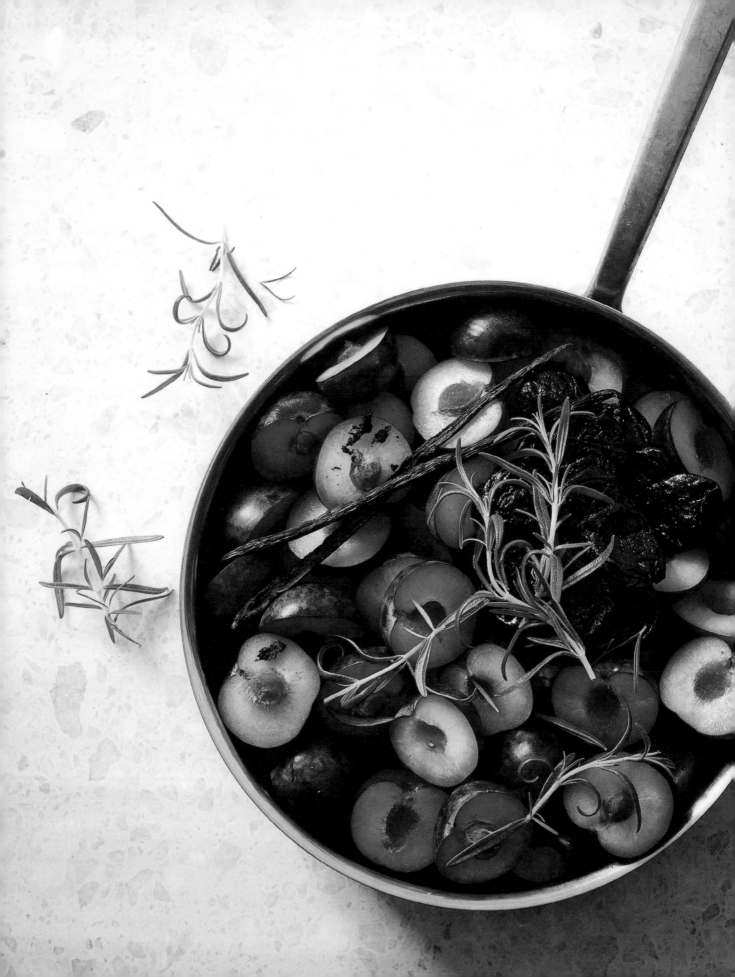

STRAWBERRY BALSAMIC LEATHER

I remember snacking on a processed version of this at primary school. It was delicious but so sweet and bad for you! I love how the reduction and drying concentrates the flavour of the berries and I've always loved balsamic with strawberries. You could apply the below recipe to any fruit you find stacking up in your kitchen, just make sure to pass it through a sieve first so you end up with a smooth pulp.

MAKES ONE 30 X 40 CM (12 IN X 16 IN) RECTANGLE

PREPARATION TIME: 20 MINUTES PLUS DRYING
COOKING TIME: 3–4 HOURS

Preheat the oven to 100°C (200°F/Gas ⅛). Line a large baking sheet with non-stick baking paper.

Put the strawberries and sugar in a food processor or blender and whiz together to form a smooth purée, then strain the mixture through a fine-mesh sieve into a large heavy-based saucepan.

Bring the purée to a boil, then lower to a simmer and cook over a medium–low heat, stirring occasionally, for 45 minutes to 1 hour, or until the mixture has thickened and reduced to about 250 ml (9 fl oz/1 cup) and stands in ribbons if poured over itself.

Gently stir the balsamic vinegar through the hot purée so that it is not entirely incorporated but rather marbles the mix, then pour the purée onto the centre of the prepared baking sheet. Spread it out as evenly as possible into a 30 cm x 40 cm (12 in x 16 in) rectangle using a spatula.

Transfer the purée to the oven and leave to dry for 2–3 hours – the fruit leather will be ready when it no longer sticks to your fingers but is still slightly tacky. Remove the baking tray from the oven and leave to cool and dry completely, this will take at least 3 hours and up to 24.

Once dry, place a sheet of baking paper over the fruit leather, then peel it away from the non-stick paper and roll it up in the new sheet. Keep the rolled fruit leather in a sealed food bag or container for up to 1 month.

— 750 g (1 lb 10 oz) strawberries, fresh or frozen

— 165 g (5¾ oz/¾ cup) raw (demerara) sugar

— 1 tablespoon best-quality balsamic vinegar

SEEDY CRISPBREAD

This is a must for your pantry. It's a delicious, moreish snack that can be eaten on its own, topped with cheese and pickles, crumbled over bowl foods like yoghurt with fruits or broken over salads for texture. As it's bound by the psylllium husks and chia seeds rather than by wheat, this crispbread is also gluten free.

I like to make a large batch of the seed mixture and store it in a large sealed jar or container, ready for whipping up some crispbread whenever it's needed.

MAKES 1 CRISPBREAD WITH EXTRA SEED MIX

PREPARATION TIME: 10 MINUTES
COOKING TIME: 45 MINUTES

Mix together all the ingredients, except for the rapeseed oil, in a suitable container.

Measure out 195 g (7 oz/2 cups) of the seed mixture and add to a large bowl. Transfer the remaining seed mixture to a sealable container or jar for later use (this quantity will give you enough to make a further 3 crispbreads).

Add 250 ml (9 fl oz/1 cup) of water and the oil to a bowl and stir through the seed mix. Leave to sit for 15 minutes.

Using a spatula, pile the mixture into the centre of a sheet of baking paper, then spread it out into a rectangular shape. Lay a second sheet of baking paper on top and roll over that to roll the mixture out into a 20 cm x 30 cm (8 in x 12 in) rectangle with a thickness of no more than 1 cm (½ in).

Bake in the oven for 45 minutes, or until the edges curl up and start to turn golden brown.

Leave the bread to cool on a wire rack to dry out and become crisp. Store in a sealed container for up to a week.

— 125 g (4½ oz/1 cup) chia seeds

— 125 g (4½ oz/1 cup) sunflower kernels

— 180 g (6 oz/2 cups) pepitas (pumpkin seeds)

— 2 teaspoons salt

— 155 g (5½ oz/1 cup) sesame seeds

— 115 g (4 oz/¾ cup) golden or brown linseeds (flax seed)

— 80 g (3 oz/1 cup) psyllium husks

— 2 tablespoons rapeseed oil

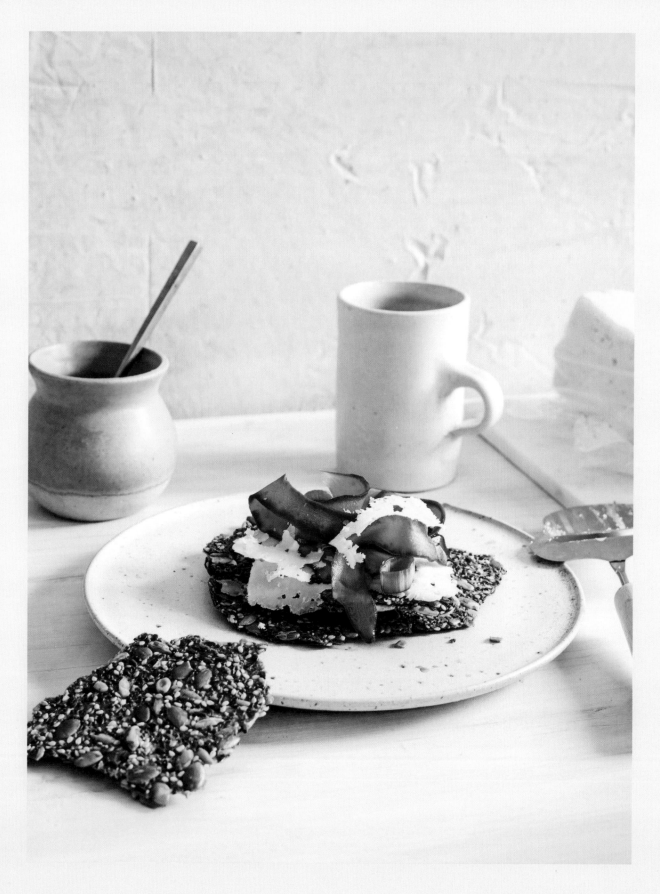

REPLACEMENTS

A few Nordic products may not be readily available worldwide. The best places to track them down are at specialist food stores or online – or at the Ikea food market! And seek out any local community events in your neighbourhood. Failing that, here is a guide to suitable substitutes.

Likewise, while the range of nutritional and health foods on offer in supermarkets is growing, you may still need to visit health stores or ethnic grocers for some ingredients in the book.

BARLEY

A whole grain incredibly full of nutritional benefits, barley also happens to be one of the first cultivated grains. To match the texture and flavour of pearl barley, use farro, millet, spelt or wheat berries – different cooking instructions are likely for each of these suggestions, so do check the packaging.

BIRCH SYRUP

Birch syrup has a much more distinctive savoury taste than maple, yet around the same sugar content. Depending on the tree it has been extracted from the flavour can be similar to wildflower honey or mineral-like in nature. Feel free to replace it with maple syrup.

CHANTERELLE MUSHROOMS

These beautiful mushrooms are fairly common in Northern Europe, North America and Asia. Some chefs profess that their flavour is best appreciated in their soaked, dried form, so if you can get hold of some that have been dried, do. In Australia, the closest in flavour is the pine mushroom, which grows in the wild and can be bought at autumn food markets.

CROWN DILL

Crown dill is the herb that has been harvested after the dill plant has blossomed in the autumn months. It has a more intense aniseed flavour than the dill herb, which can best be replicated by using regular dill and a very light dusting of liquorice powder.

DRIED WHITE MULBERRIES

These dry, sweet berries lack the tartness found in other berries, instead possessing a pleasant, perfumed flavour. The best substitute would be golden raisins.

HEMP SEEDS

These seeds are very nutritious, full of protein and have no known issues for those with food intolerances. There are many uses for them: raw, they can be sprinkled on things, ground up similarly to almond meal or even made into a milk as you would almond milk; cooked, they can substitute for breadcrumbs to be used as crust or toasted and sprinkled over salads and soups. If you don't have any the best substitutes are pine nuts or sunflower kernels.

HERRING

Kipper and *bockling* are other names for herring, so look out for these. Small mackerel fillets, or sardines make good substitutes; both are a little saltier but will do the trick. Tommy Ruff, which is often called herring in Australia, is not related to the herring from Nordic waters.

JUNIPER

Dried juniper berries are found in stores that have an extensive range of spices. They go very well in the cooking of game, meat and stews. Their flavour is intense. If you haven't any, depending on the application you could use a splash of gin, or some all-spice berries or pink peppercorns instead – though the latter two only somewhat resemble the juniper berry's flavour.

KOMBUCHA

Kombucha is a slightly sour, lightly effervescent fermented drink that is derived from black or green tea. A good substitute would be diluting an iced tea with soda water, though it won't replicate kombucha's fermented flavour.

LIQUORICE POWDER

This powder ground from the liquorice root, which is not to be confused with ground anise, can be found in speciality food stores. It can be used to add flavour when cooking sweet and savoury dishes. The flavour is stronger than that of fennel or anise seeds.

LINGONBERRY

Lingonberry is rampant across Swedish, Finnish and Norwegian forest floors. A small shrub that's low to the ground, it yields tart berries through the summer. The tartness of these berries is best balanced by sugar, usually in the form of a jam or as a syrup/cordial. Lingonberry jam accompanies many classic Nordic dishes – the best substitute for it is cranberry. Lingonberry syrup is sweeter than it is tart so any berry cordial will replace its flavour – try cloudberry, blueberry, boysenberry or blackberry instead.

MALT POWDER

Malt powder is made from sprouted burnt barley. It has a unique flavour that is important when baking an authentic Danish rye bread. Don't confuse it with malted milk powder. You can use malted milk powder as a substitute but its flavour is much milder, and bear in mind that the milk powder could affect the end result. Beer-making supply stores, bakery supply stores and health food stores are where you are most likely to find authentic malt.

MILLET

This gluten-free grain is found in pearl form – its best substitute for making the porridge in this book (see page 26) is quinoa flakes.

NUTRITIONAL YEAST FLAKES

These yeast flakes give vegan preparations a more dairy, cheese-like flavour. Unfortunately there is no real substitute so I recommend you visit a well-stocked health food store to find them if using for the recipes in this book.

POLLEN

Dried bee pollen has many health benefits and can therefore be found in many health food stores. In the kitchen it makes a great sweet, floral textural addition to dishes.

RAPESEED OIL

Rapeseed oil is also known as canola oil. Warm-pressed canola oil is easily found in grocers but cold-pressed may be a little harder to find – try good-quality delicatessens or oil specialist stores. Cold-pressed rapeseed oil is to Scandinavians what extra-virgin olive oil is to Italians, though rather than rich and fruity its flavour is intensely floral and nutty. To replicate the flavour you could try using a regular rapeseed oil and adding a touch of macadamia or almond oil.

ROSEHIPS

If you're unable to pick them straight from the bush, dried rosehips can be found in tea bags. Good quality delicatessens also sell rosehip jam or syrup. The next best alternative would be to use quince, which I find shares a similar flavour.

RYE

Rye comes in many different forms in Nordic countries but it is most commonly found elsewhere as rye flour. Cracked rye can be substituted with whole rye grains broken in a blender with any resulting flour sifted out. In place of rye breadcrumbs, a dry biscuit (such as Ryvita) can be crushed into crumbs. Rye meal is produced when the whole grain is ground. Light rye flour refers to where the germ and the bran have been removed from the kernel before being ground. A true light rye shouldn't be combined with wheat flour. Flaked rye is made from rye groats which are steamed and rolled into flakes. They are dark in colour and have a deeper flavour to that of wheat and oats, and can be added to cakes and breads and used in porridges.

SPELT

Spelt grains and flours are now very common, but if you need an alternative then use wheat berries in place of spelt grains, or wholemeal (whole-wheat) flour in place of spelt flour. For the latter, be aware that spelt flour needs less water when being worked up into a dough.

STINGING NETTLE POWDER

This powder can be found in health stores. Wheatgrass powder, baobab powder or spirulina are good substitutes.

VÄSTERBOTTEN

This hard cow's milk cheese is prepared similarly to cheddar and is from the Västerbotten region of Sweden. It has some slightly more bitter notes than parmesan but the flavour profile is similar, making parmesan the perfect substitute.

WOOD SORREL

This acidic herb leaf can be found in Asian grocers. The best alternative would be to use lemon balm with a few drops of vinegar or another leaf, such as rocket (arugula) or spinach, dressed with lemon juice.

INDEX

TACK! TAK! TAKK! KIITOS! þakka þér!

Special thanks to my beautiful wife Linda and sons Max and Leon.

Thank you to my family and friends, who I miss greatly, in Australia.

Thanks to all those who helped in producing this book. Thanks to Jane Willson, to Simon Davis for his fantastic communication and editing, to Murray Batten for his on point design and to Solveig Eriksdottir for convincing me that healthier eating can taste great. And thanks to Hardie Grant in Melbourne and London for their continued support.

Finally, thanks to ceramicists Kasper Würtz, Janaki Larsen and Jo Norton, and to Lindform and Skagen Potteri, House Doctor and Bolia for their generosity in supplying props.

Published in 2016 by Hardie Grant Books

An SBS book

Hardie Grant Books (Australia)
Ground Floor, Building 1
658 Church Street
Richmond, Victoria 3121
www.hardiegrant.com.au

Hardie Grant Books (UK)
5th & 6th Floors
52-54 Southwark Street
London SE1 1UN
www.hardiegrant.co.uk

A Cataloguing-in-Publication entry is available from the catalogue of the National Library of Australia at www.nla.gov.au

Nordic Light

ISBN 978 174379144 8

Publishing Director: Jane Willson
Project Editor: Simon Davis
Design Manager: Mark Campbell
Designer: Murray Batten
Photographer and Stylist: Simon Bajada
Production Manager: Todd Rechner

Colour reproduction by Splitting Image Colour Studio
Printed in China by 1010 Printing International Limited